D1194599

★
ICONS

Women Artists

Cover and end paper:
Pae White, *More Birds*, 2001

To stay informed about upcoming TASCHEN titles, please request our magazine at
www.taschen.com or write to TASCHEN America, 6671 Sunset Boulevard,
Suite 1508, USA–Los Angeles, CA 90028, Fax: +1-323-463 4442.
We will be happy to send you a free copy of our magazine
which is filled with information about all of our books.

© 2003 TASCHEN GmbH
Hohenzollernring 53, D–50672 Köln
www.taschen.com

© for the illustrations by Marina Abramović, Eija-Liisa Ahtila, Louise Bourgeois, Valie Export,
Natalja Gontscharowa, Hannah Höch, Candida Höfer, Jenny Holzer, Rebecca Horn, Lee Krasner,
Tamara de Lempicka, Annette Messager, Louise Nevelson, Georgia O'Keeffe, Meret Oppenheim,
Rosemarie Trockel, Berlinische Galerie (Photos by Hannah Höch): 2003 VG Bild-Kunst, Bonn

Texts by: Ilka Becker, Frank Frangenberg, Uta Grosenick, Barbara Hess, Ulrike Lehmann, Holger Liebs,
Petra Löffler, Helen Simpson, Raimar Stange, Astrid Wege

Translation by Paul Aston, Sherborne (Ahtila, Dijkstra, Holzer, Kruger, Lucas, Mori,
Neshat, Rist, Sherman, Smith); Pauline Cumbers, Frankurt am Main (Krystufek, Peyton,
de Saint Phalle); Ishbel Flett, Frankfurt am Main (Bourgeois, Goldin, Kahlo, Oppenheim);
John W. Gabriel, Worpswede (Abramović, Anderson, Beecroft, Darboven, Dumas, Genzken,
Goncharova, Guerilla Girls, Hatoum, Krasner, de Lempicka, Messager, Nevelson, O'Keeffe,
Riley, Trockel, Witheread, Zittel); Malcolm Green, Heidelberg (Clark, Horn);
Michael Hulse, Amsterdam (Delaunay, EXPORT, Fleury, Hesse, Höch, Piper)

Editorial Coordination: Annick Volk, Cologne
Design: Sense/Net, Andy Disl & Birgit Reber, Cologne
Production: Tina Ciborowius, Cologne

Printed in Italy
ISBN 3-8228-2437-2

Edited by Uta Grosenick

Women Artists

IN THE 20TH AND 21ST CENTURY

TASCHEN

KÖLN LONDON LOS ANGELES MADRID PARIS TOKYO

Contents

It's a women's world

The present book is devoted entirely to women artists. It presents the various forms taken by women's art in the 20th century, with selected illustrations and informative commentaries – while at the same time avoiding polemics or stereotyped categories.

"Good art knows no gender," say critics of feminism, in an attempt to wriggle out of the debate on the social mechanisms and the realities of the gender war. In opposition to this standpoint, the current gender discussion asserts that gender is not assigned by nature, but rather needs to be understood as a social construct. Neither view probably has had much influence on the (self-)confidence with which women have decided, and continue to decide, for a life in art.

Already at the beginning of the 20th century, women artists were able to invoke numerous rights won by their fellow campaigners of the 19th century. They were entitled to attend the same art colleges as their male counterparts, to take part in classes in drawing from life, to enter competitions, to win prizes, and to apply for scholarships. They were able to display their works at international exhibitions, and sell them through galleries, they could accept commissions and play their part in artistic life. In 1884, Amsterdam became the venue for the first exhibition devoted solely to drawings by women, and this was followed in 1908 and 1918 by two further exhibitions in Paris to which only women were invited to submit works. On the surface, then, there were no serious differences between the opportunities for male and female artists. The conventional wisdom was: "True talent will be recognized for what it is; those who possess it will be successful." In reality, however, this much-heralded equality of opportunity proved deceptive. There were very few women teachers at art colleges, or women members of art academies. They were less well represented at exhibitions, while their works found their way very much less often into public or private collections, nor were they mentioned so frequently in the literature.

During the first decades of the 20th century, European painting saw the emergence within a very short time of such diverse movements as Art Nouveau, Expressionism, Fauvism, Cubism, Futurism, Constructivism, Dadaism, Abstract Art, Neue Sachlichkeit, and Surrealism – leading to a hitherto inconceivable pluralism of styles. In addition, there were the new media of film and photography, which were gradually proving their artistic credentials while giving rise to far-reaching changes in visual perception. Even though women now had access to educational institutions, and were less restrained by social convention than previously, their professional advancement was nevertheless still dependent on their exploitation of individual contacts with men already established in the art business.

In the early 20th-century avant-garde there were a number of women artists who, having evolved their style at Russian art colleges, perfected it by continuing their studies in Paris. The second decade of the 20th century saw pictures and sculptures by women artists in every area of the visual arts, from the male nude to the abstract. The period of World War I witnessed the formation of the group of artists known as Dadaists, who pursued anarchic and pacifist intentions. During the 1930s and 1940s, some women artists discovered Surrealism, in whose visual metaphors poetic fantasy is more important than technique: they were accorded wide-ranging recognition. Nor did sculpture remain a purely male preserve.

In the post war 1950s, however, few women artists succeeded in using personal contacts with male artists and critics to make a name for themselves in the field of American Abstract Expressionism. The 1960s saw a radical extension of the traditional concept of art, with a corresponding increase in the number and variety of co-existing styles: Pop Art, Op Art, Concept Art, Land Art, Minimal Art, Happenings and Fluxus, Performance and Body Art – all emerged more or less at the same time, and women were represented in all of them. The mood of upheaval

that characterized the late 1960s gave renewed impetus to feminism. Women artists took to the barricades in the fight for equal opportunities with men in museums and academies, organizing their own exhibitions, operating galleries of their own and running their own autonomous art-classes. They also sought to use political means to break down male-dominated structures. Women performance-artists in particular demonstrated their self-assurance and the self-determination of their own bodies. Their performances involved self-harm: they subjected themselves to self-torture and psychological stress. During the 1970s, women artists sought to draw attention to, and thus to dismantle, the social clichés to which they were subject by virtue of their gender. The 1980s by contrast were a decade of disillusionment for most women artists: gender differences evinced a stubborn ability to survive, while in the artistic sphere as elsewhere, the hoped-for emancipation was still far from being achieved. A younger and self-aware generation of women built on the achievements of the feminists, concerning themselves in a more playful manner with issues of gender and identity. Finally, by the 1990s, contemporary women artists were given solo exhibitions even in the most hallowed temples of art: the 1993 Turner Prize for young art, a coveted distinction awarded by the Tate Gallery in London, went to a woman for the first time, while some women were able to command top prices in the art market. Photography experienced an undreamt-of boom as an autonomous artistic medium, allowing a number of women to make a name for themselves with their highly subjective view of the world through the camera lens. Since the late 1990s, women artists have also been making increasing use of the digital media.

The new millennium is witnessing the establishment at art academies of chairs of "gender studies", as the critical examination of the significance of one's own and other people's gender (i.e. sex as a social rather than biological manifestation) is becoming ever more central in art.

The following pages provide impressive proof that "women's art" – in the sense of art created by women – is not the same as female or feminist art. There are as many artistic approaches and expressive possibilities in women's art as there are women artists. For this reason, a chronological sequence of artistic movements has been consciously dispensed with in favour of an alphabetical sequence of artists. This allows positions which now form an integral part of the history of art to be compared with experimental tendencies only now making their appearance on the art scene. Forty-six women artists from the Western world are presented: women who have achieved world fame are juxtaposed with others whose artistic career has only just begun. For the selection, an attempt has been made to include as many of the tendencies and styles reflected in the work of 20th-century women artists as possible. The artistic techniques are numerous: painting and drawing, collage and assemblage, traditional and less traditional sculpture, photography and film, performance, video and internet. It must be stressed that the women artists represented here form only a small selection: the list of outstanding women artists is very long. The selection comprises those artistic personalities who have put a permanent stamp on 20th-century art and who will continue to influence the art – by men and by women – of the 21st century.

Uta Grosenick, Cologne, August 2003

Marina Abramović

* 1946 in Belgrade, Yugoslavia; lives and works in Amsterdam, The Netherlands

„Keep body and soul together = remain alive."

Body Material

When Marina Abramović and her partner Ulay arrived in the Chinese town of Er Lang Shan on 27 June 1988, they had covered 2,000 kilometres in 90 days – the entire length of the Great Wall – for this rendezvous at the end of the world. It was also their last collaborative work as an artist-couple. With this performance, *The Lovers,* Abramović and Ulay transformed the personal experience of having reached the end of their path together into a simple act performed at an actual geographical location. They walked towards each other from the opposite ends of the Great Wall, only in order to separate again – forever. This staging of a geometry of love made the painful division in their individual biographies appear to be the inevitable result of a law of life.

Abramović and Ulay had been collaborating since 1976, in works that made their symbiotic relationship the basis of existential experiences. In the performance *Breathing In/Breathing Out*, 1977, they exchanged their breath until all the oxygen had been exhausted (having previously blocked their nostrils with cigarette filters). In *Interruption in Space*, 1977, the two artists repeatedly ran and crashed into a wall to the point of exhaustion, and in *Light/Dark* of that same year they slapped each other in the face until one of them stopped. The point of these exercises was to subject the body to extreme physical states and test its limits. The audience's reaction formed a key component of this physical self-experience – whether in the form of mental attention or actual intervention, as in the performance *Incision*, 1978, during which Abramović was attacked by a spectator.

For the performance series *Nightsea Crossing*, 1981–86, in contrast, the participants were carefully select-ed. Abramović was especially interested in the conjunction of individual and political history, so she and Ulay took their own, shared birthday as the occasion for a performance, *Communist Body – Fascist Body*. On 30 November 1979, they invited friends to their apartment for the birthday party. The guests found Abramović and Ulay lying on a mattress asleep, or pretending to be asleep, and next to them two tables set with plates, champagne and caviar from their respective countries of origin. The performance reflected the circumstances of two biographies that had invol-untarily been marked by a dictatorship: Marina's birth certificate was officially stamped with a red star, and Ulay's with a swastika.

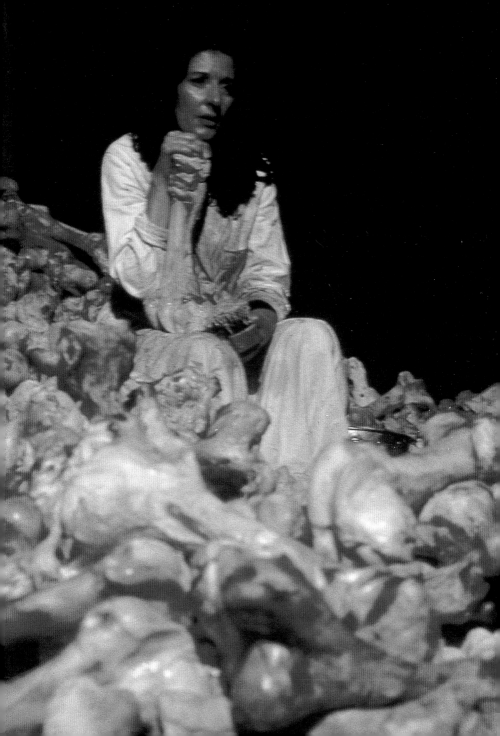

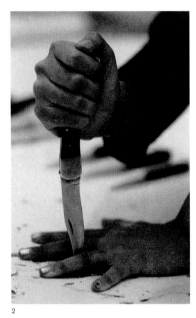

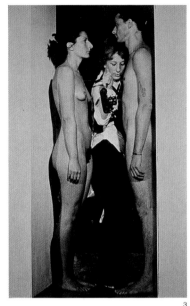

2

3

4

Dangerous rituals

Abramović heightens elements of her biography to fundamental mental situations, simultaneously dramatising them. Her body is her "material" and, together with the space it occupies, forms what she terms her "performing field". She frequently goes to the limits of the physically and mentally bearable, and sometimes even beyond. She became widely known with a series of performances in the 1970s in which she purposely subjected herself to physical pain, repeatedly injuring herself by incising her skin or cutting her hand with sharp knives. In *Rhythm 10*, 1973, she drove a knife as fast as she could between her fingers, recorded the sounds, and then repeated the procedure. Frequently the scenarios of her performances recalled ecstatic, religious practices, such as *Thomas' Lips*, 1975, into which the Christian rituals of self-flagellation and stigmatisation entered. Like Gina Pane and other performance artists of the period, Abramović inflicted bleeding wounds on herself, with the intent of escaping from her culturally determined and disciplined body. In *Rhythm 0*, 1974, she functioned solely as an object among others, offering the audience free access not only to such everyday objects as a mirror, a newspaper or bread, but to a pistol and bullets as well. Some viewers rapidly succumbed to their dark urges and abused the power they had over the helpless "object".

The body suffers

By comparison to this conscious abandonment of the ego, Abramović's works of the late 1980s had a more detached and narrative character. At this time she also developed a series of *Transitory Objects* designed to give the audience wider leeway for participation. Theatre stages were often used for performances, or the video medium was employed to increase the complexity of the artist-audience relationship. In *Dragon Heads*, 1990–92, a wall of ice blocks separated the artist – her body entwined with live pythons – from the audience. The theatrical effect of the stage-like division of the space was augmented by the use of spotlights. In the video installation *Becoming Visible*, 1992, Abramović was again surrounded by snakes. She also continued to focus on the central motifs of her activity, such as physical suffering, in works like *Dissolution*, 1997. A multiple-episode performance developed in collaboration with Charles Atlas, *Delusional*, 1994, contained passages from her biography in the form of allegorical imagery.

The treatment of traumatic memories in Abramović's major work, *Balkan Baroque*, which won an award at the 1997 Venice Biennale, gained additional political thrust due to the war in Bosnia. In the midst of an installation of three video projectors showing the artist and her parents, and three copper vessels full of water, Abramović sat for over four days, cleaning 1,500 cattle bones and singing songs from her childhood. The spiritual act of cleansing in preparation for death had once before concerned the artist, in the video installation *Cleaning the Mirror I*, 1995, where she thoroughly cleaned a skeleton with a brush and water.

Her work in progress, *The Biography*, also finds Abramović returning to certain set pieces. She repeats and varies earlier performances, narrates her biography on tape, introduces a little girl as the figure of the narrator, and integrates visual material into this multi-layered stage piece, which has been presented in various theatres since 1992. *The Biography* permits the artist to deal with the story of her life with the same freedom that she brings to her work – and, by so doing, to recreate herself continually.

<div align="right">Petra Löffler</div>

1 **Balkan Baroque,** 1997. Performance, XLVII Esposizione Internazionale d'Arte, la Biennale di Venezia, Venice, Italy
2 **Rhythm 10,** 1973. Museo d'arte Contemporaneo, Villa Borghese, Rome, Italy
3 **Imponderabilia,** 1977 (with Ulay). Performance, Galleria Communale d'Arte, Bologna, Italy
4 **The Lovers (Walk on the Great Wall of China),** 1981 (with Ulay). Performance, China

Eija-Liisa Ahtila

* 1959 in Hämeenlinna, Finland; lives and works in Helsinki, Finland

"In films and video installations, my aim is to throw light on time and narration with the help of characters in a family. So it's never clear in the story who's who or how things stand between the film actors ..."

Between dream factory and documentation

No other contemporary female artist from Finland has reaped such international praise and won so many awards as the film-maker Eija-Liisa Ahtila. She has taken part in numerous biennales and film festivals. After studying in Helsinki, London and Los Angeles, in 1999 the artist won a DAAD scholarship in Berlin and a prize for her film *Consolation Service* at the Venice Biennale. It is not just the medium that makes Ahtila's films and videos contemporary, but the subject matter as well – identity, post-modernity's loss of narrative and the fluid frontiers between seeming and being are analysed with technical assurance in an apparently documentary offering of high epic quality.

Her early works are in line with feminist thinking, but in her later works she extends her focus to the relationships between generations and the sexes, individual sensibilities and experience. Ahtila herself calls her films "human dramas", thus highlighting their existential orientation, reminiscent of films by Aki Kaurismäki or the plays of August Strindberg.

In her *Short Cultural-Political Quadrille*, 1988, women carry on a conversation while standing on black armchairs dressed as waitresses. *In His Absolute Proximity*, 1989, uses photos and poems to show how the female body is used and represented in the media. The subject of the multimedia installation *Secret Garden*, 1994, is filmmaking mechanisms and the function of female otherness.

Her first film was *The Nature of Things*, 1988. As the title suggests, it is about the nature of things in a consumer society, except that here Ahtila attributes spiritual qualities to the objects. Her second film, *Plato's Son*, 1991, is a philosophical road movie – an extraterrestrial being from the 'Planet of Immateriality' comes to Earth to study the significance and function of the human body, while the third film, *The Trial*, 1993, is about guilt and punishment as types of human behaviour. With these films, Ahtila laid the foundations for her subsequent creative work, which artistically examines both philosophical and psychological questions of human identity in the clash between truth and fiction.

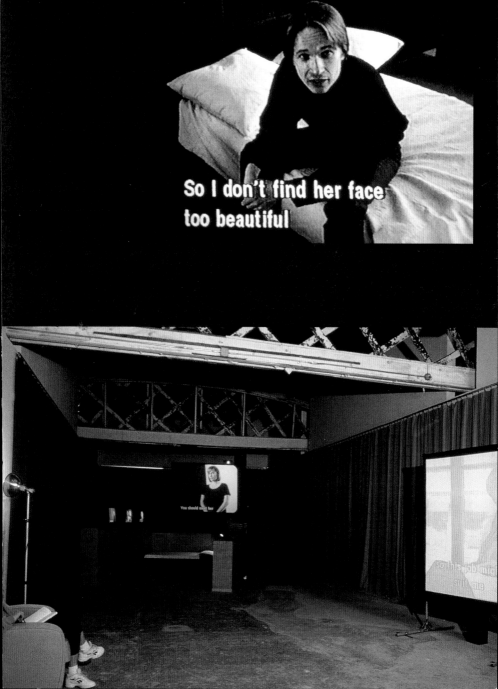

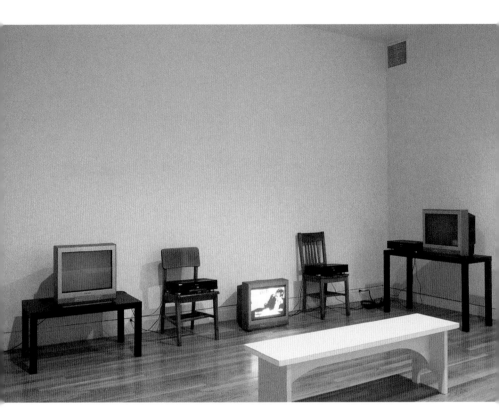

2

From short film dramas ...

With *ME/WE, OKAY* and *GRAY*, 1993, three short films each 90 seconds long, Ahtila explores the differences and analogies between advertising spots and short film dramas. There are both 35 mm and video versions of the films, so that they can be presented in different contexts, i.e. they can be shown at the cinema, on TV or between advertising spots. In *ME/WE*, a father analyses his four-member family in a monologue while the other actors move their mouths synchronously. When he describes the feelings of the other members of the family, their identities become interchangeable. In *OKAY*, a woman speaks about violent relationships while pacing up and down the room like a tiger in a cage. During the action, she alters her voice and thus her personality as well. In *GRAY*, three women ride downwards in a goods lift to a place below the surface of the water, where they float. They have a high-speed conversation about an atomic catastrophe and its consequences. While fact and fiction intermingle like first and second person, the crisis of identity is interwoven with the catastrophe, depicted both in word and image.

In 1995, she made *If 6 was 9* as a 35 mm film and three-part video installation – the film images appear alternatively on three screens – in which female teenagers give accounts of their first sexual experiences and fantasies. The girls' daily tasks clash with their accounts with a directness that seems authentic, but which is nonetheless fictional. The spoken texts oscillate between naivety and maturity, or soundbites and precociousness.

... to full-length feature films

Private becomes public here, but without harming the private sphere, because the apparently real and documentary represents only one possibility, a fictional, almost surreal vision of what life, everyday existence and the characters could be like. Ahtila achieves this by mixing genres such as avant-garde and Hollywood, documentary, short films and advertising, or by fragmenting the narrative thread, or even by using apparently absurd monologues. Her work starts at the interface of narrative cinema as a dream factory and the documentary promise of photography. It simulates documentation that is in reality fiction. This becomes clear in other films such as *ANNE, AKI and GOD*, 1998: a physically sick man fantasises about a woman, who as the film proceeds becomes real, i.e. his dream becomes reality. The film is based on the screenplay of the full-length cinema film *A Quest for a Woman*, which Ahtila is currently completing. The film *Today*, 1996/97, which is also shown as a three-part video installation, is about a father-daughter relationship. The starting point is the grandfather's fatal accident, which is depicted by the characters in three episodes. The sentence spoken by the girl at the end of the film – open, direct words that question by now almost absurd identity concepts – encapsulates Ahtila's principal artistic concern: "Perhaps it's not my father crying but someone else's. Sanna's father, Mia's father, Marko's father, Pasi's father – or Vera's father. I'm sitting in a chair… I'm 66." Ahtila's films are shown in the Finnish original with English subtitles. For a mainly non-Finnish-speaking public, language, image and content have a disconcerting effect. The viewer is enticed into another world, where he can nevertheless recognise himself.

Ulrike Lehmann

1 **ANNE, AKI and GOD,** 1999. DVD installation, DVD discs, paint, sound, 20 min.
2 **ME/WE; OKAY; GRAY,** 1993. Film stills

Laurie Anderson

* 1947 in Chicago (IL), USA; lives and works in New York (NY), USA

"My work is always about communicating."

Language, a virus from outer space

In 1981, with her song "O Superman", Laurie Anderson entered the pop mainstream. The heartbeat rhythm of the digitally altered vocoder voice and tone configurations, the strange collage of lyrics and minimalist composition took the song to number two in the British charts. It established a first link between performance art and pop culture that has lasted to this day. By that point Anderson had been active as an artist for nearly ten years, since 1972. In 1981, the year of Ronald Reagan's inauguration as US president, she made the anonymity and subliminal power of mass culture, the broken myths of the American Dream and the nuclear era the subject of a song ("So hold me, Mom, in your long arms, in your petrochemical arms, your military arms, in your arms").

"O Superman" was released as a single in 1981 by 110 Records, initially as an edition of 1,000 copies (Later Anderson would sign with Warner Brothers). Dedicated to the composer Jules Massenet, the song referred to an aria in his opera *El Cid*, in which the hero addresses God as "O souverain, o juge, o père …" The première of "O Superman" had taken place as part of Anderson's first extended music performance, *United States, Part 2,* held at the Orpheum Theatre, New York, in 1980. The artist accompanied herself with a subtext, formed by the sign language of her raised right hand, projected as a gigantic shadow on a wall.

During her art history studies at Barnard College in New York, Anderson experienced the 1968 campus revolt sparked off by the assassination of Martin Luther King, Jr. At the School of Visual Arts, her teachers included Carl Andre and Sol LeWitt. In the early 1970s, while immersing herself in Buddhist texts and the writings of the phenomenologist Maurice Merleau-Ponty at Columbia University (where she graduated in 1972), Anderson circulated the downtown New York art scene, making the acquaintance of Joel Fisher, Philip Glass, Gordon Matta-Clark, Keith Sonnier and others. Her sculptures of the period were influenced by the formal idiom of Eva Hesse. Later she would compare these formative years in Manhattan with Paris during the 1920s. Anderson wrote art reviews, taught in schools, and exhibited at various galleries and museums. Her debut as a performance artist came in 1972 in Rochester, New York, with a symphony for car horns held in a park (*The Afternoon of Automotive Transmission,* 1972), a work reminiscent of Futurist manifestations of the 1920s.

Early on, Anderson began electronically manipulating musical instruments, such as her violin. She had learned the violin from a young age and won several awards. This string instrument, whose sound range comes closest to that of the female voice, soon became a surrogate for the artist's vocalisations. In 1974, at the Artists Space in New York, she did a performance called *As:If*, which she considers her first "mature" performance in the true sense of the word. Anderson appeared in a white trouser suit, wearing a crucifix made of dry sponges around her neck and skates frozen into ice blocks on her feet. For the first time, she alienated her voice by placing a loudspeaker in her mouth. Accompanied by slide projections of individual words ("roof:rof", "word:water"), she told stories about language and religion, or related childhood memories such as that of ducks frozen into the ice on a pond.

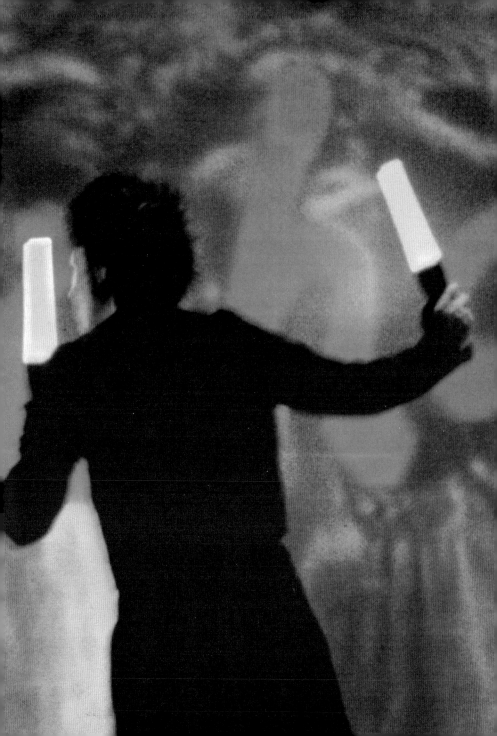

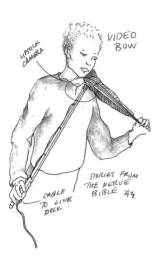

LIPSTICK CAMERA

VIDEO BOW

CABLE TO LIVE DECK

STORIES FROM THE NERVE BIBLE '93

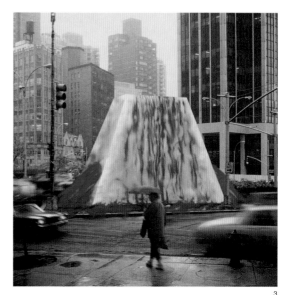

2

3

4

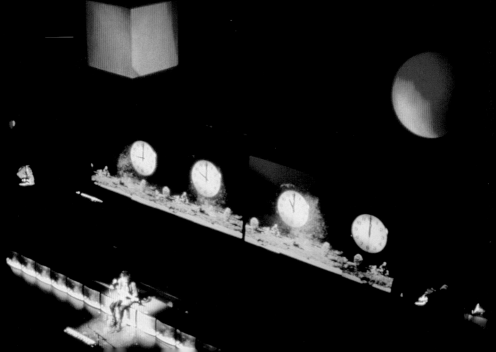

Americans on the Move

In the mid-1970s' Anderson began looking for ways to have a surrogate perform in her place, as Vito Acconti or Dennis Oppenheim had demonstrated with tapes or dummies. In the performance *At the Shrink's*, 1975, held in New York's Holly Solomon Gallery, she presented a fake hologram, generated by a super-8 film – the first of numerous clones based on her own self. In 1976, Anderson presented a great number of performances and projects in Europe. As her song repertoire included universally familiar sounds and language fragments, she was able to communicate at least rudimentarily with audiences everywhere. After returning home, in 1978 Anderson travelled across the US, working, among other things, as a cotton picker. Her impressions of American society and politics were summed up in the multimedia performance *Americans on the Move, Part 1*, 1979, an amalgamation of the spoken word, music and projected imagery, held in The Kitchen, a New York club.

Anyone who went out in SoHo in the late 1970s would have probably gone to this club, where artists such as Robert Wilson, Philip Glass or Meredith Monk appeared, or later to the Mudd Club to hear Anderson's own trio, The Blue Horn File (with Peter Gordon and David van Tieghem). Over the years Anderson designed a series of innovative instruments, and she can justifiably be considered an early master of sampling. By attaching microphones to her body and distributing them around performance spaces, she transformed both into instruments, and she also used various objects to amplify sounds (as in *Talking Pillows*, 1977–97, and *Handphone Table*, 1978). Anderson has built violins of all kinds, from a "viophonograph", on which a record was played by the bow, through a neon violin with audible electronic resonance, to a digital violin, coupled with a synthesiser.

Home of the Brave

In the conservative 1980s of the Reagan administration, Anderson sought ways to convey political messages through the mass media. In 1981, the year MTV came into existence, her eight-minute "O Superman" video (art director: Perry Hobermann) was broadcast around the clock on the channel. There followed the eight-hour production *United States,* which Anderson termed a "talking opera". Containing songs, texts, images and found footage material from various films, it dealt, as the artist said, with motion, utopias and the passing of time in a technologically determined world. The success of "O Superman", a section of *United States, Part 2,* soon caused many on the avant-garde scene to accuse her of selling out to the establishment. Ten years on, her achievement would be described as crossover. At any rate, Anderson had acquired a new audience, and the SoHo art scene disintegrated as rents rose sky-high.

In 1982, Anderson issued a long-play record, *Big Science*, the following year the Institute of Contemporary Art in Philadelphia mounted a multimedia exhibition, "Laurie Anderson, Works from 1969 to 1983", which travelled through the United States and to Britain. Under the influence of the science-fiction craze sparked by George Orwell's novel *1984* and the impoverished language called Newspeak described there, the artist produced a homage to William S. Burrough's *Language is a Virus from Outer Space*. In 1984, *Mister Heartbreak* was performed, followed in 1985 by a documentation of the concert on film, *Home of the Brave*. The record *Strange Angels*, on which Anderson sang for the first time, was recorded in 1989, a stage version being called *Empty Places*. Finally, in 1992, the World Fair in Seville hosted the première of *Stories from the Nerve Bible*, a title referring to the 1991 Gulf War. For *Songs and Stories from Moby Dick*, 1999, based on the novel by Herman Melville, Anderson invented the "talking stick", which served simultaneously as a light, a harpoon, and a digital remote-controlled instrument. Apart from her performances, in recent years the artist has organised festivals, designed websites, taught at universities, and made videos. She lives with the musician Lou Reed.

Holger Liebs

1 **Stories from the Nerve Bible,** 1995
2 **Video Bow,** 1992 Entwurfszeichnung
3 **Blood Fountain,** 1994. Computer-generated image. Design for a monument at Columbus Circle in New York (NY), USA
4 **Stories from the Nerve Bible,** 1995

Vanessa Beecroft

*1969 in Genua, Italien, lebt und arbeitet in New York, USA

"Nobody acts, nothing happens; neither does anyone begin anything, nor is anything finished."

Waiting for beauty

Vanessa Beecroft "paints" individual and group portraits in three dimensions, with living girls and women. They occupy a certain room for a certain time, are dressed, usually scantily, by the artist, often wear wigs, and never make contact with the spectators. The result is a strangely cool, eerie atmosphere, making the viewer seem somehow just as out of place as the girls themselves, who hardly move and seem merely to be waiting for something. "I am interested in the interrelationship between the fact that the models are flesh-and-blood women and their function as a work of art or image", the artist explains. Beecroft's art is hard to categorise. Does it amount to performances or "living sculptures" like those of the British team Gilbert & George, or perhaps to a modern form of portraiture, to psychologically charged still lifes with living subjects? The question remains open.

In one of her early exhibitions, in 1994 at a Cologne gallery, Beecroft presented 30 young girls in a showroom to which the public had no access. The event was visible only through a small rectangular window frame that gave one the sense of peering through a peephole. The girls all had a similar, non-athletic figure, and were dressed merely in black shoes and knee stockings, grey underwear, and black or grey tops. This uniform costume, which produced a striking visual composition in space, was rounded off with yellow wigs, some with and some without braids. Some of the girls sat there seemingly pouting, others leant against the walls, still others walked slowly back and forth. None of them seemed seriously to expect anything to happen – instead of an action-filled period of time, there was merely and literally a boring duration. The title of this work spoke volumes: *A Blonde Dream*. As the event took place in a German gallery, the allusion to the cliché of "Aryan beauty" propagated during the Third Reich seemed abundantly clear.

Born in the 1960s, Beecroft was inspired to her 30 provocative conjugations of the female figure not by personal experience, but by Roberto Rossellini's film *Germany in the Year Zero*, 1947. More precisely, by Edmund, the film's anti-hero, who in the ruins of post-war Berlin kills his father and then himself. What took place in the event was thus a closed circuit of various episodes of a narrative fiction. A media narration about a demise of morality was

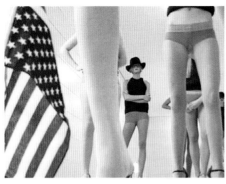
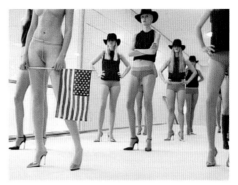
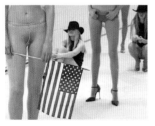

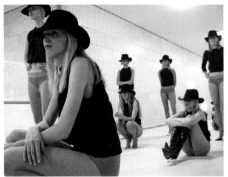
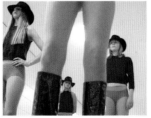
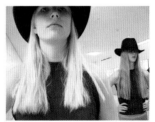
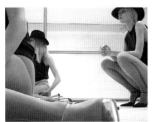
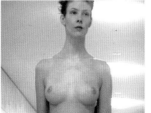
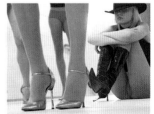

1

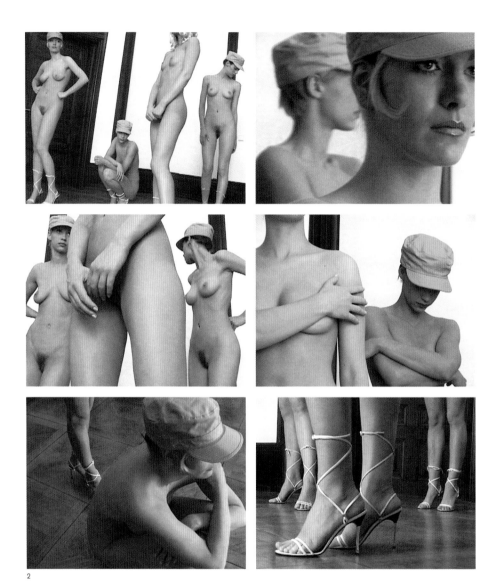

2

translated into a different media spectacle which, like the film, was composed of "real" people but which dispensed with a plot of any kind. Confronted with this very cool, well-nigh absurd translation, viewers were challenged to call up comparable visions from their visual memory, visions that might just as well have been recalled from movies as from "real life" experiences.

A blonde dream

A Blonde Dream is typical of the artist's staged installations. Again and again, Beecroft places models, actresses, even occasionally women met by chance on the street, in precisely defined visual spaces, quoting in the process from a range of cultural codes from cinema, fashion, literature or art. In *Play,* 1995, for instance, she referred explicitly to Samuel Beckett's 1963 stage play of that name. Beckett's characters were supplanted by three doubles of the artist, two seated next to each other on chairs, barefoot, wearing the same brown wig and black coat, while the third, dressed only in dark shoes, light-coloured underwear, and a red wig, circled around them with a suspicious look in her eye. A symbolic picture with far-reaching associations arose from this silent, largely motionless still life: the allusions ranged from the red hair of the socialist revolutionary Rosa Luxemburg to the naked legs and feet of countless depictions of the *Pietà*. It was intriguing to see the artist taking up the factor of perception, naturally a pre-condition of all visual art, and restating it in terms of the psychotic, self-referential, aimless and circular action of *Play*.

Diaries

Such works have been supplemented by sensitive drawings, for instance of enigmatic female heads such as *Lotte,* 1994, with her long mane of red hair. Books, too, are among the media employed by Beecroft. Early in her career she began recording important aspects of her aesthetic activity in a journal-like artist's book titled *Despair,* 1985–93. Here she not only described her eating habits, but made intimate confessions regarding her feelings of guilt and her relationship with her parents. This literary self-portrait was shown in Beecroft's first gallery exhibition in Milan, during a presentation of young girls discovered on the city streets and asked to be an "understanding" audience for the diary. Since all of the girls wore clothing that belonged to Beecroft, the readers and the subject of the book tended to merge into one. Both played roles; both were ready to identify with them, but also to distance themselves from them. The director of the tableau, for her part, stood simultaneously inside and outside the equally self-referential and extra-referential presentation.

Raimar Stange

1 **Royal Opening,** 1998. Performance, Moderna Museet, Stockholm, Sweden
2 **Leipzig,** 1998. Performance, Galerie für zeitgenössische Kunst, Leipzig, Germany

Louise Bourgeois

* 1911 in Paris, France; lives and works in New York (NY), USA

**"I've always had a fascination
with the needle, the magic power of the needle.
The needle is used to repair the damage.
It's a claim to forgiveness."**

Spools, reels and visions

A narrow corridor leads into a polygonal room whose screen-like walls are made up of doors. Inside there is a dense conglomeration of large red and pale blue spools on mounts, spirally wound objects and body fragments of clear glass, two small suitcases, a petroleum lamp, and two bottles filled with coins. A red ladder leans against the wall and a drop-shaped object dangles from one of the spool mounts. One of the doors has a small window, behind which the word "private" can be read in shabby lettering. The atmospheric density of Louise Bourgeois' *Red Room (Child)*, 1994, is created by the obsessively enigmatic logic of its *objets trouvés* and artefacts, and by the informally intangible structures of the luminous red glass spools. *Red Room* contains many of the central motifs and metaphors that have been explored by Bourgeois for decades: the claustrophobic room reminiscent of a hiding place or inner body, surrealist, organ-like partial objects, a ladder that is too short to allow escape from the room, and the spools of yarn, recalling Bourgeois' childhood. The "private" sign suggests that this is a place of personal reminiscence, and that working through autobiographical elements and constellations is one of the central processes in her creative work. Bourgeois' oeuvre, in which mastery of a formal sculptural vocabulary is inextricably linked with a complex and coded content, has remained open to the projections of its critics, while at the same time constantly fuelling biographical interpretation by many written and verbal statements. Thus, the construction of memory is a central motive for her work.

According to her biography, Louise Bourgeois' family ran a workshop for the restoration of antique tapestries in the French town of Choisy-le-Roi. Recognising her talent for the task, Louise Bourgeois' parents entrusted her with drawing sketches of missing areas in the textiles and creating cartoons for their subsequent repair. Bourgeois went on to study mathematics at the Sorbonne. From the mid-1930s, she attended a number of art schools, eventually becoming a student of Fernand Léger. She married the American art historian Robert Goldwater and moved to New York in 1938, where she continued her artistic training until 1940 at the Art Students' League. She then worked as a painter. One of her first groups of work was *Femmes Maison*, female figures whose bodies consisted partly of a house, in reference to the social status of women and their allocation to domestic territory. Bourgeois also explored the same subject in sculpture. From about the mid-1940s, she created her so-called *Personages*, pared-down stela-like figures reminiscent of totemic artefacts from tribal cultures. In the 1950s, Bourgeois developed a series of anthropomorphic sculptures made up of similar elements mounted on a rod, featuring not only objects recalling Brancusi's sculpture, but also Minimalist serial principles such as those to be found in the early works of Carl Andre.

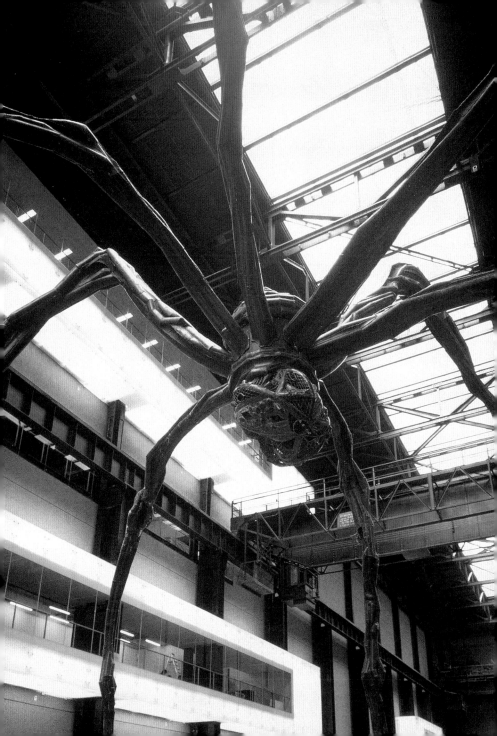

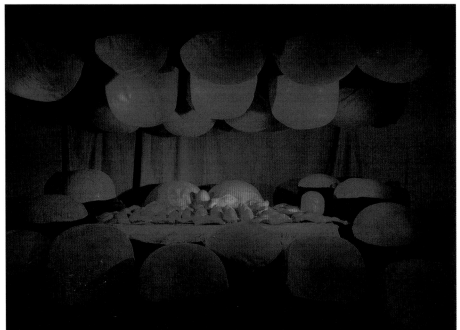

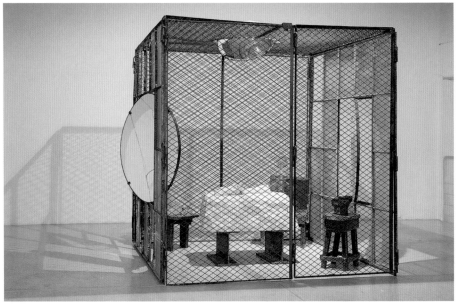

26 Louise Bourgeois

In the years to follow, Bourgeois experimented with unusual materials, such as latex, rubber, plaster and cement. In the early 1960s, she took her domestic theme a step further in her *Lairs* – sweeping, spiral, labyrinthine forms that generally open up towards a hollow inner space. Like her *Lairs*, her soft landscapes also follow principles of an organic and anti-formalist approach. An almost fleshy materiality makes such latex works as *Double Negative*, 1963, seem like visceral landscapes in which the interior appears to have been turned outwards. Spherical, mush-room-like forms grow out of fluid bases, defying unequivocal identification, but suggesting the many breasts of Artemis of Ephesus, or phalli. Like most of the sexualised forms in the work of Bourgeois, they are not clearly "male" or "female". Even *Fillette* (*Little Girl*), 1968, a large latex phallus with which Bourgeois struck a humorously provoca-tive pose in Robert Mapplethorpe's 1982 portrait of her, hypertrophies the phallic form as well as the round form. When Lucy Lippard included some of the *Lairs* in her ground-breaking "Eccentric Abstraction" exhibition in 1966, Bourgeois' works finally took their place in the feminist discourse.

In 1974, Bourgeois created her sculpture *Destruction of the Father*, portraying a symbolic patricide set in a threatening landscape with cocoon-like or egg-shaped protrusions and spherical forms that grow towards the spec-tator in a menacing way. The work has its roots in her childhood fantasy of devouring the unfaithful father, who cheat-ed on Bourgeois' mother with his mistress.

"Fear is pain"

Towards the late 1970s, Bourgeois was able to consolidate her position within the New York art scene, increasingly gaining the recognition of a younger generation of artists. It was not until 1982, when she was 71 years old, that the New York Museum of Modern Art mounted a first major retrospective exhibition of her work, honouring her previously under-represented contribution to post-war American art. Her international standing was finally con-firmed by the first major retrospective exhibition of her work to be shown in Europe, at the Frankfurt Kunstverein in 1989, and consolidated by her participation in documenta IX at Kassel in 1992 and the Venice Biennale in 1993.

From the mid-1980s onwards, Bourgeois returned to the topics of memory and childhood conflict already present in *Personages* and *Destruction of the Father* when she created *Cells*, which are large rooms with encom-passing mesh fences, enigmatic mirrors and furnishings. In Bourgeois' words: "Each *Cell* tells of fear. Fear is pain." In the *Cells*, objects function as representatives of absent persons, e.g. in the form of empty chairs or beds, whose unknown emptiness triggers memory. The *Cells,* with their connotations of fear, alienation and menacing sexuality, are iconographically closely related to the enormous *Spiders* which Bourgeois has produced in a number of variations in recent years. The potential of these works lies precisely in the tension between the autobiographical elements and a metaphorical, formally complex syntax that provides spectators with a projection screen for their own constructs of memory, thereby creating fantastic places of desire.

Ilka Becker

1 **Maman,** 1999. Steel and marble, 9.27 x 8.92 x 10.24 m. Installation view, Tate Modern, London, England, 2000
2 **The Destruction of the Father,** 1974. Plaster, latex, wood, cloth, 2.38 x 3.62 x 2.71 m
3 **Cell (You Better Grow Up),** 1993. Steel, glass, marble, ceramic, wood, 2.11 x 2.08 x 2.12 cm

Lygia Clark

* 1920 in Belo Horizonte, Brazil; † 1988 in Rio de Janeiro, Brazil

"'Inside and outside': every living creature is open to every possible change. Its inner space is an affective one."

Ritual (healing) action

A couple of amorphous creatures writhe across the floor in a cloth tube. They attempt with difficulty to reach one another from the opposite ends of the elastic construction. There are a few pants and giggling noises, and with that the tube spews a pair of bedraggled museum-goers onto the carpet. This textile object is a replica of *Túnel* (Tunnel, 1973), a work by Brazilian artist Lygia Clark. It was one of the exhibits at the Clark Retrospective at the Palais des Beaux-Arts in Brussels (1998), not presumably the place in which the artist would have wished to see one of her "proposals" – as she referred to her participatory works – realised. Clark's utility objects, ritual costumes and rooms, which she created from the mid-1960s onwards, and which were frequently part of her group work that drew much impetus from therapeutic models, resisted incorporation into museums. The works are intended rather to be touched and integrated into actions and physical processes of experience. Although museum spaces are able to present her posthumously shown works with an arena for experiences, they create distance and are unable to do real justice to her original demands for a radically experienced sensuality, and a mingling of the participants with the object.

Works like *Túnel* scarcely show that Clark's artistic career began in the 1950s in abstract art, and particularly in a critical examination of the Constructivist tendencies in the Modern Movement to which, as a member of the Grupo Frente in Rio de Janeiro during the mid-1950s, she devoted a great deal of attention. But soon the social utopias of the Constructivists, which at that time served for many Brazilian artists as their yardstick, no longer seemed enough for her. She became a founder member of the neo-concrete movement in Brazil (1959–61) and developed a critique of the Modernists' universalistic claims and ideas of autonomy regarding geometrical abstractionism. 1959 saw the appearance of the *neo-concrete manifesto*, in which art was described as equivalent to a living organism. In keeping with this, the geometrical forms in Clark's early paintings underwent an adaptation in her *Bichos* (Animals, from 1960), and were enriched with the idea of actively involving the observer. The *Bichos* are abstract metal objects whose individual parts are linked by hinges, which allows them not only to be moved, but also invites the observer to handle them. With this step, Clark's sculptural production revealed new possibilities for the integration of tactile modes of experience. The interpretation and spatial alteration of the objects is left partly in the hands of the observer, who is also integrated into the work's temporal dimension by the duration of his or her intervention. Already we find a shift in emphasis here from the dominant sense of vision – whose "splitting off" from the other senses has been diagnosed as symptomatic of the crisis of the Modern – to a complete bodily experience. A further central motif

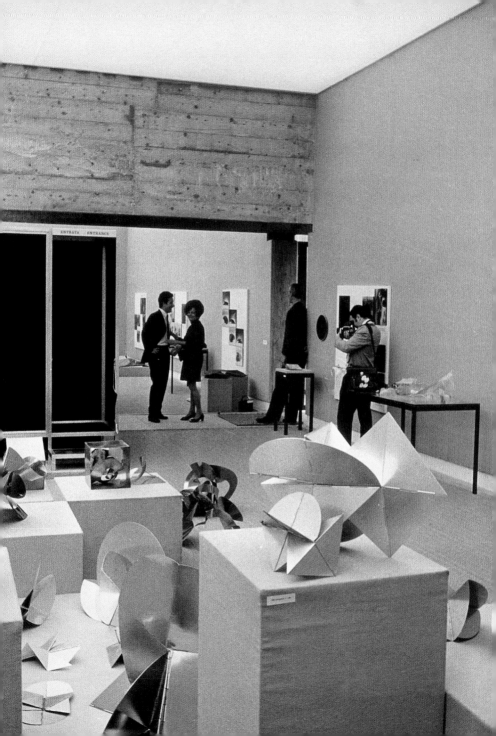

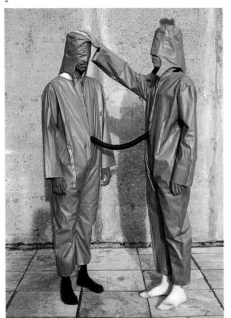

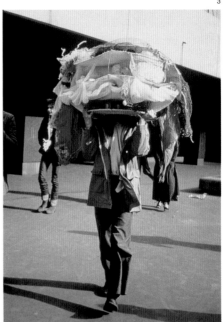

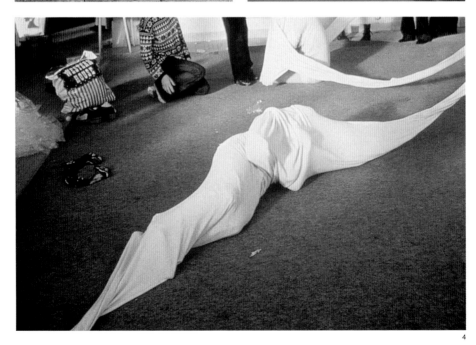

of her work is the abolition of the notion of authorship. Existence comes into being through action, and actions became increasingly central for Clark, even though she explicitly stated that she did not view them as performances. *Caminhando,* 1963, invited people to glue a strip of paper into a Moebius Strip and to cut along the middle of it with a pair of scissors, until the remaining strip was too narrow to be cut any more. Clark remarked in this connection that the action should make the actor question the customary binary way of thinking in everyday life: right and left, and up and down prove to be invalid categories for a Moebius Strip.

From 1966, Clark concentrated on work with the body. She attempted to work through physical phantasmagoria in a group process using ritual magical actions, and to form a "collective body" together with the other participants. She was aided in this by among other things transitory objects, such as those in the series *Nostalgia of the Body,* 1966. Some of these works ceased to be devised as artistic objects that could be exhibited, and consisted simply of instructions: the reader should inflate a plastic bag, say, seal it, press it between their hands and then balance a pebble on one corner. Unlike other conceptual approaches in the 1960s, Clark's written suggestions are not aimed at stimulating mental processes, but at concrete realisation in actions. With this, not only is the relationship between artist, object and observer defined anew, but strictly speaking the status of the observer is dissolved and replaced by that of the participant. Clark took a closer look at the idea of an intimate material and mental fusion between two persons in the *roupa-corpo-roupa* series of 1967, which involved all-enveloping plastic overalls. The overalls were lined with differing materials, which were aimed at conveying a "feminine" body feeling to men and a "masculine" feeling to women. By connecting the two suits with a plastic hose, both participants were able to interact, sound out each other's actions and reactions, and experience resistance and the overlapping of their body zones.

The House is the body

In 1968, Clark represented Brazil at the Venice Biennale with her installation *A Casa e ó corpo. Penetração, ovulação, germinação, expulsão* (The House is the body. Penetration, Ovulation, germination, expulsion). Once again, the artist's aim was to mediate the experience of a holistic physical awareness: the dark compartments inside the installation, which the visitors were free to walk around, were packed with materials: long, flowing "hair" in the *germination* section, or taut elastic bands in the *expulsion* section, which the visitors had to squeeze through as if in an initiation ceremony. The room entitled *Ovulation* was completely filled with balloons, which the visitors had to force their way through in order to study their own bodies in a distorting mirror at the exit. Quite evident in this work are the organic metaphors and allusions to birth and developing selfhood, with pre-linguistic, non-visual experience being given preference over the phantasmal image in the mirror. In the same year, Clark went to Paris, where she remained on and off until her move to Rio de Janeiro in 1976. During this period, she also collaborated with her students on interventions conducted in public spaces. In *Cabeça coletiva* (Collective Head, 1975), for instance, they stocked a large, hat-like object with items such as love letters, fruit, shoes and money. The hat was then taken out onto the street by two of the participants, where the "offerings" were shared out among the passers-by. After her move to Rio, Lygia Clark treated a large number of people up until 1982 in her studio, having become convinced through her many years of experience of the therapeutic benefits of her work with her *Objetos relacionais* (Relational Objects).

Ilka Becker

1 **Installation view „A Casa e ó Corpo",** XXXIV Esposizione Internazionale d'Arte, la Biennale di Venezia, Venice, Italy, 1968
2 **O eu e o tu** from the series **roupa-corpo-roupa,** 1967
3 **Cabeça coletiva,** 1975
4 **Túnel,** 1973

Hanne Darboven

*1941 in Munich, Germany; lives and works in Hamburg, Germany, and New York (NY), USA

"In my work I try to expand and contract as far as possible between limits known and unknown."

Enumerated time

Hanne Darboven's artistic obsession is with numbers. After studying art, she left her birthplace, Munich, for New York in 1966. She began filling sheets of graph paper with geometric figures, usually variations of diagonal, linear configurations done in a predetermined sequence, noted on the margin of the sheet. In the late 1960s, this equally non-objective and concrete world of numbers and graphic notations came to the attention of critics and other artists. With Sol LeWitt, Carl Andre and Donald Judd, Darboven shared an interest in elemental structures and their visualisation. She owed her breakthrough as an artist, however, to a productive misunderstanding.

An exhibition titled "Working Drawings and Other Visible Things on Paper Not Necessarily Meant to be Viewed as Art", held in the Visual Art Gallery in 1968, rang in the birth of Minimal Art. Art historians Lucy Lippard and John Chandler analysed the break with the predominant trends of Abstract Expressionism and Pop Art in their essay *The Dematerialization of Art,* and brought Darboven's drawings into proximity with works of the conceptual artists around Sol LeWitt, John Cage and Robert Smithson.

Darboven herself has always denied any link with this movement. And although she is a friend of conceptual artists such as Joseph Kosuth and Lawrence Weiner, she is less concerned with the systematic realisation of an artistic idea than with the metamorphoses of a limited formal vocabulary. Like Piet Mondrian, Darboven painstakingly investigates the fundamental reciprocal relationship between figure and ground, but without transcending it. In addition, she employs, almost exclusively, a subjective handwriting which lends her activity an even stronger air of obsession. Her early works on graph paper, *Constructions,* 1967, were already based on a fundamental order that permitted a truly infinite number of permutations. Soon the artist's studio began to fill to the ceiling with entire stacks of these works.

From the numerical elucidation of graphic variations, it was only a step to the calendar sequence, which Darboven made the basis of her record-making system in 1968. She reduced the infinite universe of numbers to a cross-sum, calculated by means of a special operation. While calculating long periods of time, Darboven realised that tak-

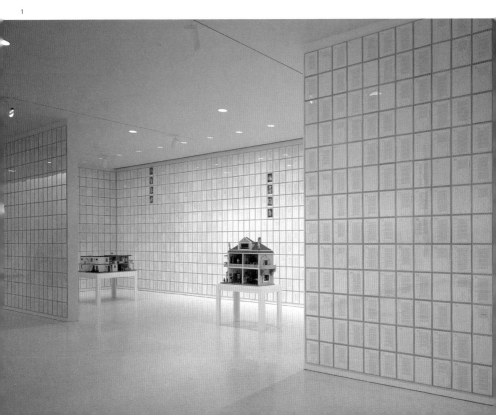

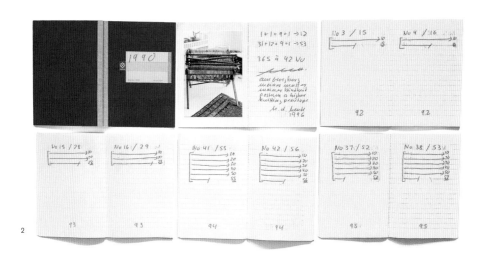

2

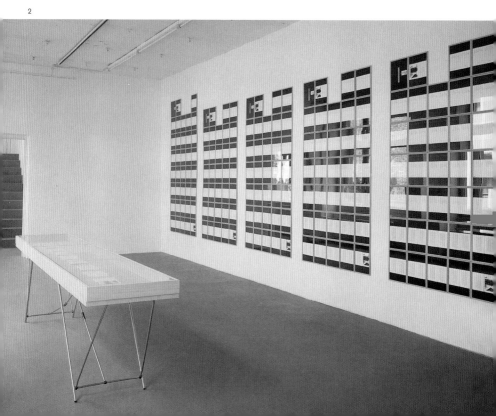

ing the cross-sum of a certain period gave a limited number of results, which oscillated between two poles. Using this system, for instance, all the days in a century could either be entered in 402 loose-leaf binders or, as a cross-sum index, on a single sheet. Darboven graphically represented these cross-sums in various ways: either by writing the number as many times as corresponded to its numerical value, noting it as a numeral including all preceding numerals, or by representing it by a corresponding number of identical small boxes.

Writing Time

By systematically recording calendar dates or making careful hand copies of printed texts, Darboven drew attention to the flux of time, not only concretely but as a matter of subjective experience. Since the early 1970s she has employed both dictionary entries and literary material, copying there out, modifying there through her own notations, or translating it into wavelike script and combining the resulting images and objects into installations. For Darboven, letters and digits represent nothing but themselves. In exhibitions, her drawings and collages are distributed among various rooms, usually in a wall-filling all-over pattern. Identical frames serve to heighten the impression of a serial accumulation and the absolute equality in value of each piece. Also, her compulsive work of writing, as it were, consumes Darboven's lifetime, which is why she deletes the word "heute" (today) in the transcriptions collectively titled *Writing Time*. In addition, she has published diaries and letters which provide information ranging from individual experiences to epoch-making events. In 1980, she once more expanded her writing system to include the translation of numerical transcriptions into musical notations.

History for everyone

Subsequently, references to current events began to assume increasing importance in Darboven's work. For *Wende '80* (Transition '80), she used an interview with the current German Chancellor, Helmut Schmidt, and his challenger in that year's national election, Franz Josef Strauss, blacking out the latter's replies. A more comprehensive point of view was taken in *Cultural History 1863–1983*. Although visual documentation had already played a part in various earlier works, such as *Evolution Leibnitz* and *Evolution '86* (both 1986), in this piece Darboven integrated postcards, covers of *Der Spiegel* news magazine, pictures of film stars, pages from a catalogue on 1960s art designed by Wolf Vostell, and sheets from earlier works, such as texts and photographs copied from *Bismarck Time*, 1978. The principle of repetition now came full circle: by quoting herself, the artist confirmed the historicity of every insight, all recognition.

For the piece *Children of This World*, Darboven converted her studio in Hamburg-Harburg for years into a collector's shop. In 1990, she began gathering children's toys of every kind and origin, from rare collector's items to knickknacks and mass-produced articles – the entire universe of childhood fantasies. She consciously selected objects from mundane culture in order to illustrate history as a process that anyone could understand, since the longings of entire generations are precipitated by things of this kind. This time, Darboven recorded her calendar calculations in school notebooks and systematised the entries in the form of musical scores, photographs and coloured markings. Still, as the number and variety of the items made clear, our grasp of history can never be anything but fragmentary, and historiography, like Darboven's numerical calculations, depends on systematic constructs.

Petra Löffler

1 **Life, Living,** 1997/98. 2,782 works on paper, 8 photographs, 2 dolls' houses, overall dimensions variable: each sheet and each photograph 30 x 20 cm

2 **Weaver's Loom Work,** 1996 (detail). 10 booklets DIN-A-6 with each 2 black-and-white photographs (Ekaha A 6 lined, 32 pages, blue cover), Pancolor felt pen, non-fading, 344 DIN-A-4-frame, photocopies from a 10-year period, 1990–1999

Sonia Delaunay

* 1885 in Gradisk, Ukraine, † 1979 in Paris, Frankreich

"I have had three lives: one for Robert, one for my son and grandsons, and a shorter one for myself. I have no regrets for not having been more concerned with myself. I really didn't have the time."

Between art and fashion

For a long time, Sonia Delaunay was seen chiefly as an applied artist, moreover one whose influence was as great as her success. In 1912, when colour and light – divorced from all objective reference – were at the heart of an aesthetic debate amongst the Parisian avant-garde, she was busy making everyday objects such as lampshades or curtains that were filled with *real* light. Together with her husband, artist Robert Delaunay, she evolved a novel form of abstract painting known as *simultanéisme*, which used luminous dynamic compositions consisting of geometrical blocks of colour that were intended to be registered simultaneously. This principle Sonia Delaunay transferred to other items such as books or clothing. For example, she transformed Blaise Cendrars' poem *La Prose du Transsibérien et de la Petite Jehanne de France*, 1913, into the first "simultaneous book", a two-metre, vertical leporello intended to be both read and viewed. From 1913, she designed "simultaneous" dresses and suits, and her surprising creations in all manner of materials, in designs using contrasting colours and geometrical shapes, were given an enthusiastic reception by eminent commentators such as the writer Guillaume Apollinaire. The clothes seemed to epitomise that synthesis of art and metropolitan life that the avant-garde of the day was seeking. When Sonia Delaunay went to tango evenings at the Bal Bullier, a Parisian dance hall, she wore a spectacular clinging dress of her own creation, which wrapped her in an abstract composition, and of this dress Cendrars wrote: "On her dress she wears a body." Robert Delaunay described her *simultanéiste* fashion as "living paintings".

Sonia Delaunay was born in 1885 in Gradisk in the Ukraine, and her original name was Sarah Stern. Her parents were factory workers, and when the girl was five years old they placed her in the care of a well-to-do relative, St. Petersburg art collector Heinrich Terk, who saw to it that she was properly educated. After briefly studying drawing at the Karlsruhe Academy of Art in Germany, she moved to Paris in 1905 and signed on at the Académie de la Palette. Her family, however, thought that a professional career in the arts was not appropriate to her station in life, and to avoid returning to Russia as they demanded, she in 1909 married a friend, the art dealer and collector Wilhelm Uhde. The previous year she had had her first solo show of figurative paintings at Uhde's Paris gallery, where the work she exhibited reflected her interest in van Gogh, Gauguin, Matisse, and German Expressionism, and was well received by the press. It was through the gallery that, in 1908, she met fellow artist Robert Delaunay, whom,

1

2

3

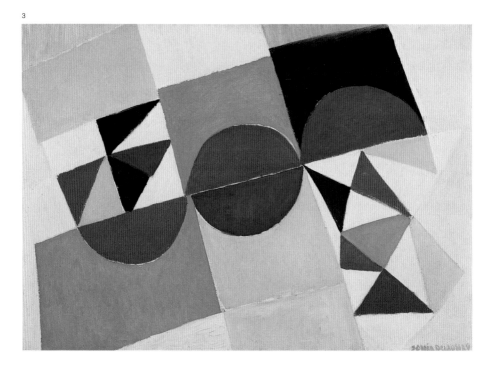

after divorcing Uhde, she married in 1910. It was the beginning of a creative partnership that was to last 30 years, a partnership founded on shared aesthetic ideas and intense debate and mutual influence, and on projects that the two brought to fruition together. It was Sonia, indeed, who largely saw to their financial security, which meant that her own work as a painter was shelved until Robert Delaunay died in 1941. This division of labour had long-term implications, and to this day there are reference works with an entry for Robert Delaunay but none for Sonia.

Despite her successful debut as a painter, in 1909 she turned to the applied arts. Her first abstract work was created in 1911, the year of the birth of her son Charles, when she made a patchwork blanket for the infant's cot, combining features of Cubist painting with reminiscences of Russian folk art. Meanwhile Sonia and Robert Delaunay were pursuing their studies in colour theory and their experiments in painting, and, in 1912, Sonia completed her first abstract painting, *Contrastes simultanés*, which suggests a landscape in sunlight. At the same time, Robert was at work on his series of *Formes Circulaires, Soleil*. The Russian Revolution of 1917 signalled a turning point, since Sonia no longer had her rent income, which had hitherto been the foundation of their financial security, and it was now that she decided to extend her work in applied art and put it on a commercial basis. In addition to designing costumes for Diaghilev's Russian Ballet and for Tristan Tzara's play *Le Cœur à Gaz*, 1923, she worked for industry, creating the interior of a Citroën car or a collection of fabrics for a Lyons textile manufacturer. In 1925, to coincide with the Exposition des Arts Décoratifs in Paris, she opened the Boutique Simultané, for fashion and accessories, with fashion designer Jacques Heim. The shop numbered among its customers stars of the fashion and film worlds, such as Coco Chanel and Greta Garbo.

Late recognition as an artist

In the early 1930s, Sonia Delaunay returned to abstract painting, not least because the depression had forced her to close the boutique in 1929, and in 1932 she became a member of the Abstraction-Création group of artists. However, it was not until the 1950s that she was accorded her first retrospective exhibitions in museums (widely seen as a yardstick of recognition) and began reaping the first of many official honours. Stanley Baron, author of a biography of Sonia Delaunay, believes that the tardiness of this institutional recognition was related to the conventional distinction between high art and the more everyday, applied variety, which was seen as a lower product altogether. Nevertheless, two decades after her death in 1979, we can now see that Sonia Delaunay's work and approach are coming into their own: in the late 1990s, many a fashion designer took to quoting the ideas characteristic of Sonia Delaunay's designs, while at museums the relations between fashion and art have been the subject of a number of exhibitions in recent years.

Barbara Hess

1 **Contrastes simultanés,** 1912. Oil on canvas, 46 x 55 cm
2 **Le Bal Bullier,** 1913. Oil on mattress fabric, 97 x 390 cm
3 **Rhythme Couleur,** 1958. Oil on canvas, 100 x 143 cm

Rineke Dijkstra

*1959 in Sittard, The Netherlands; lives and works in Amsterdam, The Netherlands

"I don't take photos of people who fancy themselves. They can't surprise me."

Identity and gaze

A young girl stands on the beach. Her heels are pressed close together on the wet sand. Behind her is the sea, and above her the infinite blue of the sky. The girl's orange bikini emphasises her well-developed figure as she presses her long blonde hair to her left shoulder, while her right hand with rings on three fingers rests loosely on her left thigh. She looks at the camera with a certain shyness and searching dreaminess, expressing at the same time a self-confidence in her stately appearance. From 1992 to 1996, Rineke Dijkstra took portraits of children and pubescent youngsters on various beaches, e.g. in Holland, the USA or the Ukraine. Sometimes they stand alone, sometimes in groups of two or three. Otherwise the decidedly conceptual approach of these "beach portraits" is always the same: Dijkstra photographs the children and youngsters wherever she comes across them. Nothing is staged. Instead, the subjects look directly and naturally at the camera. She shoots them slightly from below, always in daylight and yet with flash. The youngsters therefore stand out in the photos, sharply outlined against the sea. This very preciseness is in stark contradiction to the aura of uncertainty, even vulnerability evinced by the subjects. Fully aware of the conventions of portrait photography, the subjects cast around for the right expression and personal pose they would like to present to the photographer or later viewers of the photo. The "beach photos" are thus a sensitive testimony to their search for self and self-presentation. Somewhere in the interplay of the carefree and the cliché, the individuality and generality, identity makes an appearance at an artistic level.

The "beach portrait" series soon made Dijkstra well-known in the late 1990s. The emotional, perhaps even latently dramatic quality of the pictures, despite the minimal outlay on intervention and staging, was the formula for success. Nonetheless, the question arose as to whether she was just acting as a documentary photographer. Justly, because the question illuminates the core of her aesthetic philosophy. "As soon as you take an interest, fiction comes into play", said the French film director Jean-Luc Godard, defining the difference between document and art. The "interest"was one of "relationships and connections" In this context, Godard was referring mainly to the relationship of the individual with himself and with objectivity, i.e. the socially communicated essence. In this respect, fiction goes beyond the documentary. "Fiction is in fact the expression of documentation. The documentary is the impression", according to Godard. It is precisely this expression of the relationships between subjectivity and essence that recurs in Dijkstra's portraits. For example, during a stay in Portugal, she photographed bullfighters just at the moment of

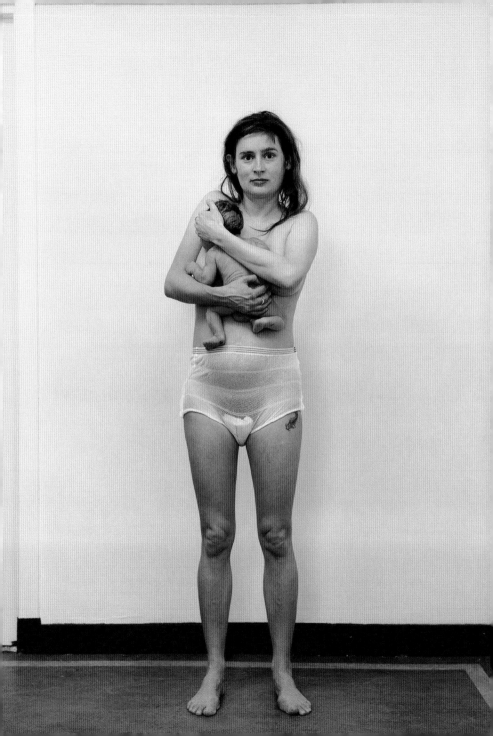

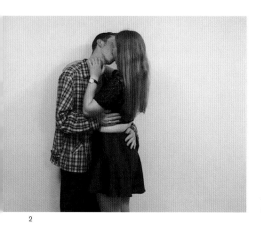

2

3

4

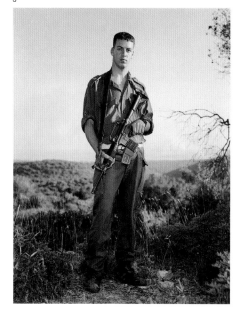

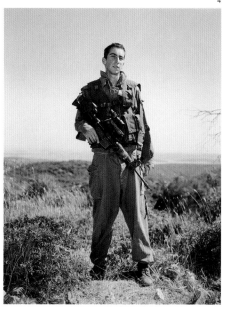

leaving the arena. The strain still shows on their faces, but exhaustion and uncertainty about what has just happened is also visible. "Universal experiences", as Dijkstra calls them, such as danger and death, or the relationship between human mastery and animal subjugation, is what these pictures are about. In *Villa Franca, Portugal, 8 May 1994*, for example, bloodstains on the white shirt collar and rents in the matadors' costumes bear witness to a fight successfully weathered.

Contradictory emotions

The photos that Dijkstra took of women who have just given birth are also about existential matters. Once again, the photos are taken with a plate camera and flash. Birth instead of death, women instead of men are now the agenda. The series forms thus a kind of counterpoint to Dijkstra's bullfighter series. In *Julie, Den Haag, February 29, 1994* we see a young mother holding a baby only a few minutes old. Proud, at once both a little astonished and imperious, the woman stands in an anonymous corridor looking at the camera. Instead of an unambiguous emotional state, we are once more presented with a fascinating mixture of contradictory emotions expressed in the pictures. Again, the titles of the pictures identify the place and time of the photos, but this time the subject's first name is included. The existential thus becomes concrete and is set in a precisely identifiable context. Or is it? The fact is, the sober hospital setting gives us no idea whether Julie is, for example, hard up or well-off. Even so, the viewer looks in vain for supposed "eternal human truths" here.

Model and self-presentation

In her first video work, *The Buzzclub, Liverpool, UK/ Mysteryworld, Zaandam, NL (1996–97),* Dijkstra concentrated wholly on the relationship between individual self-perception and social moulding. For over two years she filmed young people who regularly visited two discotheques, one in England, one in Holland. Once again, Dijkstra's subjects stand in front of a plain background, while her gaze is directed at the disco visitors arriving singly or in pairs. To a certain extent, the artist has transferred the white cube of the art gallery to the pleasure temple of youth. And vice versa – suddenly two teenagers are seen canoodling on the video screen in the museum, dance music is heard, and art lovers are confronted with the current club scene instead of the codes of art history. Sometimes the subjects stand nonchalantly holding a drink, sometimes they chew gum in embarrassment, then perform a few cheeky dance steps in front of the camera. The protagonists of this video installation trot out more or less all the 'Saturday night fever' rituals – and yet there is always a gap between the image they would like to convey and how they actually present themselves. The teenagers have not yet found their identities. Their egos still appear to contradict the standard values of the rules dictated by the discotheque environment. On this point, Dijkstra once quoted the American photographer Diane Arbus: "This is to do with what I always call the discrepancy between intention and effect."

Raimar Stange

1 **Julie,** Den Haag, The Netherlands, February 29, 1994
2 **The Buzzclub,** Liverpool, UK / Mysteryworld, Zaandam, NL, 1996/97
3 **Golni Brigade,** Orev (Raven) Unit, Elyacim, Israel, May 26, 1999
4 **Golni Brigade,** Orev (Raven) Unit, Elyacim, Israel, May 26, 1999

Marlene Dumas

* 1953 in Cape Town, South Africa; lives and works in Amsterdam, The Netherlands

**"Even when I make a picture of a living being,
I always create only an image, a thing,
and not a living being."**

Identity as interpretation

Marlene Dumas grew up in South Africa during the 1950s and 1960s. As a "white African" she soon experienced the fate of being a stranger in her own land. The apartheid regime propagated a society segregated by race and dominated by whites. To belong to a minority and to possess power over the majority induced a sense of guilt in Dumas, which she carried with her when she went to Holland to study art in Amsterdam in the mid-1970s. This was where the young artist's international career began, initially with drawings, collages and object montages, then, in 1983, with the drawings and oil paintings for which Dumas is best known today. She also rapidly made a name for herself as an intelligent, independent-minded writer on aesthetics.

Dumas' emotional painting, usually done with glazes, frequently relies on photographs she has discovered or taken, as well as on motifs from the history of art and literature. The titles as well as words and phrases introduced into the pictures – almost always human faces, nude figures, or groups of people – contribute to suspenseful layers of meaning. The result of this artistic strategy is not an expressionism that would suggest "profound authenticity" to the viewer, but it does convey a form of reflected feeling, of a broken if content-rich sensuousness. Detachment and intensity remain in balance, and the gestural, action-emphasising character of the painting process does not detract from the almost conceptual air of Dumas' imagery.

This is an art on a continual search for the meaning and possibility of personal identity, which both emotionally appeals to and intellectually challenges the viewer. The relationship with the viewer is always taken into consideration. Dumas frequently reflects on this reciprocal relationship in her writings as well.

As mentioned, what it means to have a split identity, both vulnerable and powerful, was something the artist experienced during her early socialisation in South Africa. The dilemma was deepened by the fact that she was not only white but female. From the beginning, Dumas has defined her feelings and existential self-relationship both from the outside and from an inward, self-determined interpretation. This is why her paintings rest on a dual foundation: the externally determined view represented by the photographs and other cultural manifestations, and the painting process used to suffuse this view with personal meaning. This is seen to good effect in *Snow White and the Broken*

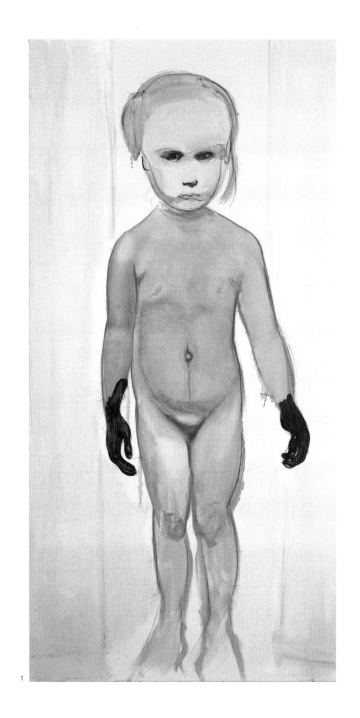

1

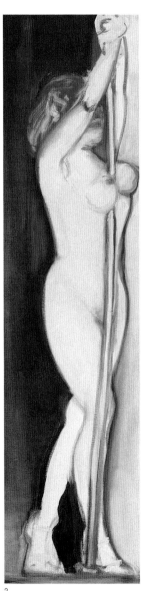
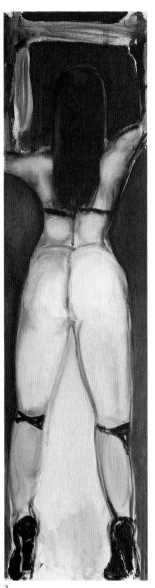
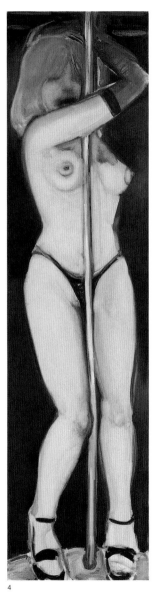

2 3 4

Arm, 1988. Snow White, a metaphor for the "white negress", lies naked and apparently helplessly exposed to the stare of men with childish faces. In her bent, evidently broken arm she holds a camera, and the Polaroids she has just taken lie strewn over the floor. The images on the photos are not recognisable, since they lie face downward.

In this image, several stories — and this is typical of the artist's approach — are simultaneously interwoven, preventing any hard-and-fast interpretation. First there is the fairy-tale reference to Snow White and the Seven Dwarfs, the story of the lovely maiden in a glass coffin who has come back to life. The camera and photos expand this narration to include a self-portrait of the artist. The figure's pose and the sombre, as it were icy colours have reminded some commentators of the dead Christ, who has taken the sins of mankind upon himself. His hoped-for resurrection provides a link with the Snow White tale. The voyeurs looming in the background, finally, recall Henry Füssli's painting *The Nightmare*, 1781, in which a swooning woman is watched by a gnome. These figures bring a similar sense of latent threat into play. Covert or overt references to apartheid are found in many other works as well. One is a female nude entitled *The Guilt of the Privileged*, 1988, in which Dumas apparently admits to her sense of guilt, presenting herself as a sexual object. Another is *The White Disease,* 1985, an oppressive image of a bloated white face.

Mental confusions

Yet Dumas' themes evince more aspects than these. The range extends from "childhood and motherhood" — as in the four-painting sequence *The First People I-IV,* 1991 — to religious issues, as in the series *Mary Magdalene,* 1995. Pornography and sexuality are also given critical, if sometimes lustful readings. The bright red mouth of *Girl with Lipstick,* 1992, or the blonde with the temptingly rolled-down stocking in *Miss January,* 1997, for instance, expose women to the gaze of the viewer, whose voyeurism is simultaneously satisfied and unmasked. Men, naturally, are also represented in Dumas' imagery, as in *The Schoolboys,* 1987, a portrait of adolescents in their school uniforms.

Whatever subject Dumas addresses, she invariably avoids a merely superficial art for art's sake. Instead, she stages sensuous and seductive images rife with meaning and open to multiple interpretations. "Mental confusions", as Dumas herself says, are the most positive reaction we can expect to have.

Raimar Stange

1 **The Painter,** 1994. Oil on canvas, 200 x 100 cm
2 **Cleaning the Pole** from the series **Strippinggirls**, 2000. Oil on canvas, 230 x 60 cm
3 **Cracking the Whip** from the series **Strippinggirls**, 2000. Oil on canvas, 230 x 60 cm
4 **Caressing the Pole** from the series **Strippinggirls**, 2000. Oil on canvas, 230 x 60 cm

Tracey Emin

* 1963 in London, England; lives and works in London

"For me, being an artist isn't just about making nice things or people patting you on your back; it's some kind of communication, a message."

The tyranny of intimacy

More legends have probably arisen around Tracey Emin than around any other artist who came on the scene in the 1990s under the label of Young British Art (YBA). Stories about her dropping out of school, doing dodgy jobs, having a wild sex life and all the attendant traumas – such as losing her virginity at 13, in what was actually a rape – appeared everywhere not just in the art journals. Readers and viewers were made privy to stillbirths, alcohol abuse, and, not least, to scandalous live appearances on TV. Such stories of lust and pain were nourished by Emin's art itself, a merciless exploitation of her own biography, whose apparently exhibitionistic directness can seem truly shocking. The viewer inadvertently becomes a voyeur who can satisfy his need for sensationalism and human interest in a way otherwise provided only by the mass media. But he can also gain something from Emin these media do not offer, since a closer look at her art reveals a poetic and precise, evidently authentic world, which is capable of throwing one back on one's own life and problems. The individual and the universal, the intimate and the public, are continually interwoven in Emin's work.

Within this force field, she manages to engender a compelling discourse on affects and desires which spirits the viewer and his longings back into the otherwise dry, academic, "objectified" art world. This is precisely where the political aspect of Emin's art lies.

The way in which moments from her own biography are interlinked with collective experience, recollection, and current concerns is clearly seen in *Everyone I Have Ever Slept With From 1963–1995*, a work of 1995. The inside walls of a small igloo tent were covered with varicoloured, cut-out letters spelling out the names of all those who shared a bed with the artist during that time period. These included early boyfriends and girlfriends, family members, her twin brother, and of course subsequent lovers. Not to forget her own name: *With myself always myself never forgetting*. Intimate moments were recalled, scenes of a kind almost everyone has experienced in a tent. In addition, the tent called up associations with prenatal security, the joys of teenage holidays, as well as with a nomadic restlessness and a despairing drive.

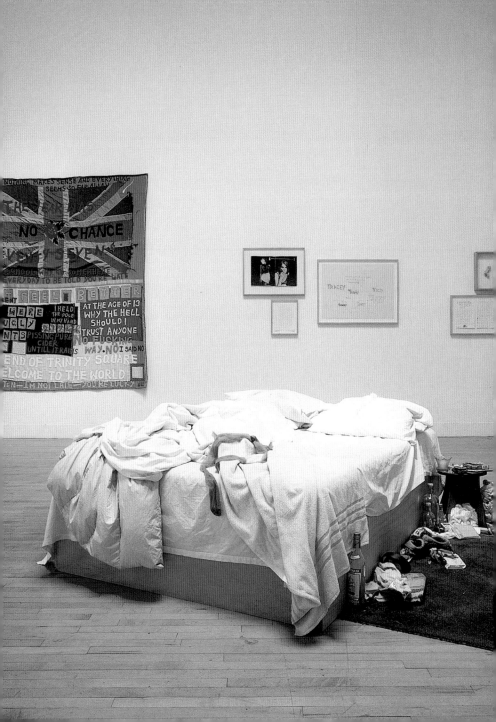

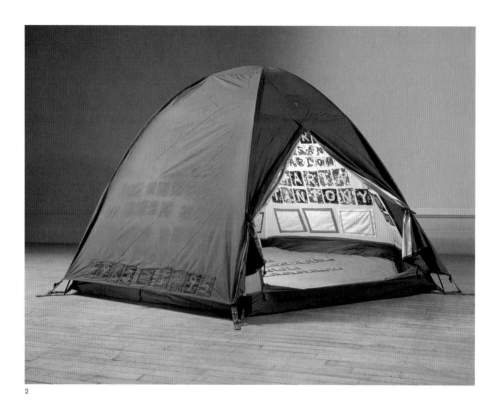

2

3

4

Documentary authenticity as fiction

The written word appears frequently in Emin's art: sentimental embroideries and "handwritten" neon tubes – as in the frigid, light-blue illumination of *Fantastic to Feel Beautiful Again,* 1997 – notations on walls, drawings and paintings, even entire books. In her *Exploration of the Soul,* 1994, Emin recorded her chequered life story from her conception to loss of virginity. Yet despite all its seeming authenticity, this retrospective recollecting view proves to be fiction, a kind of literary self-investigation which could hardly be more narcissistic, but which for that very reason hovers between a frank confession and an aesthetic *mise en scène.* On a trip through America by car, Emin read from her book at various venues, seated in an overstuffed easy chair that was covered with diverse embroideries (*There Is A Lot of Money In Chairs,* 1994). The readings were accompanied by tape recordings and live commentaries. The photo work *Monument Valley (Grand Scale),* 1995, shows the artist at one such "session". It is a good example of the way the various corresponding levels in her work enter the type of dialogue she intends to initiate in the viewer's mind.

Alternative art presentations

The effect of Emin's art is craftily augmented by the artist's personal presence, as in the installation *Exorcism Of The Last Painting I Ever Made,* 1988. This reconstruction of her own studio in the museum context included laundry hanging on a line, paintings leaning against the walls, an unmade bed, empty cigarette packets, diverse mundane objects, and drawings and painting utensils chaotically scattered over the floor. A video showed the artist, naked, presenting a painting performance. During the vernissage, Emin was there in her simulated atelier, charging the work with her immediate presence and thereby making it "corporeal" and "vital" in the truest sense of the words. Yet as the title of the installation indicated, the spiritual aspect of her work is essential to Emin.

In 1995, the artist established her own Tracey Emin Museum in London. In the private atmosphere of a rented flat on Waterloo Road, a great variety of works were presented, including the autobiographical video *Why I Didn't Become a Dancer,* 1995. The museum, as it were the quintessence of her career displayed in surroundings combining museum with gallery, apartment with souvenir or clothing store, represents an alternative to familiar modes of art presentation. A powerful form of communication that transcends hidebound rituals to address the viewer dynamically and directly through personal confession – as does Emin's oeuvre as a whole. *Raimar Stange*

1 **Installation view,** 1999. "The Turner Prize 1999", Tate Gallery, London, England
2 **Everyone I Have Ever Slept With 1963–1995,** 1995. Appliquéd tent, mattress and light, 122 x 245 x 215 cm
3 **Blinding,** 2000. Neon, 120 x 150 x 8 cm
4 **Beautiful Child,** 1999. Mono screenprint, 65 x 81 cm

VALIE EXPORT

* 1940 in Linz, Austria; lives and works in Vienna, Austria, and Cologne, Germany

"If women abandon their husbands and children, and society tolerates their action both legally and socially, as it does in the case of a man; if women achieve all of this – then they will develop an equally copious creativity."

Always and everywhere

"Export means always and everywhere," declared VALIE EXPORT in a 1996 interview. "It means exporting myself. I did not want to use either my father's name or that of my husband. I wanted to find a name of my own." A black-and-white photograph titled *Smart Export/Selbstportrait* (Smart Export/Self-Portrait, 1967/70) shows the artist in the style of the youth's protest movement of the late 1960s: a cigarette in the corner of her mouth, she is offering us a SMART EXPORT cigarette pack whose packaging is emblazoned with the artist's name and portrait: "VALIE EXPORT—semper et ubique—immer und überall" (i.e. always and everywhere). The artist wanted her adopted name to be "written only in capitals", giving it not only the impact of a manifesto, but also the quality of a logo. Coupled with the legend "MADE IN AUSTRIA", the name conveyed the idea that the production of art is also the production of a commodity, and linked that idea to the issue of how women are constructed as commodities both within and outside the art world.

VALIE EXPORT's work of the 1960s grew out of the Vienna Actionism background, but also insisted on its own discrete identity. Like the Vienna Actionist artists Hermann Nitsch, Günter Brus, Otto Mühl or Rudolf Schwarzkogler, Export often used the body (her own) as the subject and the point of departure for her work; and, again like the Actionists, she sought to transcend the boundaries imposed by taboos and so confront a sated middle-class public that had returned all too swiftly to a "normal" life after the Second World War. Nevertheless, VALIE EXPORT's actions and performances, photographs and films differed in two respects from those of Vienna Actionism. Firstly, they were emphatically feminist, deconstructing images of women established by a male-dominated society. Thus Export defined her self-inflicted injuries – as in the film ... *Remote* ... *Remote*, 1973, in which she worries at her fingertips with scissors till they bleed – not as the expression of an individual masochistic impulse, but rather, in her view, as "signs of history, revealed in actions involving the body" (cf Export in the 1979 essay "Feminist Actionism"). Similarly, the garter she had tattooed on her left upper thigh in *Body Sign Action*, 1970, was meant as a "sign of past enslavement". Secondly, however, Export's artistic output was intended from the outset as a critique of the media. She never saw photography, film or video as neutral and documentary. In her text *Mediale Anagramme* (Media Anagrams), 1990, she described her work as "notebooks in which the 'pages', notes, images, are repeatedly being shifted to different relations, and new meanings make a new context possible. The medium alone is not the message, or, to put it differently, the medium is not only ONE message." The anagrammatical principle of re-ordering

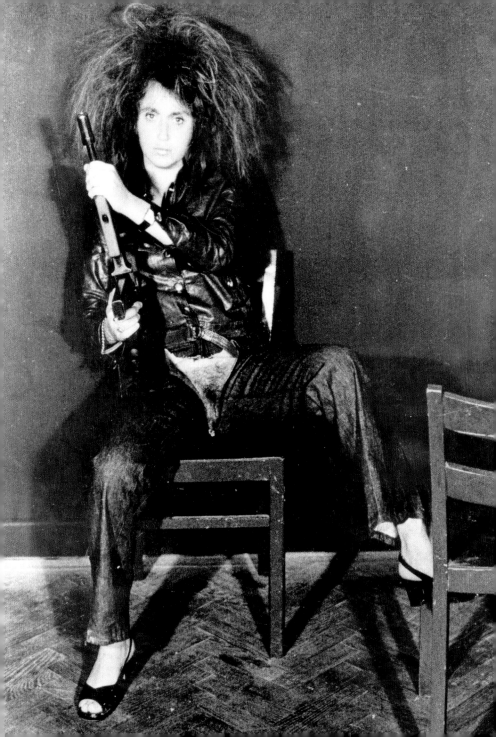

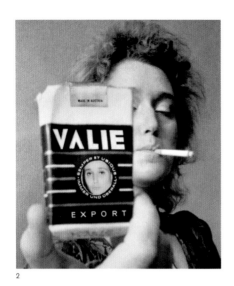

2

3

existing elements so as to produce ever new meanings has also been characteristic of Export's use of the digital media since the late 80s, as in her CD-ROM *Bilder der Berührungen* (Images of Contact), 1998, which offers not merely a comprehensive audiovisual archive of her work of three decades, but also, through the interactive side, the option of shifts in the order and mode of viewing.

Tapp- und Tastkino

Ever since the 1960s, Export has repeatedly aimed to reveal and dismantle the patriarchal regime of vision and power structures that underpin images of "femininity". Thus in her famous *Tapp- und Tastkino*, 1968, she undermined the cinema's use of the female body for a heterosexual male audience. Export strapped a box with two curtained openings onto her chest and went out in the streets, while her partner of the time, Peter Weibel, speaking through a megaphone, invited passers-by to feel Export's bared breasts through the drapes. It was VALIE EXPORT's way of transforming the voyeuristic situation of the cinema into an "expanded cinema" – substituting for a male-defined cinema image of "femininity" her own real body, and returning the gaze of those who looked at her, thus making them in turn objects to be stared at. No less radical was her performance *Aktionshose:Genitalpanik* (Action Trousers:Genital Panic), 1969: wearing a pair of trousers with the crotch cut out, and armed with a machine-gun, Export strode down the rows of a Munich porn cinema amongst would-be viewers who had been expecting screen images of genitals. Threatened both physically and psychologically by the weapon and by the "ontological leap" (as the title of a 1974 photographic series later had it) from pornographic image to real female genitals, the audience left the cinema.

Image and reality

By superimposing or layering different representations of the same subject, Export makes visible not only the constructed nature of images but also the potential to change them. She also points out the mutual influence and interpenetration of image and reality. A good example of this strategy is a series of posed photographs showing women with domestic objects in the postures of Renaissance madonnas. Thus in *Die Putzfrau (Fotoobjekt nach Tizian)* (The Cleaning Woman, photo after Titian, 1976), two contradictory stereotypes, one an idealised cliché from high culture and the other a pejorative cliché of everyday culture, are superimposed. One option for the deconstruction of received cultural gender identities and socially defined roles (such as that of motherhood) is the technological extension or relocation of biological bodily functions. With one eye on Sigmund Freud, who saw humankind as the "prosthetic god", Export's installation *Fragmente der Bilder einer Berührung*, 1994, spotlights the technologies of reproduction, which (whatever the justified criticisms) can also be a contribution to "liberation from the burden of the body" (in Export's phrase): lit light bulbs were lowered gradually and immersed in glass vessels containing milk, oil or water, and then withdrawn. The technical procedure evoked associations with an a-physical sexual act, and thus the ambivalent vision of a liberation from the body – which for VALIE EXPORT is equivalent to transcending the reality principle.

Barbara Hess

1 **Aktionshose: Genitalpanik,** 1969/1980. Black-and-white photograph, 176 x 127 cm
2 **Smart-Export,** Selbstporträt, 1997/1970. Black-and-white photograph, 61 x 41 cm
3 **Tapp- und Tastkino,** 1968. Tap-and-touch cinema, street cinema, mobile cinema, genuine women's cinema, body action, social action

Sylvie Fleury

* 1961 in Geneva, Switzerland; lives and works in Geneva

"Every satisfied desire arouses the desire for more."

The world as a shopping basket

Sylvie Fleury made her name in the early 1990s with her *Shopping bags*, arrangements of designer brand-name bags looking as if they had simply been left on the gallery floor after a shopping spree. The content was covered with fine fabrics, making the bags seem even more enigmatic, and more attractive. Fleury's hallmark was to transfer women's luxury consumer goods, as ready-mades, into the art context – everything from black-and-gold Chanel cosmetics packages in *Coco*, 1990, to photographic enlargements of the covers of glitzy fashion mags, to a spacious installation with a soft-pile carpet, stylish seating and countless designer shoes and shoeboxes. Critic Eric Troncy described her as "an artist who creates her works on a credit card", and, much as in the case of Andy Warhol, the issue of whether her art was intended to be critical of its subject matter or affirmative was much debated. Many of her works seem to confirm the cliché that fashion and decor are among the favourite interests of women, and even Fleury's projection of herself as a "fashion victim" and her statements show that she herself is an enthusiastic consumer of the commodities that appear in her work.

It can surely be no coincidence that Fleury's first work dates from a time when capitalism saw itself as the triumphant social and economic model. In 1993, she noted in an interview: "The system has collapsed, as it has in other areas, and I believe we are now at liberty to rummage about in the free world as we might in a basket of goods." The 'basket of goods' Fleury has rummaged in contains not only a substantial range of pretty exclusive products aimed at female consumers, but also the art movements of the 20th century – largely fashioned by male artists – and especially of the 1960s. She adjusts the standards of western high culture by re-encoding that culture's versions of familiar recent artworks and giving them a feminine angle. Thus, for instance, her sculptures made of Slim Fast cartons allude to Andy Warhol's famous *Brillo Boxes*, 1964, while the diet product simultaneously prompts associations with female ideals of slenderness and so of self-starvation rituals. Often Fleury deploys the products, fabric designs and fashionable colours of a given season, as in her mural paintings or missiles in lipstick colours, or uses soft materials that appeal to the sense of touch. Her subversive irony is brought to bear not only on individual heroes of art, but also on canonical forms of artistic presentation, as in the white cube – the white and seemingly neutral and rational modernist exhibition space that Fleury lined entirely with synthetic fur in her 1998 installation *Cuddly Wall*, thus

2

3

58 Sylvie Fleury

transforming it into a sensuous and mildly claustrophobic white cave, in which chrome-plated bronze sculptures by the artist's avowed design favourites were on display as museum icons: the Hermès Kelly bag, the Chanel No. 5 flacon, or an Evian mineral-water bottle.

It would be possible to argue that Sylvie Fleury pays uncritical homage to the commodities she fetishizes, unreflectingly identifying with the dictates of fashion (including fashions in art) and of the images of women propagated in public arenas. To this, art theorist Peter Weibel has countered that Fleury is recalling those utopian hopes and wishes for fulfilment in life that popular culture, in however distorted a form, promises to fulfil. Weibel points out that while there are countless works of art that legitimise male pleasures, there are hardly any that celebrate the indulgences of women in like manner. One might, moreover, argue that, while Fleury never denies that luxury holds a fascination for her, her work is not blind to the destructive aspects of beautiful illusions. Thus, in one of her mural paintings that uses quotations from glossy magazines, one of the quotes reads "Suffering in Silence – Women and Self-Mutilation". Similarly, the immaculate pink spray-jobs in her *Skin Crime* series, 1997, cannot distract from the fact that these crushed cars (in allusion to work by Pop artist John Chamberlain) are write-offs. A 1999 Fleury exhibition catalogue feature video stills of accidents in motor races.

Within the last male citadel

Motor racing is one of the last male citadels in popular culture. In designing her *Formula One Dress*, 1999, Fleury drew upon the clothing worn by Mika Häkkinen, 1998 formula one world champion, and then had herself photographed – to striking effect – alongside the motorsport idol. It is a field that affords potential for a more aggressive, deliberately trashy aesthetic. Fleury's installation *She Devils on Wheels Headquarters*, 1997, delivers the offices of an all-women motor club as promised in the title, complete with various borrowings from the covers of Playgirl magazine. A sign reading "Race in Progress" provides a gloss on the apparently unfinished provisional quality of the installation, but it might equally well be read as a glance at the competitive nature of relations between the sexes – or a reminder that the race for equal rights and opportunities is still being run.

Barbara Hess

1 **First Spaceships on Venus,** 1996. Fibreglass, loudspeakers, CDs, each 350 x 130 x 130 cm
2 **Untitled,** 2000. Carpet, "Phantom" chairs by Verner Panton, shoes, shoeboxes. Installation view, Art 31, Basle, Switzerland
3 **A 011/355,** 1999. Asphalt surface and white neon lettering. Installation view "FASTER! BIGGER! BETTER!", Mehdi Chouakri, Berlin

Isa Genzken

* 1948 in Bad Oldesloe, Germany; lives and works in Berlin, Germany

"When I go into a museum and come to a room with a lot of bad pictures, and then suddenly discover a picture that I stop in front of, I forget all the rest."

The (im)possibility of communication

The sculpture shoots through the otherwise empty space like an arrow – a photo of Isa Genzken's 1979 installation at Krefeld's Museum Haus Lange conveys an idea of the spatial effect of the geometrical floor works that established her reputation. Her *Ellipsoids,* 1976–82, and *Hyperbolas,* 1979–83, extended horizontally up to 40 feet through space. They were designed on a computer, lacked a compositional centre of interest, and were difficult to take in at a glance. Much like the sculptures of American Minimal Art, these pieces aimed at a new definition of the object-space relationship and an activation of the viewer's role.

In 1976, while still a student at the Düsseldorf Art Academy (1973–77), Genzken showed at Galerie Konrad Fischer, a key venue for advanced German artists such as Sigmar Polke, Blinky Palermo and Gerhard Richter, but also for American Minimalists like Carl Andre and Sol LeWitt. Genzken's rapid rise – she participated in the groundbreaking "Westkunst" exhibition in 1981, and in documenta 7 as well as the Venice Biennale in 1982 – seemed to belie the widespread opinion that sculpture was a classically male domain. Yet as art critic Benjamin Buchloh noted in a 1992 essay, the prejudice remained: her sculptures were denounced as phallic exaggerations, an expression of female hysteria.

Genzken remained immune to such readings. At a time when the notion of artistic autonomy seemed to have been made obsolete by an increasing dematerialization of the art object and enthusiasm for the new media, she faced the issue of the meaning of sculpture, taking account of the critique of traditional definitions of sculpture in space and the specific conditions of its production and reception. The result was a characteristic dual thrust in Genzken's work, a concern with two seemingly contradictory but actually mutually supplementary strands. The first, in addition to sculptures, included photography, video, film, collage and collage books, as well as an ongoing involvement with the classical themes of sculpture – the ordering of masses and volumes, the interplay of construction, surface character, and material, and the relationship between object, space and viewer. The other strand was characterised

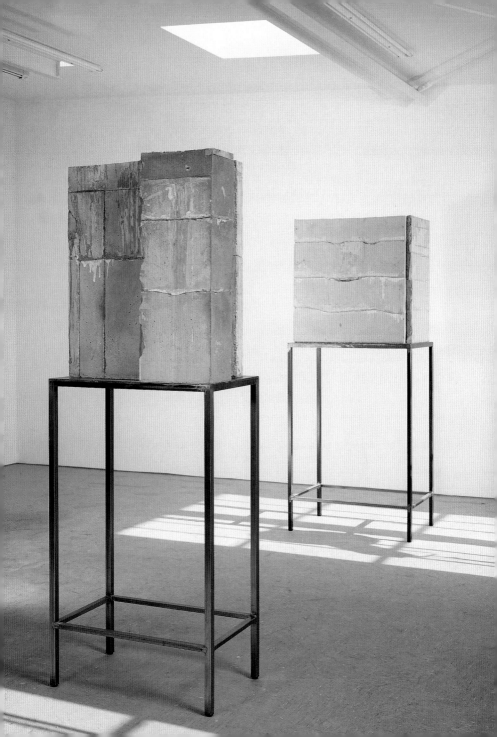

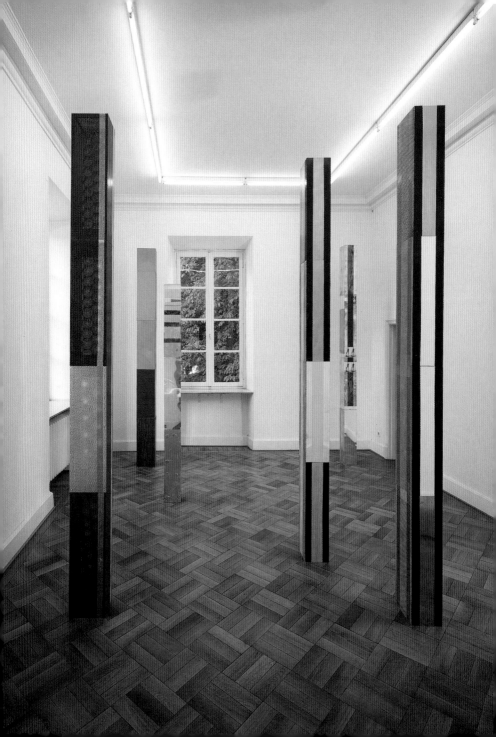

by an inclusion of personal, social and institutional references in the work, as well as by inquiry into the possibility, or impossibility, of communication. An explicit factor in such works as the collage books *I Love New York – Crazy City,* 1995/96, in the *Hi-Fi Series,* 1979, the *Ear Series,* 1980, or the *World Receiver,* 1981/87, this dialectic was also implicitly present in the varying degrees of formal closure or openness in Genzken's sculptures.

Wood, plaster, concrete

Accordingly, subsequent groups of works, developed partly in parallel and partly in sequence – be they the *Wood Sculptures,* 1976–85, the *Plaster Sculptures,* 1985–86, the *Concrete Sculptures,* 1986–92, the *Epoxy Resin Hoods* and *Lamps,* the assemblages of metal household appliances titled *Babies*, or the *Steles* of the 1990s – referred to various historical conceptions of sculpture. The floor works could be read as a critical continuation of Minimal Art. While rejecting its use of industrial methods to produce sculptures in series, Genzken insisted on the uniqueness of the sculptural object and, by choosing wood as the material, lent it an organic dimension. By contrast, the *Plaster* and *Concrete Sculptures* referred to the Constructivism of, say, El Lissitzky or Kasimir Malevich. Usually presented on floor or wall pedestals, the plaster sculptures – with titles such as *House,* 1985, or *New Building,* 1985 – consisted of irregular cast shapes that recalled architectural details and had an aspect of the unfinished and fragmentary, as if the artist were ironically denying the false promise of a reconciliation between architecture and sculpture. This refraction took even sharper form in the *Concrete Sculptures*. This ubiquitous urban material gained an astonishing lightness that was augmented by displaying the sculptures on long-legged steel tables. The structural possibilities of reinforced concrete also informed outdoor projects such as *ABC* (Münster, Germany, 1987), a twin arch of steel and concrete. The title called up associations with the nearby university library, but also with the ABC Group formed by El Lissitzky and Mart Stam in Basle in 1924, or with "ABC Art" as a derogatory term for Minimalism. In a way comparable to the concrete and epoxy *Windows,* which marked a permeable border between interior and exterior space and drew the eye to their surrounding spaces, *ABC* framed an excerpt of the urban environment.

Textiles and photographs

Genzken's play on an equilibrium of mass, volume and weight reached a preliminary culmination in her most recent work, *Beach Houses,* 2000. Constructed of cheap materials that, much like ready-mades, bore traces of earlier use and were only loosely assembled and held together in places with adhesive tape, these configurations had an aspect of extreme fragility. Similar in format to the plaster pieces, they too called up a range of associations with architectural references, if with a different focus – occasionally perhaps an allusion to one of Dan Graham's mirror pavilions, occasionally to deconstructivist architecture. The motif of the fragmentary returned also here, just as in the 36-part photo sequence *Yacht Holiday,* taken in 1993 on a voyage with the collector and industrialist Frieder Burda and the artist's then husband Gerhard Richter. As if taking an inventory, the camera captured details of the yacht – navigation instruments, portholes, deckchairs, lifeboat, etc. – without ever showing the ship as a whole. Only by mentally assembling the different points of view, could the viewer form a provisional image, subject to continual supplementation, expansion and change.

It is exactly this aspect of the transitory that Genzken has raised to an artistic principle, in the process creating a highly varied and continually surprising œuvre.

Astrid Wege

1 **Guardini, Kuß,** 1987. Concrete on steel tubing
2 **Installation view "Sie sind mein Glück",** Kunstverein Braunschweig, Brunswick, Germany, 2000

Nan Goldin

* 1953 in Washington, DC, USA; lives and works in New York (NY), USA

"Taking pictures is for me a way of touching someone – a form of tenderness."

"I photograph directly from my life"

When Nan Goldin was given her first camera at the age of 16, she photographed her friends, herself and her immediate surroundings. The pictures she has taken since the late 1960s are not the product of detached observation, but of emotional bonding between the people they portray. The camera is her constant companion, the photographs her visual diary. Over a period of 30 years, her pictures have traced the story of her life and that of her friends. At the same time, they go beyond the scope of personal biography as an eye-witness account of certain groups and subcultures with which she has been involved. Although her photographs show drug addicts, alcoholics, homosexuals, transvestites and prostitutes, they are not so much a chronicle as an affectionate, warts-and-all homage to the kaleidoscope of life and death.

In 1965, Goldin's older sister committed suicide. The family was devastated. Her friends at Satay Community School in Lincoln, Massachusetts, became a kind of substitute family. She began to take photographs, as she says, so that she would not lose them, clinging to life in order to save her own life. Even in these first black-and-white photographs and Polaroids she developed the aesthetic of the snapshot, whose intimacy and immediacy is the hallmark of her later work. Her friends liked to be photographed by her. Fascinated by the world of fashion and cinema, they would strike poses and transfer them to their private surroundings. Among her friends were David Armstrong and Suzanne Fletcher, whom she photographed repeatedly in the following decades.

In the early 1970s, Goldin photographed the weekly beauty contest held at the Boston transvestite bar The Other Side. Influenced by the films of Andy Warhol and by Antonioni's *Blow Up*, she starting making super-8 films. In 1973, she began working in colour photography, for which she used artificial lighting. A year later, she met the photographer Lisette Model and began to study at the school of the Museum of Fine Arts in Boston. It was here that she used flash for the first time. Even the few outdoor shots from this period were taken using flash, which made the scenes appear cool and artificial. For her graduate work, she submitted slides, which she used for small private showings.

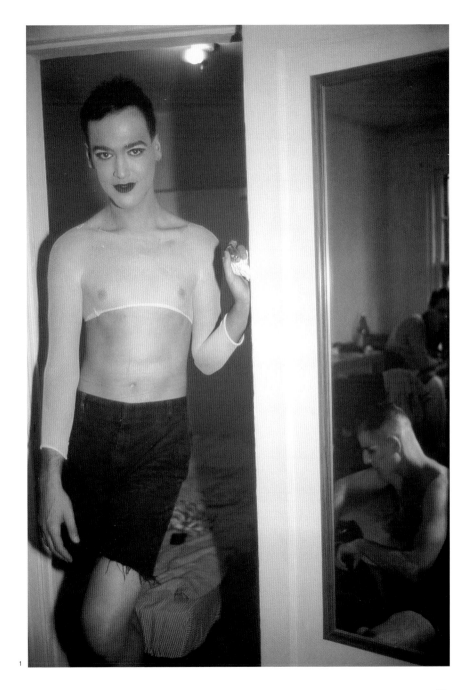

1

Intimacy goes public

In 1978, Goldin moved to New York and was soon at home in Manhattan's nightlife, working, like many artists (including Kiki Smith), as a barmaid at the Tin Pan Alley Bar, and presenting her slide shows, which she constantly changed, expanded and backed with music from 1980 onwards. On the basis of individual photos, she developed a fragmentary sequence of images based on narrative film sequences. The slide show, now encompassing more than 700 slides, is still being shown in constantly changing order with ever new motifs. In 1981, Goldin gave her slide show the title *The Ballad of Sexual Dependency* – a title she had taken from a song in Bertolt Brecht and Kurt Weill's *Threepenny Opera* – and in 1984 she published it in book form under the same title. *The Ballad* shows naked couples in bed, men making love or masturbating, empty rooms, broken bodies, women and men in bars, bedrooms, bathrooms or cars, and, time and again, women in front of the mirror. It is the empathy reflected in these images that lends them their undeniable lyricism. The motif of a woman gazing at her reflection in a mirror was a popular theme in classical painting, and is a recurrent motif in Nan Goldin's oeuvre. Even the title of her 1995 film *I'll Be Your Mirror* – featuring interviews with HIV positive friends – not only recalls her favoured theme, but can also be regarded as symbolising her work as a photographer. Her photographs, at the same time, are mirror images of her friends, her life and her means of self-assertion. When Goldin was beaten up by her lover in 1984, she photographed her own face in *Nan one month after being battered*.

Living and dying in the age of AIDS

Nan Goldin's slide shows are screened at film festivals world-wide. In Europe, she met Siobhan Liddell, and realised a number of portraits of her between 1986 and 1994. After drug-withdrawal therapy in 1988, she created many self-portraits and began to take photographs in daylight for the first time. AIDS became a focus of her work, and she photographed AIDS victims up to their deaths. In 1991, she was awarded a German Academic Exchange Service (DAAD) stipend to work in Berlin, where she lived until 1994. In Berlin, she made friends with the homosexual Alf Bold from the International Forum of Young Film and followed his progress, taking photographs of him as he went through the final stages of AIDS. In 1993, she published *The Other Side 1972–1992*, which was a compilation of her photographs of homosexuals and drag queens. That same year, she met the photographer Nobuyoshi Araki in Tokyo and carved out a niche for herself in that city, too.

Ulrike Lehmann

1 **Jimmy Paulette and Tabboo! undressing,** New York 1991
2 **Villa Bovina**, New York, New Year's Day 2001
3 **Christine floating in the waves,** St. Barth's 1999

Natalja Goncharova

* 1881 in Nagayevo, Russia; † 1962 in Paris, France

"Decorative painting? Poetic poetry. Musical music. Nonsense. All painting is decorative, if it adorns, beautifies."

Ex oriente lux!

Natalia Goncharova's diverse oeuvre was marked by frequent changes of style that reflected most every facet of the various avant-garde movements of the early 20th century. Like many other Russian artists of the period – above all, Michail Larionov, her lifelong companion – Goncharova combined modernism with elements of traditional Russian folk art and icon painting. Her *Still Life with Tiger Skin,* 1908, is a case in point. Standing on the tiger skin are two panels, one showing a scene from Japanese Kabuki theatre, the other an antique sarcophagus relief, facing each other as equally important sources of her art.

Goncharova came from a respected and prosperous family of architects. As a girl she spent a great deal of time at her grandmother's country estate. This was the source of her interest in peasant costumes and customs, hand-crafted useful objects such as wooden trays and shop signs, and the popular legends that tell of the rootedness of the Russian people in nature. After graduating from school in Moscow, Goncharova decided to attend university – by no means a common thing for women at that time. After hearing lectures in history, botany, zoology and medicine, she transferred in 1901 to the Moscow School of Painting, Sculpture and Architecture, where she took courses in sculpture with Pavel Troubetskoi. After meeting Michail Larionov, she switched to painting, focusing on the way objects reflect light or on colour harmonies, and portraying herself in a series of different costumes.

The first decade of the 20th century brought forth a spate of new artistic movements, and not only in Russia. As early as 1906 Goncharova was invited to contribute to the Russian section at the Salon d'Automne in Paris, which was curated by Serge Diaghilev. By way of compensation, Goncharova and Larionov organised three exhibitions of contemporary French art, beginning in 1908. Held under the auspices of the influential art journal *Zolotoje runo* (The Golden Fleece), these shows brought works by Gauguin, van Gogh, Cézanne, Matisse, and the Fauves to Russia for the first time. Goncharova was especially intrigued by Gauguin's ornamental treatment of figure groups.

Over the following years, an involvement with icon painting and Oriental art led to a simplified, heavily contoured or Cubistically facetted style of depicting figures and interiors which was no longer beholding to French influences. Also, like Kasimir Malevich at the same period, Goncharova turned to subjects from peasant life, producing paintings such as *Potato Harvest* and *Garden in Springtime,* 1908/09. Yet when her work was shown in 1910 at the Association for Free Aesthetics, it spanked off a scandal. Two nudes and *The God of Fertility* were even declared pornographic and confiscated by the police. Her religious pictures were accused of blasphemy. This case reflects what Jane A. Sharp has called the "hybrid nature of Russian modernism," a trait that not only art lovers found hard to digest. Also represented at the show were Alexandra Exter, Lyubov Popova, and Olga Rosanova, in the first public appearance of self-confident women artists whose work would have a great influence on the avant-garde developments of the period.

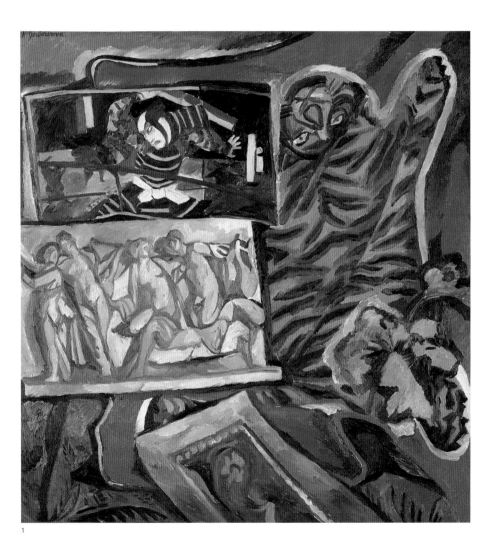

1

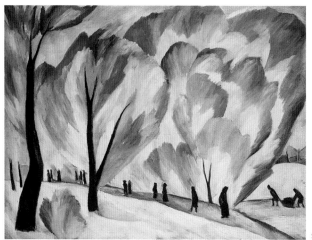

2

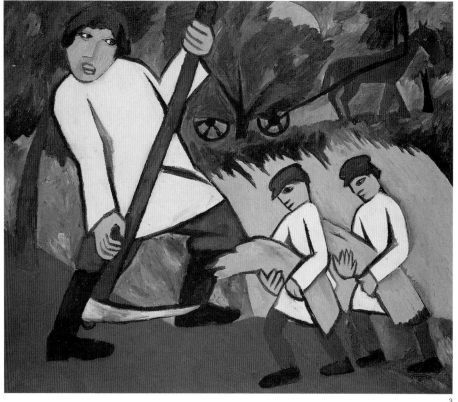

3

Undaunted by criticism, Goncharova and Larionov organised further exhibitions and founded an influential artists' group called the Jack of Diamonds. At the culmination of their Futurist phase, in 1913, Goncharova played a role in the film *Drama in the Futurist Cabinet No. 13*. Concurrently she showed Rayonist works at an exhibition titled "The Target." Apart from a continuing interest in primitive folk art, Goncharova increasingly concentrated on developing a style that would conform to modern, industrial society. Like Larionov, she amalgamated elements of Cubism and Futurism, and worked in terms of his version of Rayonism. In paintings such as *The Weaver: Loom and Woman,* 1912–13, or *Electric Lamp,* 1913, objects from the realm of modern life and work were represented in a network of reflecting light rays. In *Portrait of Larionov,* also 1913, instead of extending light reflections from objects into space, Goncharova evoked the emanations of a strong personality. Also, she merged her own profile with Larionov's face to produce – as in a picture-puzzle – the double portrait of a couple kissing.

Increasing fame

By this time, Goncharova had become a highly respected artist. Her first solo show in Moscow, held in 1913 and also representing her first retrospective, comprised over 760 works. Numerous other works were concurrently on view in exhibitions at various art centres in the East and West. In 1914, Diaghilev, creative director of the *Ballets Russes,* invited the artist to come to Paris, to collaborate on his staging of a ballet based on Rimsky-Korsakov's opera *Le coq d'or.* Goncharova designed both the costumes and the sets, based on old Russian patterns, and came for the première on 21 May, 1914 – her first visit to Paris. The ballet was a dazzling success, and established the artist's fame as a stage and costume designer. But then the First World War intervened.

In 1916, Goncharova travelled with Diaghilev's troupe to Spain, and, in early 1917, to Rome, where she met Picasso. That same year she and Larionov, who had been wounded and discharged from the Russian army, managed to return to Paris. There followed a series of sets and costumes for ballet and theatre performances, including Stravinsky's *Les Noces,* 1923, in Paris and *The Firebird,* 1926, in London, although these were not nearly as successful as her 1914 debut. Besides continuing to produce book illustrations, Goncharova found fresh inspiration in Spanish folk art, which she had discovered during her 1916 travels with Diaghilev through Spain. The result was a series of stylised female figures in traditional costumes, *Spanish Women,* which was followed by a large-format depiction of *The Evangelists*. The naturalistic costume designs of this period stood in contrast to the geometrical reduction of Goncharova's free painting, such as a mahogany screen with the motif of *Spanish Women.*

Declining influence

Yet since she was interested neither in promoting the sale of her pictures nor in making appearances, like Larionov, on the Paris art scene, Goncharova's influence began to decline. A return to post-revolutionary Russia was out of the question for these emigrés for political reasons. Although both artists survived the war and German occupation relatively unscathed, the post-war years found them seldom leaving the seclusion of their Paris apartment. At this period Goncharova painted primarily in an abstract vein, including a series devoted to the first Russian satellite, *Sputnik.* It was not until 1954 that her work was rediscovered, in the context of a Diaghilev exhibition curated by Richard Buckle in Edinburgh and London. In 1961, a year before her death, the British Arts Council mounted a Goncharova and Larionov retrospective that included both paintings and theatre designs.

Petra Löffler

1 **Nature morte à la peau de tigre,** 1908. Oil on canvas 140 x 137 cm
2 **Le Givre,** 1911. Oil on canvas, 101 x 132 cm
3 **Les Faucheurs,** 1907. Oil on canvas, 98 x 118 cm

Guerrilla Girls

Gorillas and guerrillas

Every profession needs a conscience. And the guise in which an often guilty conscience appears is characteristic of the profession in question. The guilty conscience of the art world during the 1980s and 1990s bore the name "Guerrilla Girls" and wore short skirts, net stockings, high heels, and gorilla masks. They were a group of artists, writers and film-makers whose success in the early 1990s paralleled a crisis in the art market. Their humour and love of provocation was the best thing that could be thrown at this spectacle. Yet they also proved to be a role-model, and soon their type of intervention became *de rigueur* – being against the spectacle rapidly became part of the spectacle.

The Guerrilla Girls were, and probably still are, an extremely heterogeneous group of women of various ages, ethnic backgrounds, sexual orientation, and success on the art market. They are and were anonymous. It was once chic for women on the art scene to say they belonged to the Guerrilla Girls. For a time, it was even a mark of quality. How many of them were there? Only a few people know. During their public appearances they used code names, those of dead women artists and writers such as Frida Kahlo, Eva Hesse, Alice Neel, or Paula Modersohn-Becker, in order to draw attention to their achievements.

They were guerrillas before they became gorillas. The history of the Guerrilla Girls began in 1985, on the occasion of an exhibition at the Museum of Modern Art, New York, a review of major contemporary art titled "An International Survey of Painting and Sculpture". Of the 169 artists participating, only 13 were women. The Guerrilla Girls demonstrated against this imbalance in front of the museum. Passers-by remained unimpressed. Learning from this experience, the group began to embarrass the art market itself – collectors, artists, gallery owners – by announcing their omissions on posters in the streets of New York's SoHo. It began with street fighting, and it continued with the transfer of Hollywood devotionals and strategies to the art market.

These partisans were also girls in masks. Their ape masks were inspired by King Kong, a clever ploy in several respects. They appropriated the image of masculine dominance and virility in which King Kong figures as the enemy incarnate, and they put the public in the role of the frightened masses – quite funny in view of the actual distribution of power. And they not only dipped into the storehouse of Hollywood costumes, but quoted their great predecessor in an apeskin, who had spread horror among 1930s audiences in a movie of the day – Marlene Dietrich.

Girls in masks

The patently disastrous situation not only of women artists, but of non-white artists also, triggered laughter among the Guerrilla Girls, a mock hysterical giggle that poked fun at a system which excluded their gender. The gorilla masks bobbing through their videos and films provoked the old prejudice that feminists were women who couldn't catch a man. Yet the point of the Guerrilla Girls' exercise was to breathe life into feminism by means of new tactics and strategies. In 14 years they designed over 70 posters and print objects, and mounted demonstrations protesting against sexism and racism in the art world. Their first works, done during the Reagan administration in the

THE ADVANTAGES
OF BEING
A WOMAN ARTIST:

Working without the pressure of success.
Not having to be in shows with men.
Having an escape from the art world in your 4 free-lance jobs.
Knowing your career might pick up after you're eighty.
Being reassured that whatever kind of art you make it will be labeled feminine.
Not being stuck in a tenured teaching position.
Seeing your ideas live on in the work of others.
Having the opportunity to choose between career and motherhood.
Not having to choke on those big cigars or paint in Italian suits.
Having more time to work when your mate dumps you for someone younger.
Being included in revised versions of art history.
Not having to undergo the embarrassment of being called a genius.
Getting your picture in the art magazines wearing a gorilla suit.

A PUBLIC SERVICE MESSAGE FROM **GUERRILLA GIRLS** CONSCIENCE OF THE ART WORLD
532 LaGUARDIA PLACE, #237• NY,NY 10012
www.guerrillagirls.com

1980s, were followed by one poster after another, of which museums and libraries collected entire portfolios. The Guerrilla Girls addressed political topics from abortion to the Gulf War, from homelessness to rape. Their focus was on political correctness, and they collaborated in this with other artists' groups, for instance in the orbit of Act Up. Lectures in museums and schools on four continents followed.

In addition to posters, the Guerrilla Girls also created billboards, bus advertising and magazine spreads, organised protest actions and floods of protest letters, and initiated fake prizes revealing the underlying mechanisms of the art market. Their approach was spread around the world by sisters in spirit who likewise called themselves Guerrilla Girls. They understood themselves as a female counterpart to the generally male tradition of anonymous benefactors of the downtrodden, such as Robin Hood, Batman and the Lone Ranger. To this list they added a specifically female variant – the Guerrilla Girl.

Sisters in spirit

History is a flowing, continually changing text that is not only subject to correction and verification, but requires them. The art history written by the Guerrilla Girls is not likely to include many familiar male artists. Instead of reducing art history to a few "masterpieces" and "geniuses", it will make room for the many. To call the Guerrilla Girls "quota queens" would be mistaken. They have not demanded that 50% of artists in exhibitions be female or members of minorities, but simply stated that the actual figure was less than 10%. They mounted resistance to the language of art criticism, countering the patriarchal model of the "master" in "masterpiece" with a tribe of lusty pri-

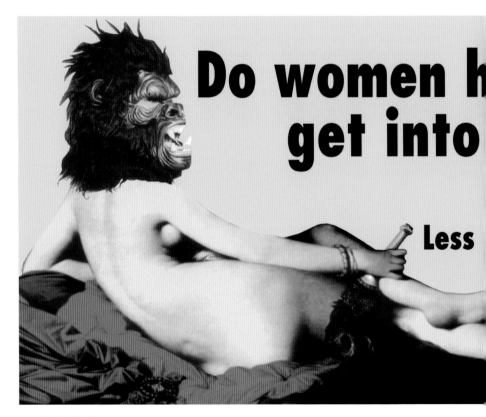

mates, and freely translating the Latin word "genius" to mean testicles. (This may explain why it is so seldom used to describe women.) The Guerrilla Girls have argued that art made by women and minority artists is truly different from that of their male colleagues. If art is a reflection of experience, and if we agree that sex and race influence this experience, then logically their art must be different. If someone needs a King Kong mask over her head to get into a museum, the museum has reason to scratch its own head. All the Guerrilla Girls wanted was museum and gallery art to reflect a true picture of cultural history, not merely the part contributed by males. They have made dealers, curators, critics and collectors responsible for this imbalance. With success, with setbacks. After all, it's hot under those masks.

Frank Frangenberg

1 **The Advantages of Being a Woman Artist,** 1988
2 **Get Naked,** 1989

ve to be naked to
the Met. Museum?

an 5% of the artists in the Modern
Art sections are women, but 85%
of the nudes are female.

GUERRILLA GIRLS CONSCIENCE OF THE ART WORLD
w w w . g u e r r i l l a g i r l s . c o m

Mona Hatoum

* 1952 in Beirut, Lebanon; lives and works in London, England

"You first experience an artwork physically. Meanings, connotations and associations come after the initial physical experience."

Without a country

A Palestinian by birth, Mona Hatoum's biography has been shaped by dual exile. She grew up in Beirut, where her parents had fled in 1948 from Palestine. They lived as aliens in Lebanon and, in 1975, Hatoum went to London. When civil war broke out in Lebanon shortly thereafter, she was no longer able to return to her family. After studying fine art for six years in London, she graduated from the Slade School of Fine Art in 1981, observing, from a distance, the political and religious conflicts in the Near East with growing concern. With a performance entitled *The Negotiating Table,* she reacted to a 1982 massacre in which over 1,000 Palestinian refugees died. The artist donned a blindfold and was then wrapped in a plastic sheet and covered with bloody animal entrails. She remained lying on a table in this state for three hours. But victims are not a matter for negotiation – the chairs around the table remained empty.

The irreconcilable territorial claims of Israelis and Palestinians are still the cause and target of fundamentalist violence. When Hatoum returned to the Near East in 1996 to arrange an exhibition in divided Jerusalem, she had the territorial map clearly in mind. On the floor of a gallery she laid out pieces of olive oil soap, a traditional Palestinian product, and traced the region's disputed borderlines in red glass beads. The Palestinian enclaves resembled a scattered archipelago. Yet even more than the lines on the map, the familiar smell of soap called up memories of the Palestinian homeland. As the title of the installation, *Present Tense,* indicated, the artist was convinced that no country's frontiers are forever fixed. Soon she was to make this statement on a global scale. In 1998, at the Kunsthalle Basel, she laid out the contours of the continents using glass marbles – a fragile *Map* which the slightest tremor would have destroyed.

Hatoum's interest in cartography, which she shares with artists such as Alighiero Boetti, is no casual one. Wars have been waged with the aid of maps, and entire continents colonised. This aspect was addressed in the artist's work, *Plotting Table,* 1998, evoking the type of table on which manoeuvres are planned. In Hatoum's installation, the table-top had hundreds of holes drilled through it. Fluorescent light streamed from below to illuminate a

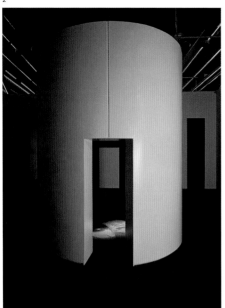

world map, suggesting that the theatre of military operations is a global one. In the post-colonial era, the arena of power politics has been in continual flux. This was alluded to in Hatoum's *Continental Drift,* 2000, a map consisting of iron filings subjected to a rotating magnetic arm that kept them in incessant motion.

War in the living room

Yet the global view is not the only one that inspires surprising insights on Hatoum's part. That unsuspected dangers can lurk in more familiar places as well, was seen in the installation *Home,* 1999. Comprising of several conventional metal kitchen appliances connected by electric wires to light bulbs that blinked on and off at irregular intervals, the arrangement was lent an eerie touch by the crackling, amplified sound of the live electric current. In an installation of the following year, *Homebound,* the artist arranged chairs, birdcages, bedsteads, and a metal-clothes stand around a table with various household objects. These were likewise connected to an electrical current and separated from the viewer by a wire barrier. The 50-cycle current was programmed to turn the lights and sound on and off intermittently. Familiar things were removed to an inaccessible distance – Hatoum's wired living spaces were no place to live. In a similar way she has alienated objects such as a wheelchair, by replacing its handles with sharp knives. *Untitled (Wheelchair),* 1998, like *Marrow,* a bedstead made of rubber, was a functionless aesthetic object in the tradition of Surrealist *objets trouvées* or *sculptures involontaires.*

In contrast, an object such as Hatoum's vegetable shredder, enlarged to 21 times its actual size and titled *La Grande Broyeuse (Mouli-Julienne x 21),* 2000, had a human scale that gave it the air of some instrument of torture. This association was conscious, the work having been inspired by Franz Kafka's story *In the Penal Colony.*

Habits of perception

In such finely-tuned conceptual works, Hatoum unsettles familiar points of view and value systems. They contain an implicit critique of habits of perception that all too readily shut out the unfamiliar and alien. A comparable shift in the hierarchy of vision was already achieved in 1961, by the Italian conceptual artist Piero Manzoni. In his sculpture *Socle du Monde,* Manzoni declared an iron cube, by way of an inscription, to be the "pedestal of the world," that is, that the earth rested on a foundation created by him.

In 1992/93, Hatoum repeated Manzoni's claim, with a slight yet momentous difference. The surface of her cube was covered with iron filings which, polarised by hundreds of tiny magnets fixed to the surface of the cube, formed an organic surface pattern. Manzoni's Minimalist pathos was transformed into a play of forces that oscillated between form and non-form. Similarly provocative was her piece *Corps étranger,* 1994. For a solo show, at the Centre Georges Pompidou in Paris, Hatoum realised a long-cherished project: to explore the inside of her own body by camera. The camera functioned as a scientific eye that invaded the boundaries of the body both inside and out. At the same time, Hatoum's body became the object of an incursion that affected her psyche as well. Medical investigation exiles the human body, separates it as a site of experience from the observing mind – an experience that Hatoum never ceases to convey to the viewer of her works in a particularly physical manner.

Petra Löffler

1 **Untitled (Wheelchair),** 1998. Stainless steel and rubber, 97 x 50 x 84 cm
2 **Corps étranger,** 1994. Video installation with cylindrical wooden structure, video projector, amplifier, four loudspeakers, 3.5 x 3 x 3 m
3 **Continental Drift,** 2000. Stainless steel, glass, iron filings, electric motor, 33 cm (h), diameter 4.2 m

Barbara Hepworth

* 1903 in Wakefield, Yorkshire, England; † 1975 in St Ives, Cornwall, England

"The sculptor must search with passionate intensity for the underlying principle of the organisation of mass and tension – the meaning of gesture and the structure of rhythm."

The exceptional case

Barbara Hepworth was asked in 1950 to represent Britain at the Venice Biennale, an outstanding achievement for any artist. Henry Moore had shown there two years previously and both she and Moore were part of an extraordinary group of British sculptors who would dominate the world stage in the immediate post-war years.

During her early years as a sculptor, Hepworth made representational work in stone of figures and animals, often exhibiting with her first husband, John Skeaping. In 1931, she met the painter, Ben Nicholson, whom she later married. Together they worked towards an art of complete abstraction, making close contact with artists in Paris, particularly Georges Braque, Constantin Brancusi and Piet Mondrian. An early abstract work from this period is *Three Forms,* 1935, which is also typical of her long-lasting fascination with multiple forms and their spatial relationships. From 1936–1939 Hepworth and Nicholson were at the centre of an important group of Modernist artists, resident in Hampstead, London, including Henry Moore, Naum Gabo and Piet Mondrian.

In 1939, when war broke out in Europe, Barbara Hepworth and Ben Nicholson moved to a small fishing port in Cornwall called St Ives. Artists had long been settling in St Ives, drawn there by large, relatively inexpensive studios, the dramatic Cornish landscape and the wonderful quality of light found on a peninsula. Hepworth fell in love with Cornwall and St Ives was to be her home for the rest of her life. Her work changed in response to her new environment and she became interested in the ancient standing stones found in the region, the sea and the dramatic landscape around her. All of these elements made their presence felt in her work almost straight away and her sculpture became less austere after her move from London.

Hepworth's first love was carving and she made work in a wide variety of interesting materials, including woods such as walnut, teak and mahogany and stones such as marble and alabaster from Italy, as well as Cornish slate. Although she had experimented and made a few works in metal already, it was not until the 1950s that she began seriously to start exploring the potential of this material. In the mid-1950s she became interested in sheet metal, making constructed forms and, in 1956, she began to make bronze casts from her original carvings. *Spring,* 1966, is typical of this method of working and it was cast from an original elm carving Hepworth had made in the previous year. Casting enabled her sculpture to be shown out of doors and reach a much wider audience. It also

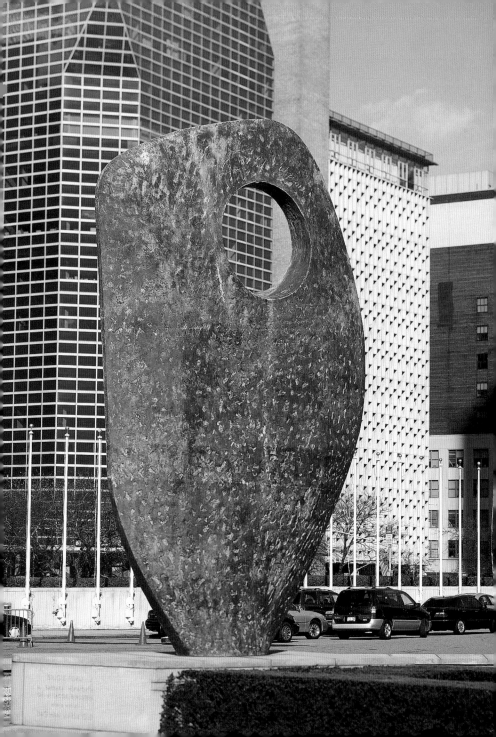

2

3

allowed her to work on large-scale public commissions. Her most important public sculpture *Single Form,* 1963, stands outside the United Nations in New York. It was unveiled in 1964, as a memorial to Dag Hammarskjöld, the UN Secretary General, who had become a personal friend. After this commission and on her return to St Ives, Hepworth immediately went back to carving and completed *Pierced Monolith with Colour,* 1965. It was a personal piece and remained in her garden at St Ives until her death.

Barbara Hepworth received many honours and became a Dame of the British Empire in 1965. She also held many honorary degrees and served as a Trustee of the Tate Gallery from 1965–72. Like Henry Moore, Barbara Hepworth came from the North of England and she was always proud of her Yorkshire roots, despite her deep attachment to Cornwall. She was a small woman and totally dedicated to her art, much of which was very physically demanding. Hepworth had a very personal relationship with all the materials she used, carving everything herself and using assistants only for the bronzes and the largest works. As a result, her output is not huge compared to some of her contemporaries, but in terms of diversity of scale, form and material it is almost unrivalled. Her aim in life, in her own words, was to make "as many good sculptures as one can before one dies".

A Pictorial Autobiography

Despite an almost total immersion in her work as a sculptor, family life was vitally important to Hepworth. She had four children, a son from her first marriage to John Skeaping and triplets, a son and two girls, with Ben Nicholson. Her children played a central role in her life and, in 1970, she compiled and published *A Pictorial Autobiography* which contains many photographs of her children and grandchildren interspersed amongst images of her work, photos of Cornwall and the people and places that inspired and influenced her. It is a document that very much reflects how Hepworth saw herself and the world and explains how deeply entwined her art was with her life.

Hepworth died suddenly in a fire in her studio in 1975. Trewyn Studio in St Ives, where she had lived for almost 30 years, is now a museum run by the Tate Gallery. Her work can be found in all the most important museum collections in the world and she is particularly well represented in the collections of Leeds and Wakefield City Art Galleries, the Scottish National Gallery of Modern Art in Edinburgh, the Tate Gallery, London, the Rijksmuseum Kröller-Müller, Otterlo, the Netherlands and the Art Gallery of Ontario, Toronto, Canada. Today, Barbara Hepworth is regarded as one of the most important British sculptors.

Helen Simpson

1 **Single Form,** 1963. Bronze, (h) 6.40 m. Work commissioned by the Jacob and Hilda Blaustein Foundation for the United Nations, New York (NY), USA
2 **Three Forms,** 1935. Serravezza marble, 20 x 53 x 34 cm
3 **Spring,** 1966. Bronze, 85 x 57 x 53 cm

Eva Hesse

* 1936 in Hamburg, Germany; † 1970 in New York (NY), USA

"I try my hand at the most absurd and extreme contrasts. That has always been more interesting for me than something normal with the right height and proportions."

An unknown quantity in art, an unknown quantity in life

Born in Germany, Eva Hesse grew up in New York, emerging as one of the most innovative and influential artists of the 1960s. In the brief period from 1965 to 1970 alone, her sculptural output numbered some 70 works. In this body of work she addressed and reinterpreted the paradigms of Pop Art and Minimalism, then the dominant movements in art – serial production, repetition, grids, the cube, the use of industrial materials and methods of production. The elusive impact of Eva Hesse's work partly derives from her use of soft, flexible, often translucent materials, either organic or seemingly so, such as fibreglass, resin, latex and rubber, synthetic tubing, and cord. They may be aesthetically appealing, indeed beautiful (a quality Eva Hesse was wary of), but they may equally suggest matter evacuated from the body. The reactions of those who visited her shows give a good indication of just how involved people felt with her work, both psychologically and physically. For instance, an early version of *Accession*, 1968, a galvanised steel cube open at the top, with innumerable short rubber tubes resembling hair on the inside, was wrecked when people tried to climb into it. Photographs show the artist herself interacting with her work: in one picture, she is seen stroking the inside of *Accession II*, 1968, while in another she is lying on a couch and her body is covered with tangled cord – a humorous self-display that, to judge by Hesse's smile, evidently alludes to the ritual of a psychoanalytical session.

Eva Hesse saw herself as an artist from an early age. At 16 she was already writing to her father: "I am an artist. I guess I always feel and want to be a little different from most people. That is why we're called artists." She studied applied art from 1957 to 1959 at the Yale School of Art and Architecture, where German émigré Josef Albers was on the teaching staff. But while Bauhaus veteran Albers was all for strictly rational and systematic painting, Hesse's approach to the medium was more subjective, and coloured by Abstract Expressionism, as a number of self-portraits dating from around 1960 show. Willem de Kooning, Arshile Gorky and Jackson Pollock were among Hesse's major influences. But if she invariably felt painting to be a difficult, intractable affair, her output in drawing was all the more copious. The decisive breakthrough in her career – the change to three-dimensional work – did not occur while she was in the New York art milieu, however; it came in 1964–65 during a fourteen-month stay in Ger-

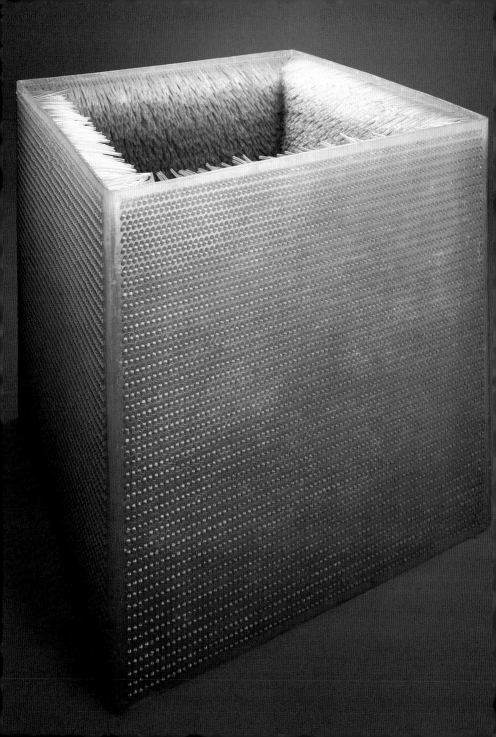

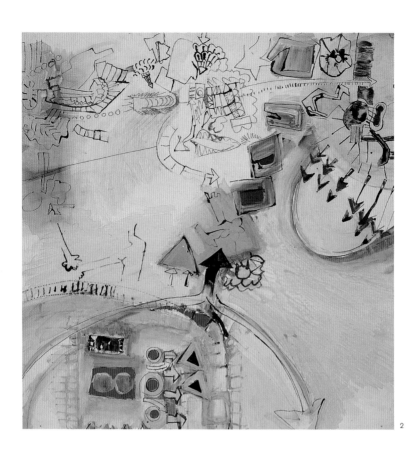

2

3

many. The textile manufacturer Arnard Scheidt, an art collector, had invited Hesse's husband, American sculptor Tom Doyle, to use a factory building at Kettwig an der Ruhr as a studio. During that period, Hesse not only produced a large number of graphics surrealistically combining the mechanical and the organic, but also made 14 reliefs that were exhibited at the Kunsthalle in Düsseldorf in 1965. They were structured on rectangular fibreboard panels using plaster, papier mâché, and textiles such as cord or string, and then painted. A number had elements implying movement into the surrounding space, such as the violet cord in *Up the Down Road*, July 1965. The title is typical of the suggestive hint of paradox often found in Hesse's titles. It might be a pointer to a personal crisis recorded in Hesse's diaries, but equally it might register a fundamental unease at returning to the country which perpetrated the Holocaust, from which Hesse and her parents had fled in 1939.

Eva Hesse's return to New York in 1965 marked the beginning of her established phase as a sculptor. One of her most significant statements of the period was *Hang Up*, 1966, an outsize, empty frame structure wrapped in bandages, with a steel wire attachment or peg extending outward. In her last interview, given to Cindy Nemser in 1970, Hesse described *Hang Up* as one of her best works: "It was the first time where my idea of absurdity or extreme feeling came through." Like many of her later works, it is difficult to determine whether it is a picture or sculpture. The same is true of *Contingent*, 1969, eight cotton cloths steeped in latex and hung parallel, at right angles to the wall; or of *Right After*, 1969, an arrangement of fibreglass cords dipped in resin and hung from hooks in the ceiling. The title *Right After* refers to the making of this work after an operation for a brain tumour, which in fact killed her in May 1970.

The martyr of art

Eva Hesse's diaries, which were made public soon after her death, and the need of art criticism to have its martyr, led to an Eva Hesse myth. For a long time it was the tragic aspects of her life story – the suicide of her mother, the early death of her father, the failure of her marriage, and her own physical and mental state – that dominated interpretation of her work, which tended to be seen as the expression of specifically female experience. In 1994, though, Tom Doyle encapsulated a quite different political factor governing Eva Hesse's life and work in the following startling words: "The artist who had the most influence on Eva was Adolf Hitler." Recent studies, such as *Another Hesse* by American critic Anne M. Wagner (from which Doyle's quotation has been taken), give a more balanced account of the complex artistic, social and historical influences, relations and meanings of Hesse's work.

Barbara Hess

1 **Accession III,** 1967/68. Fibreglass, plastic tubes, 80 x 80 x 80 cm
2 **Untitled,** 1963. Watercolour, gouache, Indian ink on paper, 57 x 57 cm
3 **Repetition Nineteen III,** 1968. Fibreglass, polyester resin, 19 parts, each c. 50 cm (h), diameter c. 30 cm

Hannah Höch

* 1889 in Gotha, Germany; † 1978 in Heiligensee, Berlin, Germany

"I should like to erase the fixed boundaries that we self-assured humans like to draw around anything we can achieve."

Hannah Höch triumphs!

"Dada triumphs!" This slogan was used by Hannah Höch, pioneer of photomontage and a member of the Berlin Dadaists from 1917 to 1922, in her famous collage *Schnitt mit dem Küchenmesser durch die letzte Weimarer Bierbauchkulturepoche Deutschlands* (Slash with the Kitchen Knife through the final Weimar Beer-Belly Cultural Epoch of Germany), 1919. The Dadaists' satirical declaration of victory was an attack on Europe's woeful social and political condition in after the First World War. They used the aesthetic weapons of collage and photomontage as an (anti-)artistic means of shocking the public and thus as a way of deconstructing a situation considered absurd.

Hannah Höch grew up in a middle-class home in the small town of Gotha in Thuringia, and, in 1912, began studies at the College of Applied Arts in Charlottenburg, Berlin. From Höch's point of view, this was a compromise: "All my dreams had been focused on the Academy, but I did not dare make known my wish to go there", she remarked later in her autobiographical *Lebensüberblick*, 1958, commenting on her true ambition to become a painter. The outbreak of the First World War in August 1914 (at which time she was in Cologne at the Werkbund exhibition) signalled the collapse of Höch's "hitherto well-tempered view of the world". In 1915 she returned to Berlin and entered the graphic art class taught by Emil Orlik at the State Museum of Applied Arts. That same year she embarked on a seven-year relationship that was to last seven years, with writer and artist Raoul Hausmann, through whom she was introduced to a number of artist's groups, among them the Expressionists (with their focal centre at Herwarth Walden's gallery and publishing house, Der Sturm), the Italian Futurists, and the Dadaist circle that was constituted in 1917, including Richard Hülsenbeck, Johannes Baader, George Grosz, John Heartfield and Wieland Herzfelde. Despite their anarchic-cum-revolutionary stance, the Berlin Dadaists were in fact something of a gentlemen's club with a patriarchal profile, in which the presence of women remained the exception. Höch was indeed the only woman artist included in the First International Dada Fair at Otto Burchard's Berlin gallery in 1920. Among the items she exhibited there was the photomontage *Schnitt mit dem Küchenmesser* (Slash with the Kitchen Knife…), which not only slashed Weimar's beer-belly culture, as the title promised, but also targeted the social situation of women: a map showed which European countries had given women the vote, while in her montage of men's and women's bodies Höch subverted unambiguous images of gender identity. The broader political statements made in the work are even

1

2

clearer: at the bottom left, together with photographs of crowds and Höch's initials, are the heads of Dadaists and of Marx and Lenin, while at the top right, over the words "The Anti-Dadaist Movement", are portraits of Friedrich Ebert, Kaiser Wilhelm II, Field Marshal Hindenburg, and other military leaders. In the centre of the composition is Käthe Kollwitz, the first woman to be made a member of the Academy of Arts, in 1919; her portrait seems virtually suspended over the body of dancer Nidda Impekoven, who personifies the self-confident, financially independent New Woman of the 1920s. The material Höch used, both pictorial and textual, came in part from technical brochures or private photographs, but in the main was taken from illustrated magazines. This was a medium Höch was steeped in, not only in her work as an artist, but also in her professional work as a graphic designer for the publishing house Ullstein from 1916 to 1926. The montage *Meine Haussprüche* (My Domestic Mottoes), 1922, juxtaposed excerpts from handicraft patterns such as Höch was producing at the time with photographs of machine parts, portraits, children's drawings, and quotations from authors as various as Hülsenbeck, Baader and Hans Arp, Goethe and Nietzsche. This work was made at the time when the Berlin Dadaists went their separate ways, and Höch and Hausmann similarly separated – the names of Arp and Kurt Schwitters signalled her new artistic affinities.

In the post-Dada period, Höch continued to extend the potential of collage and photomontage, both formally and in terms of content. Her work in the 1920s included *Mischling* (Half-Breed), 1924, and series such as *Aus einem ethnographischen Museum* (From an Ethnographic Museum), 1925–29, which deconstructed clichéd images of ethnic and sexual identity and remade them in a ludic spirit. Though Höch remains primarily known to this day for her photomontages, she also produced a substantial and stylistically diverse body of work parallel to these: there are pictures in which the montage principle was imported into painting, for instance, and there are also surprising surreal tableaux, still lifes in the manner of the New Objectivity, and expressive portraits.

Surviving the Nazi era

In the 1930s, Höch found herself under mounting pressure from official arts policy in the Nazi Third Reich, a dilemma that found expression in various works. The (pre-Reich) collage *Dompteuse* (Trainer), 1930, not only expressed private conflict with her partner of many years' standing, the Dutch woman writer Til Brugman, but also (in the uniform-like clothing worn by the figure) articulated a sense of political menace. A number of her artist friends left the country after the Nazis came to power, but Höch, though lambasted as a "cultural Bolshevik" and banned from exhibiting, remained in Germany, in "inner emigration". In mortal danger, she created an archive of Dadaist work in her home on the outskirts of Berlin, and it was this that made the group's rediscovery after the Second World War feasible.

Although Hannah Höch began exhibitioning again in galleries in 1946, and was included in international Dada retrospectives, it was not until the major 1971 show of her work at the Academy of Art in Berlin that her achievement became an object of closer scrutiny and interest. Even so, Höch has time and again been reduced to her role as of Raoul Hausmann's partner, seen as a "fairy" (Eberhard Roters), "the Sleeping Beauty of Dada" (Heinz Ohff) or the "indispensable worker-ant" (Hans Richter) of the Dadaists. Not until the 1980s did feminist art history take a subtler, more careful view of Höch's complex and committed work.

Barbara Hess

1 Schnitt mit dem Küchenmesser durch die letzte Weimarer
 Bierbauchkulturepoche Deutschlands, 1919. Collage, 114 x 90 cm
2 Die Braut oder Pandora, 1927. Oil on canvas, 114 x 66 cm

Candida Höfer

* 1944 in Eberswalde, Germany; lives and works in Cologne, Germany

"I photograph rooms the way they are."

Found spaces

"What interests me about spaces is the mixture of different epochs, how different periods represent themselves", stated Candida Höfer in 1998, indicating a key theme of her work: the superimposition of various time levels that becomes evident in the stylistic discontinuities between architecture and interior decoration. Since 1979, Höfer has been photographing public and semi-public interiors – waiting rooms, hotel lobbies, spa facilities, banks, churches, theatres, university auditoriums, libraries, archives, museums and, since 1990, zoos. With a sure sense of the coexistence of the anachronistic, her images capture bizarre and occasionally paradoxical things when the history of a place and its current functions and uses collide. For instance, the modern radiators at the *Musée Antoine Wiertz Brussels I 1985* take on an almost sculptural character; our eye stumbles over a beverage vending machine in the Palladian *Teatro Olimpico Vicenza 1988* or the computer workplaces at the *Deutsche Bücherei Leipzig I 1997* reflect an innovative approach to information and knowledge.

Höfer's photographed interiors are places of transition, but also for the accumulation, storage and organisation of knowledge – locations of the cultural memory, designed for collective use. Yet they very seldom include actual human beings. Human presence is only indirectly sensed in the signs of use visible in the rooms, or in figurative representations in art, such as the mural in *Palacio de los Marqueses de Viana Córdoba 1993*.

The human figure was not absent from Höfer's work from the beginning. In 1972, she began an approximately six-year project called *Turks in Germany,* presented in 1975 in the form of slide projections in her first solo exhibition at the Galerie Konrad Fischer in Düsseldorf, and expanded in 1979 into a dual projection, *Turks in Germany and Turks in Turkey.* The photographs focused on people's relationship to their everyday, usually urban environment, in cities such as Ratingen, Cologne, Düsseldorf and Hamburg. Besides picnic scenes in parks, men sitting in tea rooms, and families at home in their flats, the series included many images of Turkish shopkeepers. Yet as she recalled in a 1989 interview, Höfer ultimately felt like an intruder into these people's private sphere, and hence has since avoided including persons in her photographs.

1

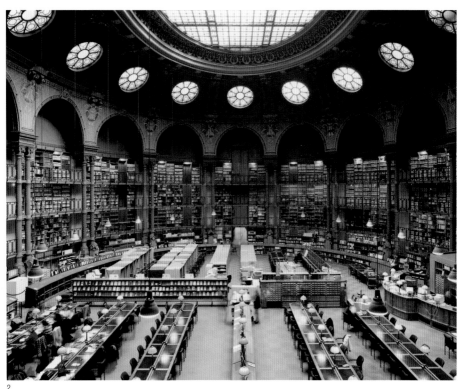

2

Discovered locations

The interest in spatial structures already evident in this early work was further honed by Höfer's attendance of Bernd Becher's photography classes at the Düsseldorf Academy from 1976 to 1982. Yet, unlike the systematic documentary approach of Bernd and Hilla Becher, whose encyclopaedic "typologies" of industrial buildings strive for an utmost objectivity through homogeneous compositions, Höfer's camera positions – and thus the composition of the image space – are determined by the atmosphere of the specific interior. Similarly, her choice of motifs depends on personal preferences and chance opportunities. Still, Höfer does follow a consistent aesthetic principle: she photographs existing locations and situations largely without altering them, and works solely with the given light sources. Here, the principle of series and repetition becomes crucial. Elements that repeat themselves, like the window band and rows of lamps leading the eye into the background in *Abbey Mountain St. Benediktusberg Vaals II 1993*, the reading tables in *British Library London I,* 1994, the coat racks in *Mirabelle Palace Salzburg IV 1996,* or the minimalistic seating arrangements in the new *Bibliothèque Nationale de France Paris III 1998* articulate and lend rhythm to the pictorial space. They make visible the regulatory force of three-dimensional organisation and the architectural parameters that assign objects and persons their place within the overall structure.

Public places

Many of Höfer's photographs are devoted to libraries and museums, institutions in which Western notions of order in cultural history are categorised, administered, stored and displayed. The camera again and again captures situations illustrating the artificial nature of this system of order. In *Koninklijk Museum voor Schone Kunsten Antwerp II 1991* for instance, the eye is drawn to the scaffolding being used for renovation work in the farthest corner of the museum room; or, in *State Museum of Natural History and Prehistory Oldenburg I 1998,* we gaze into the depot with its countless stuffed birds closely packed on plain white cabinets. In *Museum of Ethnology Dresden IV 2000,* Höfer takes us into the museum workshop, where varicoloured pedestals form a random arrangement. These things, relatively unimportant apart from their purpose of displaying museum items, become display objects in their own right, pointing up the meaning-engendering aspect of the pedestal.

Höfer subtly employs this insight into the power of presentation in her own choice of formats and the arrangement of her exhibitions. For instance, the medium-format photographs of interiors in a trendy American hotel shown at Johnen & Schöttle in summer 2000 were hung not at eye-level but at waist-level, thus augmenting the suggestiveness of the images by emphasising the body axis and physically drawing the viewer into the image. The "placement of the exhibits" thus takes on dual meaning – as the object of aesthetic interest, as Höfer pointed out in 1989, and as a working principle.

Astrid Wege

1 **Festspielhaus Recklinghausen I 1997.** C-print, 120 x 120 cm
2 **Bibliothèque National de France Paris XXIV 1998.** C-print, 60 x 75 cm

Jenny Holzer

* 1950 in Gallipolis (OH), USA; lives and works in Hoosick (NY), USA

"It's women who've been doing the most challenging art in the last decade. Psychologically seen, their work is much more extreme than men's."

Message en passant

Employing the medium of the word, Jenny Holzer gives expression to messages, statements, theses and antitheses on the subject of taboos, sex, violence, love, war and death. While she was a student, she was oriented towards abstract painting, but her aim was nonetheless to convey content and present her themes to the public eye. Initially, therefore, she wrote explicit texts on abstract pictures. In 1977, she moved to New York and has since concentrated on the medium of language. In the same year, she began her first series, called *Truisms*, printing one-liners in capitals on T-shirts and posters that she fly-posted throughout the city. Almost unnoticed, she attached her messages to telephone boxes, parking meters and house walls. The 40 to 60 sentences contained in each work were arranged alphabetically. They read like truisms or gawky statements about social conditions, politics, everyday life, violence and sexuality, and brought the reader up short, prompting him to reflect. The Anglo-American tradition of Speaker's Corner, the specifically American narrative tradition, and superficial *Reader's Digest*-style opinion-forming were as much Holzer's model as the conceptual art of Lawrence Weiner or Joseph Kossuth. But at first she did not feel she was an artist, seeing her activity instead as part of the agitprop tradition.

Between 1979 and 1982, Holzer created another series of posters. However, unlike *Truisms*, the texts of *Inflammatory Essays* were no longer a series of successive statements, but pamphlets or aphorisms – short structured texts consisting of just a few sentences inspired by the writings of Hitler, Lenin, Mao and Trotsky as well as other political figures and philosophers. In 1980, Holzer began a series of text panels made of bronze or some other metal whose inscriptions were executed in large lettering. She put up the panels besides the brass plates of doctor's surgeries or even gallery signs. This *Living Series*, up to 1982, was not so much in pursuit of 'great political ideas', but scattered everyday first-person messages and instructions, injunctions or advice aimed at an unspecified 'you'. Thanks to the inconspicuousness of the medium, noticed casually en passant, combined with the violence of the words, Holzer momentarily caught the attention of passers-by with her messages. She was exploiting advertising methods in the urban environment both to counter sanitised phraseology and put across her own message. At first, she made no use of artistic settings for this.

Her real breakthrough came in 1982, when she presented her sentences to the public in the form of constantly changing messages on an LED display in New York's Times Square. Borrowing from *Truisms*, one statement followed another, the best-remembered being "Protect me from what I want". Holzer used the display's ever-chang-

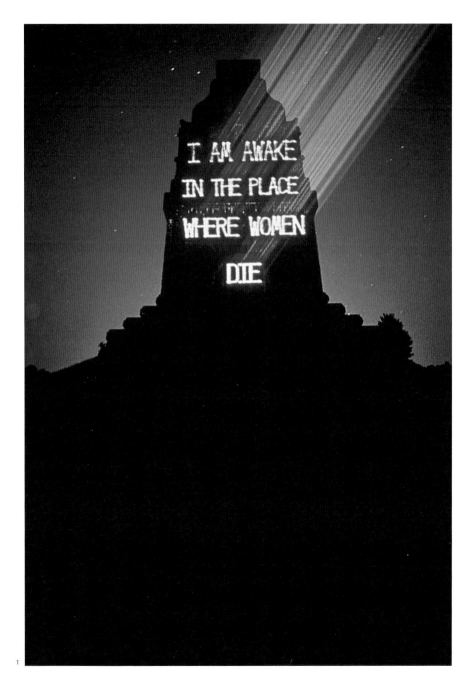

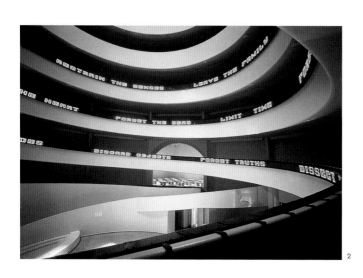

2

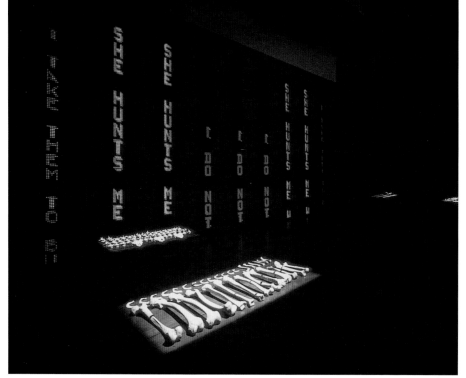

3

ing text to pile thesis on antithesis, thereby intensifying the provocative force. From now on, she worked in this advertising medium in a variety of places, such as football stadia, banks (interspersed with stock market news), and the forest of signs in Las Vegas. In such locations, she often sought the close proximity of ordinary advertising and neon signs to exploit the contrast with them.

Survival messages

Between 1983 and 1985, Holzer worked on her *Survival Series*, which she presented on various combinations of LED monitors, small-format electronic displays, and photographic light tables. The contents of the new series were more complex than before, and the language more aggressive. In addition, the works' humanitarian assumptions and stance caused them to appeal to the reader, an example being: "Go where people sleep and see if they're safe." In such advertising vehicles, Holzer had found a medium that she could also exhibit in museums and galleries, although its effect here was much more muted than in the outside world.

Departing from the rapidly changing illuminated texts, in 1986 Holzer developed benches made of stone with texts carved into them, where exhibition visitors could sit down. She called these exhibition items inviting rest and contemplation *Under a Rock*, and they were later shown not just in exhibitions, but also in sculpture parks. The following year she did some sarcophagi made of granite, which were likewise inscribed. When she took part in documenta 8 in 1987, she used in her installation narrow coloured strips of light for the first time, whose letters ran individually from top to bottom or vice versa. In 1990, she hit the headlines at the Venice Biennale when – as a new mother – she was the USA's sole female artist, showing a work about the mother-child relationship, and her pavilion received the accolade of best national display.

Bloody news

In 1993, the year the Bosnian war was in full spate, Holzer had the message "Where women die, I am wide awake" printed in ink mixed with the blood of Bosnian women on the front cover of the magazine of the *Süddeutsche Zeitung*, which triggered public outrage. With this action and the photo series *Sex Murder*, 1993/94, where she wrote individual sentences on the women's skin, Holzer wanted to draw attention to the numerous rapes and sexual murders in Bosnia. Holzer is passionate about human rights and the rights of women.

In 1996, she used lasers to project location-specific texts on the battlefield memorial to the 1813 Battle of Leipzig. In the same year, she did the *Arno* project for the Florence Biennale: text images were beamed at night by xenon projection on embankment walls and nearby houses, and reflected in the river. Holzer always updates her range of media and works with the latest technologies, so that her response is appropriate and contemporary. She is thus already using three-dimensional LED displays, generating computer graphics for a cyberspace installation, and developing spots for the music channel MTV. But irrespective of the medium, her messages always pack an emotional punch, provoking the reader to stop and think.

Ulrike Lehmann

1 **Kriegszustand,** Leipzig Monument Project (Völkerschlachtdenkmal). Laser projection. Outdoor installation,
 Galerie für Zeitgenössische Kunst Leipzig, Leipzig, Germany, 1996
2 **Various texts,** 1990. LED sign, 160 m x 36 cm x 10 cm. Installation view,
 Solomon R. Guggenheim Museum, New York (NY), USA
3 **Lustmord,** 1993/94. Nine LED signs, c. 300 bones with rings, each LED display 452 x 25 x 11 cm.
 Installation view, National Gallery of Australia, Canberra, Australia

Rebecca Horn

* 1944 in Michelstadt, Germany, lives and works while simultaneously travelling

**"What I am interested in is an object's soul,
not its mechanical trappings."**

A journey into the interior of the body

When Rebecca Horn was a young girl, her father told her fairy tales of witches, goblins and dragons, setting the scene of the action in their own vicinity, the Odenwald in Hesse. Since that time, Horn has suffered from great anxiety. Another key experience occurred during her schooldays: at junior school she had to take her turn, like all the other children, at leading prayers, but did not know how to do so. Her anxiety became so great that she lost control of her bladder, and consequently was punished. After being sent to boarding school, she ran away – accompanied by the fear that witches would pursue her. Subsequently she received private tuition from a blind professor in France. At her father's wish, she began reading economics and philosophy at college, but after six months began attending the Art School in Hamburg – at first secretly.

In 1967, Horn created her first sculptures, made of polyester and fibreglass. She seriously damaged her lungs while inhaling the polyester fumes produced during the work. While recuperating in a sanatorium, she searched for possibilities of communicating with others, despite her isolation. The result was a number of drawings and her first body sculptures made of cloth and bandages, borne by the wish to communicate via her body. Her ill health stood in the way of a career as an art teacher, so she decided to become an artist. Since then, her sculptures, performances, films, photos and installations have worked around a number of key episodes from her childhood, along with her anxieties, such as claustrophobia, fear of flying or her reluctance to wear gloves, and also contemporary biographical, political and historical events.

1970 saw the creation of Horn's *Der Überströmer* (The Overflower) – in which transparent tubes filled with red liquid were draped like a gown over the naked body of a man to look like an external circulatory system – and *Das Einhorn* (The Unicorn). In the latter piece, the artist had an oversized pointed wooden pole made and attached it like a horn to the head of a naked woman, who then performed a rehearsed "trance journey" through a backdrop of woods and fields. These works, which isolate their wearers and focus on mental and physical affliction, as well as on sensual and erotic experiences, were termed by Horn "personal art". This performance, which the artist filmed on cinefilm, led to her invitation, in 1972, to the documenta 5 at Kassel. Between 1968 and 1974, she developed sculptures that were tailored to people's bodies, such as *Die Bleistiftmaske* (Lead Pencil Mask), and *Handschuhfinger* (Glove Finger), both 1972, as well as mechanical fans made of feathers or fabric, which were tied onto and moved

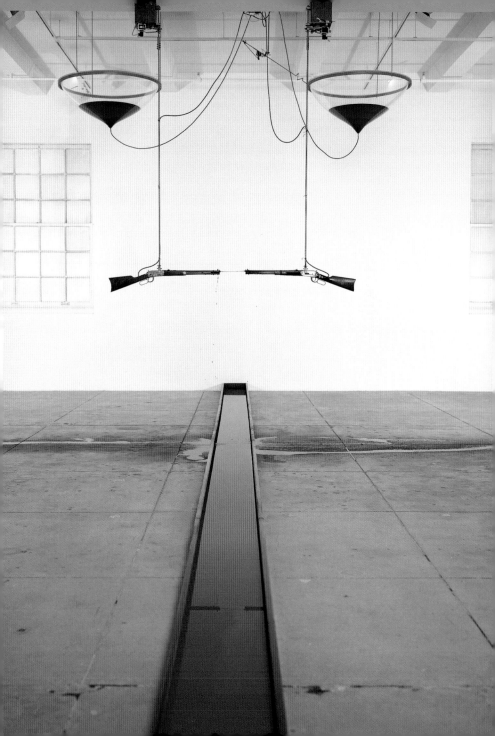

2

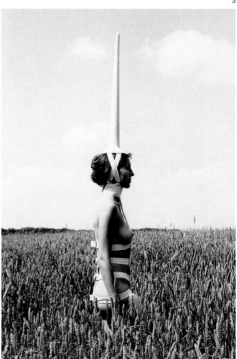

3

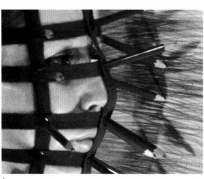

4

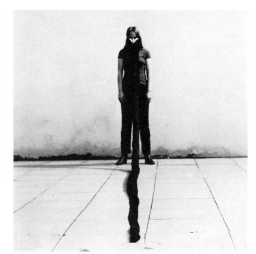

5

by people's bodies. These body sculptures were the protagonists in Horn's performances, which she documented in films, videos and photos. Akin to 1960s Body Art, but unlike Happenings, Horn's actions bore a resemblance to initiation rites. Performed without an audience, they were marked by an extreme perfectionism that left nothing to chance.

Her *Chinesische Verlobte* (Chinese Fiancée) of 1976 – a darkened room in which singing voices could be heard – heralded a new period in her work, in which Horn placed her performances in larger epic contexts as cinematic stories, leading her to become a film-maker. Her first film appeared in 1978, *Der Eintänzer* (The Taxi Dancer), in which a blind man (a reference to her blind professor) learns the tango, and a round mechanically-driven table likewise "dances". For this and further feature films, such as *La Ferdinanda*, 1981, and *Buster's Bedroom*, 1990, she created mechanical props and body sculptures, which play their parts on an equal footing with the actors, and have come to be included in important collections as artworks in their own right. Notable examples are the *Pfauenmaschine* (Peacock Machine), 1979/80, made with white feathers, the *Dialog der Silberschaukeln* (Dialogue between the Silver Swings), 1979, or the motor-driven wheelchair whose extended mechanical arm raised the whisky glass to Geraldine Chaplin's lips in the film *Buster's Bedroom*.

Mechanical sculptures

Time and again, feathers, tubes and funnels flowing with coloured liquids appear in Horn's work, but also alchemists' materials, such as mercury or salt, or sulphur and charcoal, as for instance in *Hybrid*, 1987. The central themes of these works are the flow of life, genesis, the passage of time and eventual decay, but also heaviness and lightness. Her mechanical sculptures and apparatuses made of everyday items – knives, scissors, suitcases, eggs, metal poles, a blind man's cane, feathers, violins or brushes – conjure up life, without actually being alive themselves. They visualise mechanisms and feelings deeply rooted in life, such as power, struggle, isolation, threats, as well as liberty and eroticism. Horn's poetic objects develop a life of their own, taking a resolute stand with regard to personal, historical and societal occurrences, as in *Chor der Heuschrecken* (Locust Chorus), 1991, about the Gulf War. Other examples include her no less impressive installation *Gegenläufiges Konzert* (Contrary Concert), 1987, set in the old kennels of Münster, in which the persistent beating of a small hammer summoned memories of the Nazis' torture methods and acts of violence; or her piece involving an entire schoolroom in Kassel during documenta IX, *Der Mond, das Kind, der anarchistische Fluss* (The Moon, the Child and the Anarchic River), 1992, in which school benches were hung from the ceiling and connected by lead tubes and funnels – a piece in which she worked through experiences from her junior school days.

Horn's other sculptures and installations similarly place familiar objects in unfamiliar contexts. They are brought into action and at the same time enter into a dialogue with other objects: brushes splash paint on the walls, violins play a concert on their own, a pair of scissors hangs just above an egg, knives stand erect and menacingly beneath brushes, tubes with coloured liquids snake through the room like the arteries in a body. Funnels drip, a stack of hospital beds stands in the middle of a room on rickety legs, and a piano suspended upside down from the ceiling from time to time allows its keys to hang out like so many tongues.

Even when the viewer is unfamiliar with what exactly has prompted Horn's works, her mysterious objects, machine sculptures and everyday utensils penetrate, with their collective archaic symbolism, deep into that person's consciousness, giving him or her a feeling of pensiveness and discomposure. Rebecca Horn's works, which are just as much inspired by Raymond Roussel's 1914 novel *Locus Solus* and by the "consciousness machines" described in it, as they are by Oscar Wilde, Marcel Duchamp and the Surrealists, impress us with their compelling imaginativeness, precision, and effective language and symbolism.

Ulrike Lehmann

1 **High Moon,** 1991
2 **Pfauenmaschine,** 1982. Installation view, documenta 7, Kassel, Germany
3 **Einhorn,** 1970
4 **Bleistiftmaske,** 1972. Film still
5 **Rüssel,** 1968

Frida Kahlo

* 1907 in Coyoacán, Mexico; † 1954, in Coyoacán, Mexico

*"My painting is not revolutionary.
Why should I delude myself that
it is informed by a fighting spirit."*

"I never painted dreams"

Frida Kahlo found a universally comprehensible visual language somewhere between naivety, realism and surrealism. The internationally acclaimed oeuvre of this Mexican artist, born in 1907, comprises almost 200 works, most of them small-format self-portraits. These, like both her still life studies of fruit and her animal portrayals, are highly expressive and precisely detailed paintings. As often as not, her works bear harrowing witness to her own physical and mental suffering with a disturbing immediacy that makes them unforgettable.

As a child, Kahlo was confined to bed for nine months after contracting polio, which left her with a slightly malformed foot. At the age of 18, she was involved in a road accident, when the bus she was travelling on collided with a tram. She was impaled on a metal rod and suffered fractures of the spine, pelvis and legs. After a month in hospital, she had to wear a plaster corset for a further nine months. It was while she was in hospital that Kahlo began to draw and paint – first the accident and then herself. Her first self-portrait, dated 1926, shows her in a heroic pose. It was followed by many more, of which Frida Kahlo later said that she painted herself because she spent so much time alone and was the subject matter she knew best.

Her life was a constant struggle between life and death, a brutal fate that did not cause her to become resigned to her lot, but posed a keen challenge. Kahlo was bedridden for many months of her life, and in two drawings, *The Dream* or *Self-Portrait in a Dream I* and *II*, both 1932, as well as in her oil painting *The Dream* or *The Bed*, 1940, she presents herself lying in bed. It is a four-poster bed with a baldachin hovering in the clouds. On the baldachin lies a human skeleton, similar to the traditional Mexican figure of Judas, of which Kahlo owned some examples. The visual approach in Kahlo's picture goes beyond the level of the dream to enter the world of trauma.

Kahlo underwent repeated hospitalisation and operations. Within the space of a single year (1950), she had five toe amputations, various bone transplants and seven operations on her spine. After a leg amputation in 1953, she was confined to a wheelchair. In her short life of just 44 years, she had to come to terms with enormous physical suffering. Her self-portrait *The Broken Column*, 1944, is a harrowing image of Kahlo in a steel corset, with the fractured column symbolising her injured spine. Because of the accident, she was unable to bear a child. Her three miscarriages or abortions and her unfulfilled wish for children are addressed in such works as the lithograph *Frida and the Miscarriage*, 1932, and the oil painting *My Doll and I*, 1937.

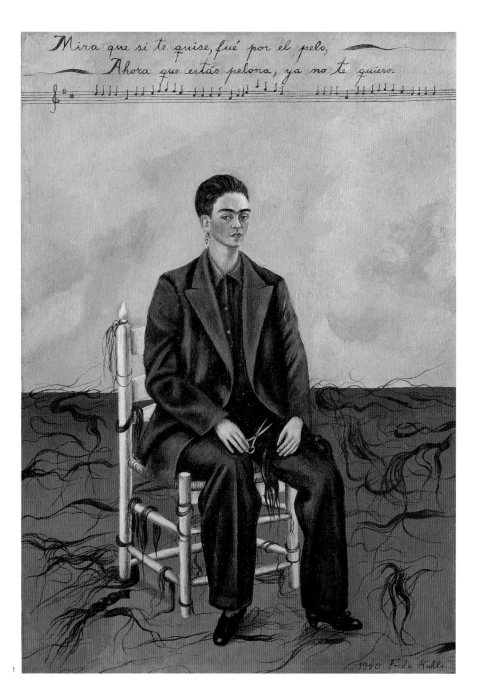

2

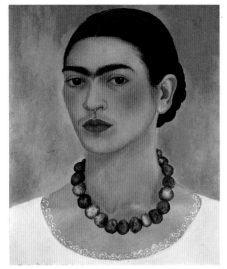

3

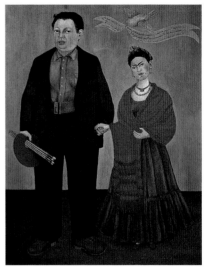

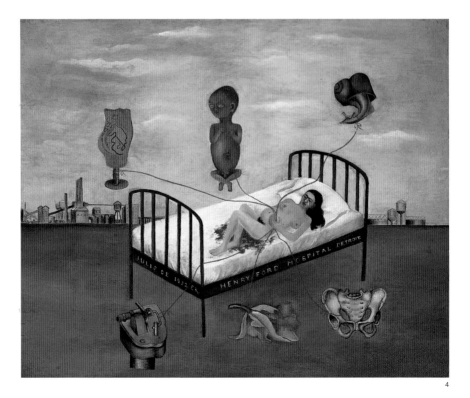

4

Art for life

In 1929, Frida Kahlo married Diego Rivera. Both were members of the Communist Party. Rivera, whose popularity in Mexico bordered on hero-worship, was an artist best known for the monumental wall paintings he created for the Communist regime. Between 1930 and 1934, Kahlo and Rivera lived in the USA, where Rivera had been commissioned to execute a number of works. For Kahlo, Rivera was an anchor and "the universe". One of her paintings is even entitled *The Loving Embrace of the Universe, the Earth (Mexico), Myself, Diego and Mr Xólotl*, 1949. Rivera was an unfaithful husband, whose affairs included a relationship with Frida's sister Cristina. They divorced in 1939, only to remarry at the end of 1940. Her physical sufferings were compounded by profound emotional pain. Yet, even though Frida Kahlo repeatedly confided her death wish to her diary and actually attempted suicide on more than one occasion, her painting did help her to come to terms with her situation and experiences. Her famous double portrait, *Two Fridas*, 1939, was created shortly after her separation from Rivera. The problem of double identity it explores was superseded a year later by a change of identity, addressed in *Self-Portrait with Cropped Hair*, 1940, created a year after the divorce. She is sitting on a chair, dressed in a suit, the scissors still in her hand.

Frida Kahlo was a self-taught painter who never had any academic training. Her works are painted in a realist and later increasingly surrealist style, and some of them are oriented towards aspects of traditional Mexican folk art, such as the little votive images painted on metal known as *retablos*.

"Happily I wait for the end"

Though Kahlo was in contact with the Paris Surrealists (especially André Breton) and many critics considered her to be one, she herself maintained "I didn't know I was a Surrealist until André Breton came to Mexico and told me so." Yet she did not accept the classification. "I never painted dreams. What I portrayed was my reality." Kahlo's paintings are inner images, realities created from within by outward reality. Even though her art explores her own biography, the spectator can understand and interpret the themes, forms, models and symbols it presents. The uncompromising candour and directness with which she addresses her personal fate in works that tangibly visualise her pain cannot fail to touch the viewer. Although the suffering they speak of is personal, each image stands as an example of a broader and more universal theme.

Ulrike Lehmann

1 **Self-Portrait with Cropped Hair (Autorretrato con pelo cortado),** 1940.
 Oil on canvas, 40 x 28 cm
2 **Self-Portrait with Necklace (Autorretrato con collar),** 1933.
 Oil on metal, 35 x 28 cm
3 **Frida and Diego Rivera or Frida Kahlo and Diego Rivera (Frida y Diego Rivera o Frida Kahlo y Diego Rivera),** 1931.
 Oil on canvas, 100 x 79 cm
4 **Henry Ford Hospital or the Flying Bed (Henry Ford Hospital o La cama volando),** 1932.
 Oil on metal, 31 x 38 cm

Lee Krasner

* 1908 in Brooklyn (NY), USA; † 1984 in New York (NY), USA

"I merge what I call the organic with what I call the abstract."

The action widow legend

Pollock – Krasner, Krasner – Pollock. Two artists, one marriage – and a cliché of art history that is far from doing justice to either of them. In Krasner's case, the oeuvre of her husband, Action Painter Jackson Pollock, who died in an automobile accident on 11 August 1956, long stood in the way of a serious evaluation of her own work. In 1972, in his book *Jackson Pollock: Energy Made Visible*, art critic B. H. Friedman coined a phrase to describe Krasner and other female survivors of the Abstract Expressionists – "action widows". This label impugned Krasner's supposed influence on the art market as administrator of her husband's estate, and suggested her artistic dependency on an idol of post-war American abstract art. And the label still sticks today, in so far as it would seem impossible to write about Krasner without writing about Pollock.

The Pollock legend already arose during his lifetime and was embellished after his death as fast as the prices of his paintings rose – the alcoholic maladjusted *artiste maudite*, "Jack the Dripper", uncrowned king of the New York School with his wild unleashed painting arm. This legend had a lasting influence on critical opinions of Krasner's work. Moreover, after Pollock's death there was a tendency to delete his wife and her painting from her husband's biography entirely. To do justice to Krasner's achievement, then, it will continue to be necessary to unravel the existential and artistic strands of their shared life. The question is not whether, but how, this should be done. There was not only a Krasner, painter and wife of Pollock, but also a painter Krasner *ante* Pollock and an artist Krasner *post* Pollock. As early as 1956, art critic Clement Greenberg stated – contrary to the conventional wisdom – that "even before their marriage her eye and judgement became important in his art, and continued to remain so."

Born into a New York family of immigrants from Odessa, Krasner was raised in the Orthodox Jewish tradition, growing up in Brooklyn. In 1922, she began to study art at Washington Irvine High School in Manhattan, discovered Russian literature, and read Nietzsche and Schopenhauer. Later she attended the Women's Art School at the Cooper Union and took courses at the Art Students League as well as at the National Academy of Design. Linked at this time with the White Russian emigré Igor Pantuhoff, she studied at the City College of New York, working part time as a waitress in a cocktail bar. She met the poet and critic Harold Rosenberg, soon to become a key interpreter of American post-war art, with whom she would share a lifelong friendship and intellectual involvement.

Influenced by Italian Pittura Metafisica, especially by Giorgio de Chirico, in the 1930s Krasner produced paintings such as *Gansevoort I*, 1934, and *Gansevoort II*, 1935. During her attendance at Hans Hofmann's School of Fine Arts (from 1937), she learned much from the German artist about international modern avant-garde and abstract painting, including Matisse and Picasso (*Untitled [Still Life]*, 1938). In 1939, Krasner became a member of

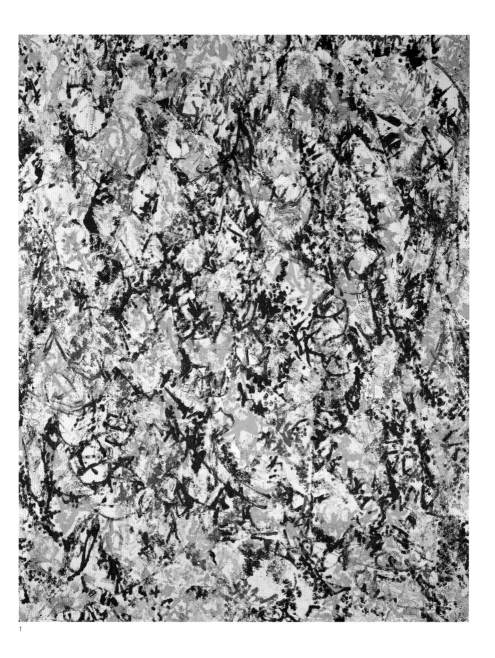

1

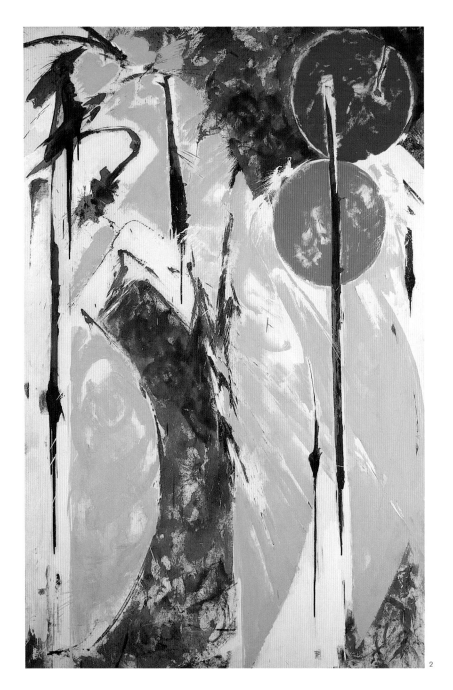

2

the advanced American Abstract Artists group, in which she championed Marxian ideas. The years 1934 to 1943 found her participating in the Works Progress Administration, which led to designs for murals in the Mexican tradition, and also – in 1941 – to some in an abstract idiom. It was also at the end of this year that her encounter with Pollock would have crucial consequences for the development of both. She had already met Pollock before, in 1936, yet at this point Krasner was still much better known than the young, aspiring 29-year-old artist, whom she visited in advance of a joint participation in the exhibition "French and American Painting" in New York (1942). In 1945, Pollock and Krasner were wed. Meanwhile she had introduced him to the New York art scene.

From artistic "black-out period" ...

Krasner once called the years from 1943 to 1946 her artistic "black-out period". Her paintings consisted of layers and layers of brushwork that resulted in grey, petrified-looking surfaces. Like the artist in Honoré de Balzac's story, "Le Chef d'Oeuvre Inconnu", 1831, Krasner was embroiled in a vain search for a balance between intuition and rationality as the basis for the perfect work of art. A more contextually oriented interpretation might find the reason for this crisis, during which Krasner worked as if obsessed, in the horrors of the Holocaust. In terms of art history, she took cues from Newman and Rothko and the tradition of the abstract sublime. By 1946 at the latest, mutual influences had become apparent in Pollock and Krasner's work. Pollock began his "drip paintings" and, in 1947–49, produced the "poured paintings", as Krasner executed her series of *Little Images*, 1946–49. *Abstract #2*, 1946–48, and *Painting No. 19*, 1947/48, translating Pollock's techniques of notation, sign-making, and paint-pouring into more formulaic, calligraphic and hieroglyphic terms. Krasner's painted continuums were more controlled and disciplined, perhaps reflecting her current concern with Surrealist *écriture automatique* and with linguistic systems such as Hebrew and Celtic. *Composition,* 1949, strongly recalled certain works by Paul Klee. Both Pollock and Krasner dispensed with references to reality, and also suppressed the direct trace of the artist's hand. Yet Krasner's approach was more detached, less reflective of the artist's personality and inward mental disquiet.

... her own pictorial rhetoric

Krasner's refusal to imitate Pollock, her attempt to develop her own pictorial rhetoric, became even clearer after Pollock's death, as Anne Wagner points out in her essay "Pollock's Absence, Krasner's Presence". Her paintings were now often built up in a circular manner, the colours muddy, with accents of white or bright magenta – nearly the opposite of the *Little Images*. From the well-nigh frightening *Prophecy*, started before Pollock's accident, through the volcanic *The Seasons*, 1957, *Birth*, 1956, and *Celebration,* 1957/1960, to the sombre *Gate,* 1959, in which Pollock's credo "I am Nature" was thought through and continued beyond his visions, there emerged a number of further major works as Krasner unceasingly questioned her approach and redefined her artistic identity. In 1981, she fell seriously ill. Krasner died three years later, after a career in art that had lasted 55 years.

Holger Liebs

1 **Flowering Limb,** 1963. Oil on canvas, 147 x 116 cm
2 **Invocation,** 1970/71. Oil on canvas, 217 x 142 cm

Barbara Kruger

* 1945 in Newark (NJ), USA; lives and works in New York (NY) and Los Angeles (CA), USA

"Making art is about objectifying your experience of the world, transforming the flow of moments into something visual, or textual, or musical. Art creates a kind of commentary."

Who's talking?

"Why are we shown one picture and not another?" runs one of the slogans that have made the American artist Barbara Kruger known since the early 1980s. The provocative question addressed directly to the viewer indicates the subject areas that Kruger treats in her text + image combinations. She looks at the way violence, power and sexuality are produced and rendered visible by mass media images in our society. Kruger's position assumes a priori that our view of reality, ideas of normality, stable gender roles, and acceptance of everyday violence are constantly recreated and influenced by images and language. Her grainy black-and-white photos reproduce models which are in turn reproductions and mass-distributed. They chiefly involve 1940s and 1950s photo albums, prospectuses and user instructions which spread conservative social clichés and stereotypes in an especially succinct fashion. We find the established role models revived particularly in the Reagan era, when, for example, there was not just a repressive discussion of AIDS (the target of Kruger's *Visual AIDS Project*, 1992), but the achievements of the women's movement, especially women's right of disposal over their own bodies and their reproductive functions, were once more scrutinised. Kruger investigates the voices behind such pictures. Her appeals against the massive anti-abortion campaigns of these years are an example of her role as an activist, which takes the form of conspicuous slogans and a critical questioning of the way females are depicted in images, such as the declaration *Your Body is a Battleground*, 1989.

That Kruger's striking works in public and institutional spaces, her billboards, wall installations, pictorial objects, books and even shopping bags borrow aesthetic strategies from advertising can be explained by her professional development. She grew up in Newark and, in 1964, began to study art at Syracuse University. From 1965, she attended courses at the Parsons School of Design, where her work was particularly influenced by the photographer Diane Arbus and the graphic designer and artist Marvin Israel, a former art director of *Harper's Bazaar*. Her studies completed, she worked at an agency, then for the fashion periodical *Mademoiselle*. Kruger has been an active artist since 1969. When she moved into her loft in New York in 1970, she came into contact with feminist groups at local exhibitions. She was particularly impressed by the large textile wall-pieces of Magdalena Abakanowicz, who incorporates explicitly "female" production methods into her artistic practice, querying the traditional distinction

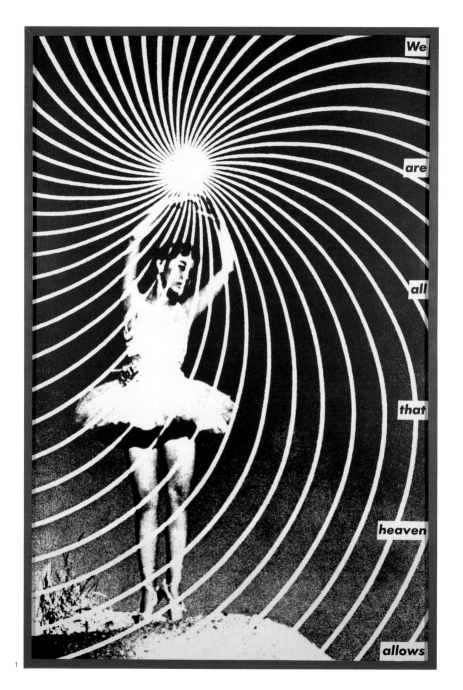

1

between art and craft. During this phase, Kruger also began to write poetic texts of her own, presenting them at poetry readings at, for example, New York's Artists Space, where she had her first solo show in 1974. From 1975 to 1979, Kruger taught at universities and art institutes throughout the country, coming into contact with more recent art concepts and theories, which led her to reconsider her artistic identity and further develop her work. Her artistic production was also influenced by the arguments about the cultural and social determination of female identity, for example in the films of Chantal Akerman, in the work of Mary Kelly and Carol Squiers, or in the films of Sam Fuller and Yvonne Rainer. It is a theme developed in Barbara Kruger's work as a critic.

Artist and critic

In the late 1970s, Kruger began to write for *Artforum* and other publications, mainly about films, television and pop culture. In 1979, she showed her first collage-type pictures in New York's PS1. They consisted of photographed pictorial material intercut with text elements. Initially, individual words such as "nature" or "tradition" cropped up as well as linear elements alluding to, offsetting or commenting on semantic references in the photographic field. Imitating advertising strategies, she developed her own artistic trademark, a kind of corporate identity of black, white and red elements. The texts became more complex and were set in what became her favourite typeface in her work, Futura Bold Italic. The texts' instantly recognisable design and aggressive tone emphasise and reinforce the brutality and graphic force of the visual codes. They focus on the ideological structures of knowledge systems, the main topics being monitoring systems, medicine, representations of the body, sexual identity, emotions, work, power and the misuse of power. In her spatial installations, she uses walls, floors and ceilings as carriers of omnipresent, large-format images and texts, which often cover the entire room, excluding any possibility of "looking away".

"I shop, therefore I am"

In the 1980s, Kruger made a number of sorties into exterior locations, such as the façade of the Museum of Contemporary Art in Los Angeles (1989–1990) or an amphitheatre in front of the North Carolina Museum of Art, in Raleigh (1987–1996). She quit the institutional spaces of the art trade, establishing a presence in public spaces with large-scale billboards and poster campaigns – in 1996, city buses transported Kruger's posters through the streets of New York, each poster being a moving image with an outsize eye, emblazoned between the vehicle's rear lights, that screams "Don't be a jerk." A shopping bag designed by Kruger bears the slogan "I shop, therefore I am". In Kruger's anti-prestige projects, art itself is not excluded from consumption. An untitled work of 1985 places the slogan "When I hear the word culture, I take out my checkbook" diagonally across the picture of a ventriloquist's dummy. By 1994, Kruger was extending her media repertoire, using sound for the first time in an installation at the Mary Boone Gallery. In 1998, she combined her artistic work with her interest in the cinema, showing rear-screen projections at Deitch Projects. As with her context shifts of photographic material, she links her procedure with starting points that lie outside the artistic framework and integrates them in a strategy of alternating place and meanings.

Ilka Becker

1 **We are all that heaven allows,** 1984. Black-and-white photograph, 186 x 120 cm
2 **Power Pleasure Desire Disgust,** 1997. Multimedia installation, Deitch Projects, New York (NY), USA

Elke Krystufek

＊ 1970 in Vienna, Austria; lives and works in Vienna

"I believe art is like an orgasm, but if it is just bad boring sex, I won't do it."

Body talk

One reason why Andy Warhol's assistant Brigid Berlin was afraid of dying was that "then my mother will come and find all my things – my vibrator". It is a fear that the Viennese artist Elke Krystufek would not seem to share (anymore), for in her legendary performance at the opening of the group exhibition "JETZTZEIT", 1994, at the Kunsthalle Wien, she bared her breasts and masturbated in front of the vernissage guests, including her mother, who is said to have congratulated Elke afterwards on her artistic work. The exhibition space was arranged like an outsized bathroom, with toilet bowl, washbasin, tiled walls, mirror-cupboard and bath tub. The private homely character of the space was further underscored by a coffee-maker, a stereo system and a television set, on which a video of the American rock-music eccentric Kim Fowley, supposedly Krystufek's ex-lover, was running. In this intimate yet sterile atmosphere, Elke began to masturbate pleasurably, first with her hand, then with a plastic dildo and vibrator. After that, the artist filled the tub with water and took a relaxing bath. As in many of Krystufek's works, the performance addressed the interrelationship between (male) gaze and (auto)erotic pleasure, as well as the interplay between artistically staged identity, feminist emancipation, and the female body. What at first sight may seem like a crude and narcissistic provocation, brusquely ignoring the distinction between private and public spheres, turns out in the end to be a deliberate game in which social orders and their unconscious normative ascription – intent on authoritatively determining all expressions of sexuality – are consciously subverted.

A brief excursion into the realm of film theory helps to make the strategies used by Elke Krystufek more transparent. In a 1973 essay entitled "Visual Pleasure and Narrative Cinema", the film director, scholar and feminist Laura Mulvey examined the relationship between the patriarchal unconscious, the pleasure derived from looking, and the conventional image of woman in cinema and society. Male phallocentrism, Mulvey observed, has defined woman's role in society as "an image of the castrated woman". In order to "arrive at a new language of desire", this definition must first be analysed, after which the (visual) pleasure derived from perceiving these images should be destroyed.

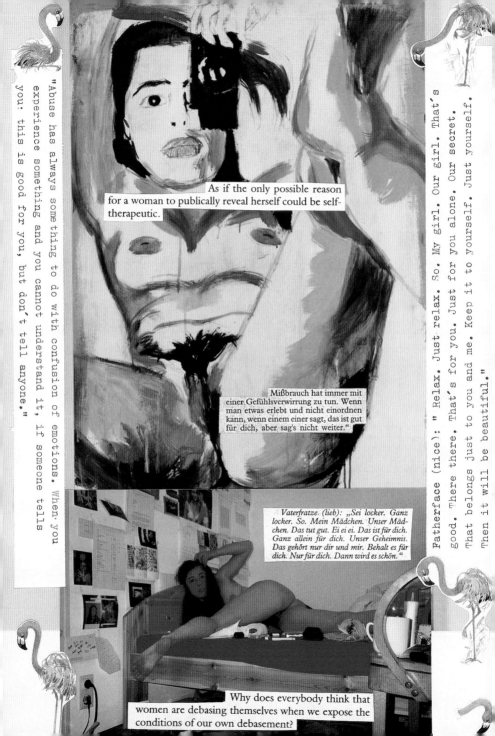

"Abuse has always something to do with confusion of emotions. When you experience something and you cannot understand it, if someone tells you: this is good for you, but don't tell anyone."

As if the only possible reason for a woman to publically reveal herself could be self-therapeutic.

Mißbrauch hat immer mit einer Gefühlsverwirrung zu tun. Wenn man etwas erlebt und nicht einordnen kann, wenn einem einer sagt, das ist gut für dich, aber sag's nicht weiter."

Fatherface (nice): " Relax. Just relax. So. My girl. Our girl. That's good. There there. That's for you. Just for you alone. Our secret. That belongs just to you and me. Keep it to yourself. Just yourself. Then it will be beautiful."

Vaterfratze (lieb): „Sei locker. Ganz locker. So. Mein Mädchen. Unser Mädchen. Das tut gut. Ei ei ei. Das ist für dich. Ganz allein für dich. Unser Geheimnis. Das gehört nur dir und mir. Behalt es für dich. Nur für dich. Dann wird es schön."

Why does everybody think that women are debasing themselves when we expose the conditions of our own debasement?

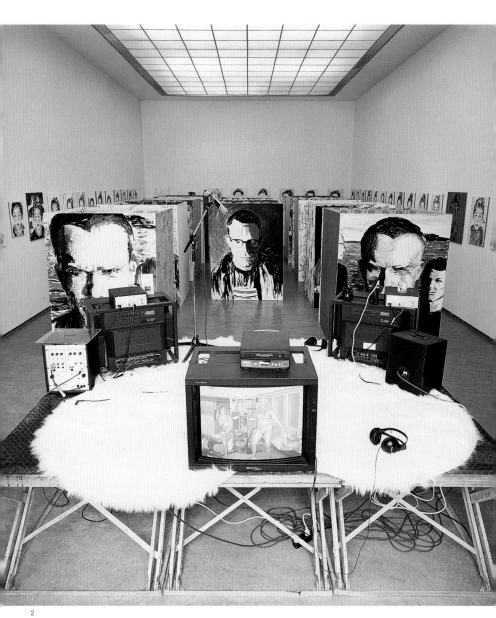

Autoerotic and exhibitionist delight

Elke Krystufek starts by decoding the definition of sexuality, availing herself of this process for her own pleasure. In the above-mentioned performance, she relied on the undiminished pleasure derived from looking, the spectator's almost voyeuristic penetration into the intimate sphere of other people's (feigned or imagined) lives. Krystufek does not experience the "absence of a penis" she so drastically demonstrates as a loss, rather she reverses this so as to achieve autoerotic and exhibitionist pleasure: "Can men masturbate better? I don't think so. I think women are able to more often", is the artist's subsequent self-assured claim. By contrast, during this performance, the spectator suddenly finds himself in the role of the voyeur, while at the same time becoming Krystufek's object of desire. Instead of just instrumentalising the female body, she instrumentalises the observer. By using the weapons ascribed to women by the (male) gaze, Elke Krystufek obviously gets the better of a mechanism which she nevertheless cannot escape – and that is the problem.

Post-modern role-play

Elke Krystufek's oeuvre comprises not just apparently embarrassing performances – for the most part deliberately amateurish videos and compelling installations – but also many drawings complete with texts, irritating collages, expressive (portrait) paintings, and staged photographs. Her themes range from various sexual practices to biographically-coloured family relationships, from "typical female problems" such as anorexia to Pop Art/post-modern role-play. In the latter case, Krystufek assumes the identity of female icons: in the photo series *Marilyn speaking*, 1997, as elsewhere in her work, she plays with the cliché of a Hollywood sexpot, using this carefully donned mask to mirror her own desires, weaknesses and wishes. In her performances, the photographs then serve as a mirror for the artist, so to speak. The photographs in *Marilyn speaking* are combined with statements such as "I'm a sex-maniac so I want only sex-maniacs around me." Other text fragments introduce the ideal of a utopian community, or show up commonplace differences – another work in the series contains the statement "I'm living the life you'd never dare to live." As is often the case in the reception of entertainment films, Krystufek's identification with a superstar is driven by the vision of a better ego, although it also reflects on the concrete failure of that desired ideal. This dual impulse at the tense moment when fiction and life meet presupposes a concept of subjectivity that sees itself as both authentic and staged. Only in relation to others, that is, to idols of the cinema, music or art world, does Krystufek develop a feeling for her own identity and physicality.

Raimar Stange

1 **Layout by Elke Krystufek.**
 Above: **Next time it will be on videotape,** 1991.
 Acrylic, dispersion paint on canvas, 170 x 120 cm.
 Below: **Chelsea Light,** 1998. C-print, 50 x 70 cm
2 **Installation view,** Portikus, Frankfurt am Main, 2000

Tamara de Lempicka

∗ 1898 in Warsaw, Poland; † 1980 in Cuernavaca, Mexico

**"My aim: never copy.
Create a new style, light, brilliant colours,
and sense the elegance in your models."**

Glamour girl

By the time she was 25, Tamara de Lempicka had found her motto: "There are no miracles. There is only what you make yourself." The well-born Polish girl was determined never to be bored, and the best way to ensure this was by being glamorous. In the 1920s, no one embodied this phenomenon better than de Lempicka, who was perhaps the first woman artist to be a glamour star – as seen in her painting *Self-portrait (Tamara in a Green Bugatti),* 1925, which continues to grace schoolbooks and postcards to this day. "Style is the prime means of changing oneself and becoming what one would like to be." De Lempicka, childlike bride, emigrée, young mother, earned a fortune with her stylistically polished paintings, investing the money in countless huge hats and extravagant dresses.

She was portraitist of America's upper crust, depicting venal women and sensual girls in white and pink, and kings without a throne. Her studio apartment in Rue Méchain on Paris' Left Bank was furnished in Art Deco by Mallet-Stevens. It was the stage on which she both performed her life's role and created her art. Every detail was carefully worked out, down to her initials on the chairs. Her wardrobe, her parties, her social life were legendary. She loved the society world as much as the art world. Yet she was interested only in people she called the best – the wealthy, the powerful, the *arrivistes*. Everyone else, the bourgeois and the mediocre, she shunned.

Tamara de Lempicka was born as Tamara Gorska into an upper middle-class milieu in Warsaw in 1898. In St. Petersburg, in 1916, she married Tadeusz Lempicki, a lawyer and man-about-town. During the Russian Revolution, the couple fled by way of Finland to Copenhagen, and finally to Paris. Here Tamara had her only child, a daughter, Kizette. It was in the French capital that she decided to take up art. In 1918, she began studying painting with Maurice Denis and André Lhote. Denis, a member of the pre-war artists group the Nabis, to which Gauguin had also belonged, taught de Lempicka to simplify colours and forms, and to contour motifs sharply – and also how to give colours that enamel-like gloss that was to become so characteristic of her. Lhote, a co-founder of Neo-Cubism, demonstrated how decorativeness could be combined with features of the avant-garde experiments of a Georges Braque or a Juan Gris. Cubism subjected the human figure to a geometrical disassembly, reducing the anatomy to cubes, cones and spheres.

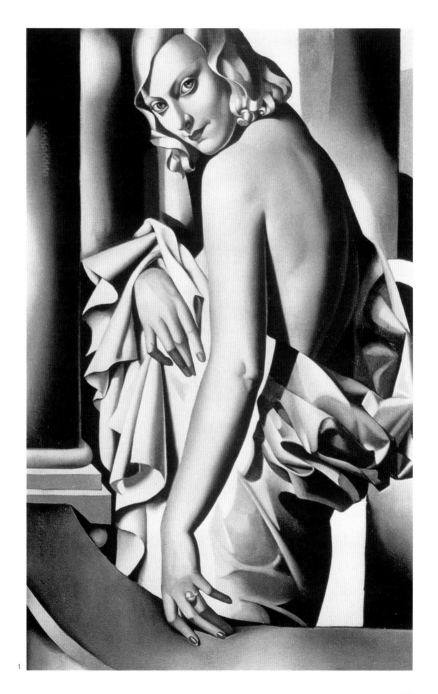

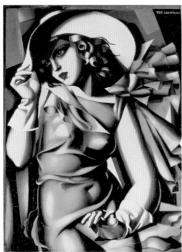

2

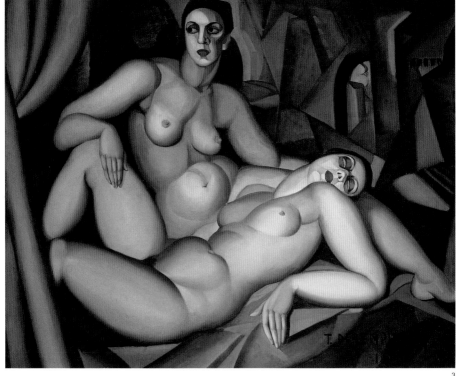

3

Yet de Lempicka's subject matter differed from that of other fashionable Art Deco painters. She depicted friends and acquaintances, experimented with contrasting planes and bright highlights. She became a detached portraitist with a rather condescending gaze, developed a sensuously decadent style that favoured strong hues. Some works achieved the quality of sensitive caricatures that perfectly recorded the spirit of the age. With a highly becoming arrogance, she caught the tics and revealing gestures of her sitters on canvas. Her glamour was, as we would now say, "cool", and so were her pictures. "A painting must be clear and clean. I was the first woman to paint clearly and cleanly – and that was the reason for my success."

Consorting with the rich and beautiful

The 1920s witnessed de Lempicka's rapid rise to fame. In 1923, she began exhibiting her work in the grand Salons. The Galerie Colette Weill gave the artist her first solo show, which attracted attention. Then came her first significant award, for a portrait of her daughter, *Kizette on the Balcony,* 1927. This was the breakthrough de Lempicka had so desired. Before the year was out, she was divorced from Tadeusz Lempicki. In 1928, she began depicting the European and American elite. After portraying the Hungarian baron, landowner, and art collector Raoul Kuffner, she married him in 1933 – life and art were intimately interwoven for de Lempicka. In the early 1930s, her fame reached an apex, and museums began to acquire her work. In view of the growing fascist threat, she convinced her husband to sell a considerable portion of his real estate in 1938. De Lempicka, the *grande dame* of Art Deco, left Europe with Baron Kuffner in 1939, for the United States. "The baroness with a brush" soon became the favourite portraitist of Hollywood stars.

Down with ugliness

De Lempicka detested the Existentialist philosophy that prevailed in post-war France. She had no good word to say about contemporary painting, avoided the "cult of ugliness" she thought had prevailed. Yet wanting to find new modes of expression, she turned, if without true enthusiasm, to abstract, non-objective painting. One of her last shows took place in New York in 1962, the year her husband died of a heart attack. De Lempicka, perpetual nomad, sold all her possessions, fled New York, went on three trips around the world, then settled for a time in Houston, Texas, where her daughter Kizette and her family lived. In 1978, she then moved to Cuernavaca, Mexico, where she befriended the sculptor Victor Contreras, 40 years her junior. At the time, Cuernavaca was a favourite refuge of wealthy Americans and the cosmopolitan jet-set. Their lavish and decadent lifestyle attracted Baroness de Lempicka, confirming her own love of extravagance. She returned to the painting style that had made her famous 40 years before. Tamara de Lempicka died in Cuernavaca in 1980. Judging by what we can see in her best pictures, hers must have been a wonderfully exciting life.

Frank Frangenberg

1 **Portrait de Marjorie Ferry,** 1932. Oil on canvas, 99 x 65 cm
2 **Jeune fille en vert,** 1927. Oil on canvas, 53 x 39 cm
3 **Les deux amies,** 1923. Oil on canvas, 130 x 160 cm

Sarah Lucas

* 1962 in London, England; lives and works in London

SELFISH

"You have to think twice about everything I say, no matter whether I mean it seriously or jokingly. That is provocative."

Objects of desire

Quantity turns into new quality. In the case of Sarah Lucas, this simple principle – not just of Marxist dialect-
ics – takes on artistic forms at once crude and critical. In many of her works, she shows the male gaze directed at
the woman he desires or at the woman as an object of desire, and in the process so overstates this chauvinism that
the gaze is unmasked, with the artist herself clearly taking pleasure in the interplay between gaze and the eye-catch-
ing object of the gaze.

In one of Lucas' best-known works, *Au naturel*, 1994, a cucumber protrudes from under an old mattress. It
stands erect on a mattress laid out on the floor, and at its base nestle two oranges. To one side of this graphically
presented phallic symbol lies an empty bucket, behind which a pair of melons protrude from the mattress – a patent-
ly sexual allusion to breasts and vagina. What Lucas is doing here is to exaggerate grossly the reduction of the con-
trasting "objects of desire" in a manner that is both aggressive and jocular, although outright laughter sticks in the
throat because the artist's staged objectification of sexuality is too mundane.

The sculpture *Bitch*, 1995, is even more absurd. Standing on a table on two wheels are a pair of outsize
melons draped with a T-shirt. On the other side of the table, a smoked fish dangles between the legs, a parody evok-
ing the odour of female genitals. Once again, the allusions are instantly understood, but this time other aspects come
into play, for example the element of almost archetypal female fears, which can at any time turn into unbridled desire
and lust – non-ambiguity is certainly not Sarah Lucas' thing.

The installation *Car Park*, 1997, likewise adroitly suggests several levels of interpretation. An ordinary car
stands in the museum space, its windows smashed, and splinters of glass scattered on the floor. On the wall behind,
Lucas' photo series *Concrete Void*, 1997, can be seen, which was taken in a London multi-storey car park. It shows
cars parking, dark corners of the parking decks, lines indicating the individual parking slots, simple sign-posting, and
even a trashed shopping trolley. People, by contrast, are notable for their almost total absence from the 108 large-
scale black-and-white photos. The wall-filling photo series with its precarious views and diffuse moods gives rise to

1

2

3

an opaque weave of different perspectives. An eerie menace seems to lurk everywhere in this grey, artificially lit labyrinth – who likes going into a multi-storey car park alone at night?

Arresting metaphors

In later works, Sarah Lucas increasingly turns her attention to the problematic relationship between male desire and female role perceptions in art. At the "Beautiness" exhibition, 1999, staged in a former car-repair shop in central Berlin, a naturalistically shaped male forearm moved up and down with stoic regularity. Its fist was only half closed, while the object that it was manipulating remained invisible. In the exhibition, the masturbation acted as an arresting metaphor for the self-satisfaction of a still male-dominated art trade. The motif was played through by the artist with considerable virtuosity: high up on the wall as an onanistic pendulum clock (*Wankertoo*, 1999); in a cannibalised BMW (*No Limits*, 1999) as an almost surreal installation; and reduced to a minimum in a sterile glass cube (*Wichser Schicksal* [Wanker's Fate], 1999). Masturbation as a provocative subject was here significantly linked with stylistic borrowings from male artists, the repertoire quoted ranging from Bruce Naumann to Marcel Duchamp or Ed Kienholz.

As a counterpoint to the self-satisfaction that she had propounded in her ironic-overt manner, Sarah Lucas portrayed in a small adjoining room female forms made out of countless ordinary cigarettes: two handy little balls which on a T-shirt turned into impressive breasts, and a vacuum cleaner (*It Sucks*, 1999) with a brown bra, countered the indefatigable forearm with an almost restful comfortableness, playing with the long-dismissed but still virulent cliché of the women as submissive and pleasure-giving. And then "existential" elements were integrated into the "Beautiness" exhibition in an ironic and yet thoroughly wistful way: a coffin of slender neon tubes (*New Religion*, 1999) together with a bath from which a fleshy mass made of concrete seems to run (*Pig*, 1999). In these works, too, Lucas borrows from male precursors, recalling Dan Flavin and Joseph Beuys.

The travesties and tragi-comedies presented by Sarah Lucas convince through their insistent, precise and self-assured language. But she can irritate in equal measure, too, with her consummate and overdone recycling of clichés that (as the American saying goes) defeats the enemy by singing its own songs. Lucas does not need to forego her own pleasure in this and also admits a contradictory ambiguity, which makes her aesthetic strategy all the more convincing.

Raimar Stange

1 **Beyond The Pleasure Principle,** 2000. Installation view, Freud Museum, London, England
2 **Chicken Knickers,** 1997. C-print, 42 x 42 cm
3 **Au Naturel,** 1994. Mattress, water bucket, melons, oranges and cucumber, 84 x 168 x 145 cm

Annette Messager

"Being an artist means incessantly healing one's own wounds and simultaneously opening them again in the process."

Crime scenes

One of the artist's most humorous works is found in an album from the series *Annette Messager truqueuse* (A. M. the Tricky). *La femme et la barbe* (The Woman and the Beard, 1975) consists of photographs of a face with a long beard, grinning, eyes closed. Is it a male face? Messager subverts any clear interpretation, since the photos were the result of an ironic shift in sexual markers. The face was actually painted on her stomach, just above the pubic area. In this interlocking of "natural" and "artificial" physical traits, head and abdomen were exchanged and the pubic hair reinterpreted as a beard. The artist used her body as an anonymous carrier of meaning, as painting ground and inscription surface.

In *Mes jalousies* (My Jealousies, 1972), in contrast, Messager retouched photos of young women with wrinkles and gaps between their teeth in order to underscore their youth and beauty. "The basic idea," she explained, "was to bring together all these little dreams, vanities and *idées fixes* of little fashion assistants on one and the same level, to emphasise this unappreciated, scorned, so-called "feminine" field — pretty little watercolours, little diary entries, magazine clippings." Later, the artist would develop the theme by painting over photos of parts of the body, such as the fingertips of a hand with faces or the wrinkles in an enormously enlarged palm with a fantastic landscape (*Mes Trophées,* 1988). The collection of *Mes jalousies* and another series, of cute baby photos with their eyes scribbled over, drew harsh criticism, since Messager had infringed on the holiest taboos of bourgeois femininity: motherhood, youth and good looks. The forms which worrying about physical attractiveness can take were parodied in her wall installation *Les Tortures volontaires* (Voluntary Tortures, 1972), a conglomeration of advertising pictures showing the grotesque, outmoded to futuristic masks and disciplinary apparatuses to which women subject themselves in the interest of body shaping — a scenario that evoked images of Frankenstein's lab or medieval torture chambers.

This simultaneous quotation and demolition of female clichés marked Messager's artistic strategy from the beginning, in an approach that combined features of Art Brut, Conceptual Art and Surrealism. She was especially interested in the photographs of Man Ray or Jacques-André Boiffard, the Surrealists' obsession with the human body, with the dramatic convulsions of hysteria, fetishes and animistic thinking. An example of the results was *Attitudes et expressions diverses,* 1973, consisting of photos of women to whose facial expressions and gestures were

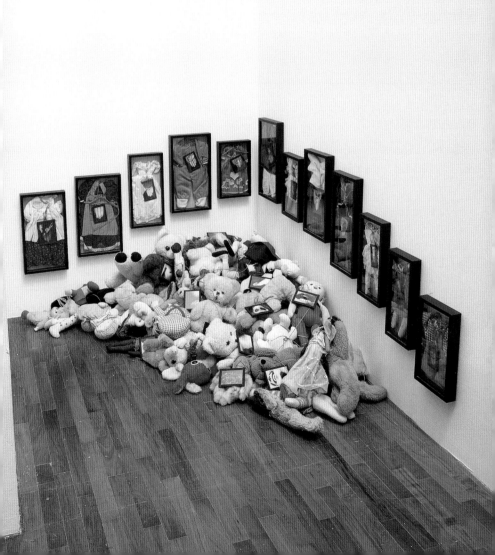

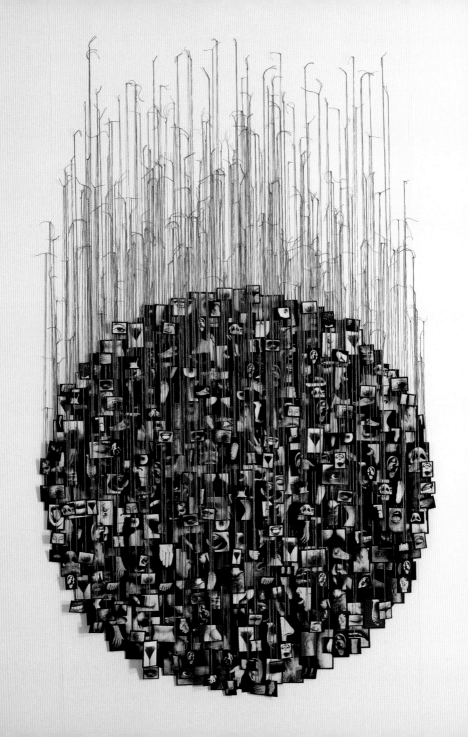

ascribed various states of mind such as "pain", "weariness", "worry" and "disquiet". The photos recalled illustrations of hysteria from the *Iconographie photographique de la Salpétrière*, 1878, made in connection with the researches of the neurologist Charcot. Messager worked with the vocabulary of cinema, her photos having almost the effect of film stills with their suggestive cropping and camera angles, dramaturgical emphasis, and narrative condensation.

Her use of small formats and banal objects, often from the economically and symbolically "low" area of domestic, feminine-connoted activities, and her strategic mixing and combination of various methods and materials in *bricolage*, or DIY, probably had its point of departure in the anti-hierarchical thrust of the 1968 student movement, out of which, especially in France, emerged a feminist thinking in whose context Messager's approach began to take shape. In the early 1970s, she decided to divide her apartment into two areas – a chamber in which she took on the identity of a collector, and a studio in which she played the role of artist.

"I am the liar"

In the 1980s and 1990s, Messager began to concentrate increasingly on photo installations and theatrical spaces in which lengths of cord, nets, sewn objects and stuffed animals were frequently combined with photographs of body fragments or small drawings of human organs. "Now it has become clear to me," she noted at the time, "that taxidermy and photography are based on the same motives. Taxidermy consists of fixing a flying bird or freezing the position of a lion stalking his prey. Photography stops motion in the same way, fixes life, freezes it." Cloth organs hung like cadavers in a slaughterhouse from the ceiling; yet they also recalled Duchamp's installation with coal sacks, or Eva Hesse's ceiling arrangements, and congealed into psychological topographies: "All of my work is really a huge patchwork, just as our culture as a whole is a somewhat awkwardly assembled hobby kit, a disparate miscellany, a conglomeration of elements of the most diverse origin… a lot of joined together events that then shape our identity." Messager says photography is so crucial to her because it represents real persons. In some of her installations, such as *Jeu de deuil*, 1994, she connects photos dangling from the ceiling with wool threads taken from cut-up clothing which establish both formal and symbolic links between the body fragments illustrated. The images have the character of crime scene photographs, evidence of the way the act of photography "kills" its subjects.

A further presentation medium of her diverse work is plain floor or wall showcases, in which, for instance, women's clothing is displayed like items in a museum of natural history or sloughed-off physical shells lying in glass coffins (e. g. *Histoires des robes*, 1990). "I am the liar," says Messager, "the harbinger of dubious love affairs, equivocal memories, the tamer of paper spiders…"

Ilka Becker

1 **Histoires des Petites Effigies,** 1990. Stuffed animals, doll dresses, over-painted black-and-white photography,
 Installation view, The Museum of Modern Art, New York (NY), USA
2 **Mes Vœux,** 1989. Black-and-white photography, thread, 320 x 200 cm

Mariko Mori

* 1967 in Tokyo, Japan; lives and works in Tokyo and New York (NY), USA

**"My work is a revelation of thought.
I positively enjoy projecting the esoteric gesture
through the inner world."**

Synthetic pictorial visions
between yesterday and tomorrow

Like many artists these days, multimedia artist Mariko Mori lives in two worlds – her home town is Tokyo, her elective home New York. Her performances and fashion designs, videos and photos reflect the contrast between the old and the new world, between East and West, synthesising the two worlds in hyperrealistic visions. They involve not only Japanese Buddhism and Shintoism, but also the latest technology, digital picture manipulation, science fiction, techno and Neo-Pop, comics and advertising.

In her earlier photographic works, Mori herself poses as a female cyborg dressed in a gleaming silver hi-tech suit, surrounded by Japanese from the ordinary everyday life of this world and yet isolated: in an underground train, which because of the way the photo is taken looks like a round UFO (*Subway*, 1994); in front of an office building, where she offers passing business people tea (*Tea Ceremony III*, 1995); or as a mixture of Barbie doll and Fritz Lang's mechanical woman from *Metropolis* in a pachinko amusement arcade (*Play with me*, 1994).

The 3D photo-installations *Birth of a Star*, 1995, marked a turning point in her work. Mori presented herself alone in front of a white background, while gaily coloured balls floated around her like stars. She depicts herself with thick earphones, miniskirt and plastic stockings like a computer-generated pop idol of mixed 1970s and 1990s inspiration. Two yellow plastic bows, fixed to her upper arms like wings, recall the figure of an angel as intermediary between heaven and earth. Since then, her outsize colour photos and videos have been produced by an 8- to 19-strong team of associates and numerous sponsors.

Miko no inori

Mori's lavish productions require specialists in costumes and jewellery, stylists, hairdressers and make-up artists, technicians, lighting and camera crews, composition and sound artists, computer animation and design experts to make a perfect picture set-up. Mariko Mori is the director, play writer, singer and main actress in her photos, videos and performances. Just as perfect as the presentation, each visual statement or cinematic action is multi-layered. The artist completely integrates new visual worlds hovering between past, present and future, dream and fiction, tradition and modernity, religion, nature and technology, profundity and persiflage with her own cyber-realism.

2

3

4

She mixes and unites contrasts, whose boundaries oscillate fluidly in the pictures. She manipulates, synthesises and harmonises in the hope of a better world on the other side, though without adopting a critical note, because her mission is to depict enlightenment in Nirvana. Buddhists believe in rebirth and a condition of blessed peace. Mori's pictorial visions make tomorrow's possibility today's reality.

Clothed in a gleaming whitish-pink suit and with pointed blown-up plastic angels wings, she stands in an airport in Japan holding a crystal ball in her hand. Her eyes are indicated by rays of light as she looks in the crystal ball, i.e. the future. This video work, titled *Miko no inori*, 1996, seems to be programmatic for Mori's whole oeuvre, in which she endeavours to unite her art and philosophy, her religious and magico-spiritual visions.

Kumano

In the photograph *Kumano*, realised two years later, Mori seems to have found her future self-portrait. On the left of the picture, she kneels in front of a red bridge, such as is found in Japanese temple compounds. Wearing a tall headpiece made of pearls and precious clothing, she is the embodiment of traditional Japan. In the background, a waterfall appears between trees. On the right of the picture, she stands in front of a futuristic-looking polygonal temple, the *Dream Temple*, the form of which is reminiscent of old Japanese architectural traditions. Her figure itself is almost transparent, to this extent constituting a virtual shadowy apparition of the future. As if standing wreathed in mist or gleaming light, she appears either no longer corporeal or not yet palpable. The two scenes are linked by the common forest backdrop and the old characters written above, which are painted on the surface of the photo.

Dream Temple

In her latest work, *Dream Temple*, 1999, Mori has taken the digital temple from *Kumano* a step further, transforming it into a veritable "Gesamtkunstwerk" or total work of art. This, her most multi-layered project to date, combines architecture, computer graphics, 3D effects, a vision-dome system and virtual reality in order to explore the nature of human consciousness as such. With a diameter of 33 feet (10 m) and a height of 16 feet (5 m), the octagonal *Dream Temple* consists of ordinary and dichroic glass, whose softly gleaming, iridescent surface changes with the light. It is based on the Yumedono temple in Nara, built in the 8th century to house the statue of the Bodhisattva in a meditative atmosphere. In Mori's temple, the divinity is of course lacking, its place being taken by the viewer, who enters the central building to discover himself in an all-over video projection, in which abstract images of astral bodies turn into images of germination and growth. But, because of Mori's perfect image manipulation and presentation, which both recall genetic engineering and combine the real with dreamlike futuristic utopias, the term "Cyborg Surrealism" – coined by Donna J. Haraway – seems apt for Mariko Mori's work.

Ulrike Lehmann

1 **Dream Temple,** 1999. Audio, metal, glass, glass fibre threads, Vision Dome, 3D semi-circular display, 5 m (h), diameter 10 m
2 **Pure Land,** 1998. Glass with photo interlayer, 5 panels, overall 302 x 610 x 2 cm
3 **Entropy of Love,** 1996. Glass with photo interlayer, 5 panels, overall 302 x 610 x 2 cm
4 **Burning Desire,** 1998. Glass with photo interlayer, 5 panels, overall 302 x 610 x 2 cm

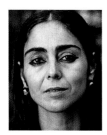

Shirin Neshat

* 1957 in Qazvin, Iran; lives and works in New York (NY), USA

"I see my work as a pictorial excursus on the topic of feminism and contemporary Islam – a discussion that puts certain myths and realities under the microscope and comes to the conclusion that these are much more complex than many of us had thought."

Between two worlds

Given an ever more global world, increasing migration and greater receptiveness to non-western cultures, public interest has grown in recent years in artists who come from other cultural milieus and whose works deal with multicultural influences.

Shirin Neshat grew up in Iran and went in 1974 to study in California. She did not revisit her homeland until 1990, when she found society there completely transformed. Meanwhile the Iran of Reza Pahlevi had turned into an Islamic republic. Based on the resulting cultural shock she herself experienced and described, she began to depict the role of women in Iran and the phenomenon of veiling behind a black chador.

Her first works in the photo series *Women of Allah* date from 1993. They are black-and-white photographs of uncovered body parts such as faces, feet or hands, against which a weapon or flower has been juxtaposed. Neshat has overwritten the pictorial parts of these exposed body parts beneath the veil in Farsi, because without this addition she found the images "naked". The artist selected texts from female Iranian writers, metaphors of carnal lust, sensuality, shame and sexuality, which had prompted her pictures in the first place. For Western viewers, of course, the texts are not legible and thus look like ornamental calligraphy or arcane decorative elements. In Iran, by contrast, where they could be read, Neshat's pictures are not shown. Despite the indecipherability, Neshat has fascinated the public at numerous Western exhibitions and world-wide biennials with her enigmatic, voyeuristic, symbol-laden, powerful and exotic photos, and she rapidly conquered the market.

In 1997, she looked for new ways to introduce further narrative components into her work, and began to experiment with film. In the same year she produced the four-part video work *The Shadow under the Web*. In the various film projections, which are screened simultaneously on all four walls of the exhibition room, a woman in a chador (Neshat herself) is seen running uninterruptedly beside a historic city wall, through a mosque or bazaar, and down empty narrow alleys. We hear only her heavy breathing and panting. Because of the difficult political situation in her native country, Neshat moved the filming to Istanbul, carrying out the shooting jointly with Iranian film-makers. It was important for her to have an Islamic setting, where public places are male and the private ones female. Here the chador becomes a protection for a woman who seems hounded and in flight, fleeing her confined existence in

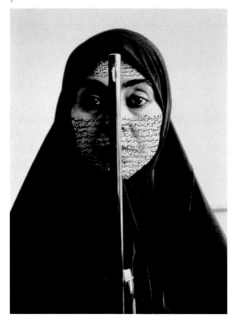

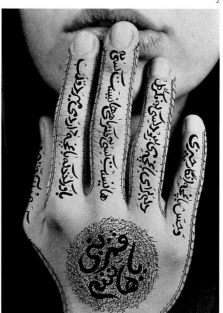

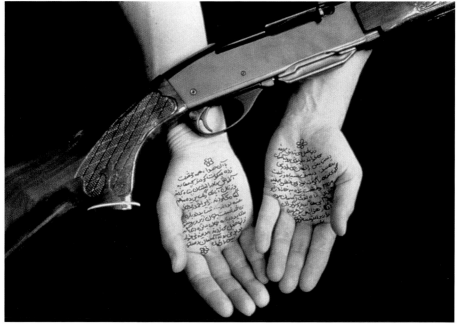

137

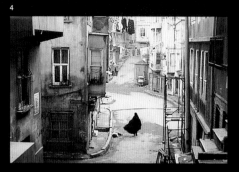

4

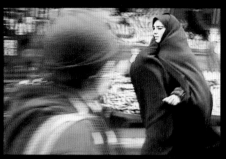

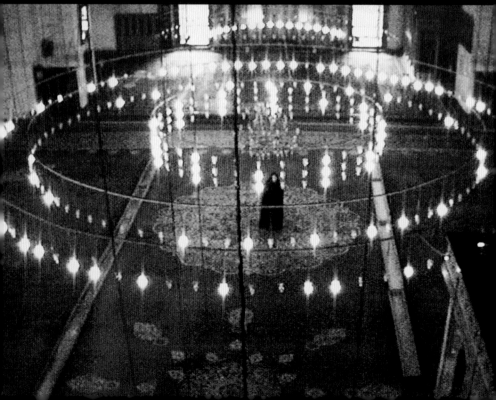

4

Islamic society and searching for herself. But running is frowned on and untypical in the places of repose or commerce shown. It is much more an expression of our Western civilisation, and so becomes here a symbol of a stressed modern society – not least because the viewers themselves have to run in the middle of the projection surfaces in order to be able to see all four films at once, which is ultimately impossible. Neshat's film, which contains biographical features and whose subject is the transition between two worlds, contains – like her subsequent videos as well – deliberate inconsistencies that bring out the different social structures, patterns of behaviour and thought, taboos and contradictions of Western and Islamic society.

Her second film, *Turbulent* (1998), which won an award at the Venice Biennale in 1999, acted as a magnet for the public. In two projections opposite each other, a man and a woman (both from Iran) apparently sing to each other. When the woman's voice begins, the man's falls silent, and vice versa. The woman sings wordlessly, isolated in an empty room. The man, who directly faces the camera, stands with his back to a male audience. It is an emotionally charged duel between the sexes that could never actually take place in patriarchal Islam because women are largely excluded from musical performances. But in this black-and-white film, the legendary voice of the woman is victorious, while the man falls silent.

Rapture

In the thoroughly pathos-laden and symbolically charged video work *Rapture*, 1999, which shows on the one hand a group of men in a fortress and on the other a group of women in a desert-like seaside landscape, Neshat again uses the means of double projection to generate fictitious communication, action and reaction between the two, but also to show the separation of the sexes in public life in Iran.

Soliloquy

In the two-part film *Soliloquy*, shot in Turkey and the US and completed in 1999, Neshat contrasts the worlds of two women: East and West, the traditional and the modern, community and the individual. On the one side, we see the veiled woman of the Orient, and, on the other, the woman of the West, in New York. As if in an unequal mirror image, they stroll up and down their respective home locations, performing their religious observances in the church or mosque. The correspondences of localities highlight the contrasts between their different ways of life and social structures.

Shirin Neshat's films, in which the action is deliberately scaled down and which build on the suggestive force of the images, are the expression of her experiences in two cultures. They therefore always follow a dualist principle. In a perfect blend of fiction and reality, they depict two worlds (man and woman, West and East, freedom and fundamentalism, tradition and modernity) with total respect. Needing no words, her films touch deeply emotional levels by means of picture and sound alone, presenting a narration of reality without being real, while at the same time remaining ultimately enigmatic.

Ulrike Lehmann

1 **Rebellious Silence,** 1994. Gelatin silver print, ink, 36 x 28 cm
2 **Untitled (Woman of Allah),** 1994. Gelatin silver print, ink, 36 x 28 cm
3 **Stories of Martyrdom,** 1994. Gelatin silver print, ink, 28 x 36 cm
4 **The Shadow under the Web,** 1997. Video still

Louise Nevelson

✳ 1899 in Kiev, Russia; † 1988 in New York (NY), USA

"Life in its essence is a mystery."

Architect of shadows

Louise Nevelson was born in Kiev as the daughter of Mina Sadie and Isaac Berliawsky. In Nevelson's case, genealogy makes sense – the invisible threads that connect us with the past are present everywhere in her oeuvre. Her grandfather was a lumber dealer, as was her father, and she herself seems to have inherited this family affinity with wood. She selected wood as her material both because she wanted to become a sculptress and because she did not want "colour to help" her.

In 1905, her family emigrated to the United States, settling in Rockland, Maine, where there were only 30 Jewish families. Nevelson's family ties were very strong, especially to her father. He was an advocate of equal rights for women, while her mother was a free-thinker. Despite being doubly stigmatised as a Jew and an aspiring artist, Nevelson nevertheless believed her path to be predestined and art to be her one true calling. Her marriage with Charles Nevelson, whom she wed after finishing her studies in 1918, was doomed to failure. Because she was fascinated by everything that had to do with art – singing, dancing, painting, acting and piano lessons – her husband's expectation of her that she should live the life of a middle-class wife and mother could not be fulfilled, and the two separated in 1931, while their son Myron, born in 1922, went to live with his grandparents.

Meanwhile Nevelson moved to Munich, where she continued her training with Hans Hofmann. On a trip to Paris she saw African art for the first time, at the Musée de l'Homme. One thing that intrigued her here was that she felt entirely familiar with these works of art, as if she had known them forever. She had the same feeling with regard to American Indian ceramics. In the 1920s and 1930s Nevelson amassed a large collection of these ceramics, as well as African and Pre-Columbian art.

She kept her distance from group, including the then highly influential representatives of the 1950s New York School, such as Barnett Newman, Mark Rothko and Jackson Pollock. Nevelson had her first show in 1941, at the age of 40, at New York's Nierendorf Gallery, but it was not until 1959 that her work was represented in the Museum of Modern Art. Looking back, she saw the reason for this belated recognition: "I took wood from the streets, old wood with nails and all sorts of things. Now when you think of monied people, they will invest in materials that are expensive. And actually the majority of people don't have homes; rather they live in showplaces, exhibition rooms. Consequently, they are never going to take old wood and give it its true meaning."

Nevelson was a woman who viewed her position on the art market with critical detachment. In 1966, at the age of 68, she finally received international recognition. In 1967, the year of her retrospective at the Whitney Museum, capping the most successful phase of her career, she relinquished nearly all her possessions and completely

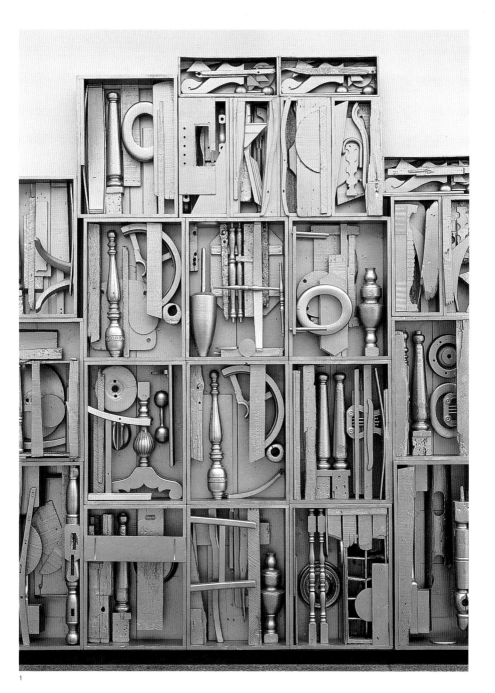

1

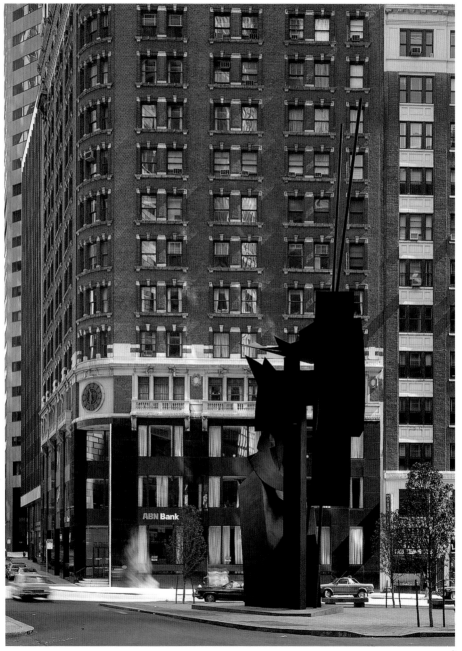

2

refurnished her house with grey metal cabinets and furniture. This courage to jettison the extraneous again and again advanced Nevelson's life and career. In 1957, she began dipping every element of her sculptures in matte black paint. By divorcing things from their functions she lent them poetry.

Many talents and skills went into Nevelson's sculptural works. Their flowing moving aspects derived from theatre and dance, her first points of contact with art. The artist herself viewed her works as collections of elements that were in continual flux and interplay, a never-ending dialogue of contradictory relationships. In the mid-1940s, she began to create sculptures with a performance aspect, such as the figurative group *Moving-Static-Moving,* which exemplified the dynamic character of her approach – anonymous terracotta figures that rotated around their own axis, establishing continually changing relationships with the surrounding space. Even the sometimes massive block-like forms in her work retained the light-footedness of dancers. Whereas other sculptors strove for permanence, as reflected in materials like steel, in predetermined compositions, and in consistent combinations of form, Nevelson preferred the more malleable material of wood.

Found objects with previous lives

The works that established Nevelson's reputation were emblematically abstract, dark boxes, configurations resembling bookcases hung on the wall and filled with wood pieces and fragments in seeming disarray, as if in an old curio shop. Most of these wall sculptures were painted a unified black, which lent them a shadowy, Gothic character. They consisted of wine crates, parts of chairs, lengths of wood jutting with nails, all found in the Manhattan streets – *objets trouvés* of various kinds and ages with traces of wear and tear that bore witness to their previous importance in someone's life. Fragments of old chests of drawers, window shutters, barrel lids, chair legs, split boards and objects of undefinable origin, all acquired a new context in small-format boxes.

The fact that these objects seemed to find the artist rather than the other way round, confirmed Nevelson in her calling. And she set out to make them her own by covering them with an all-consuming black that erased the traces of their previous existence. For Nevelson, black was not merely black, nor was any colour simply a colour per se. Colour was "the essence of the universe", she stated, continuing the line of thinking that had found its abstract apex in Malevich's *Black Square.* In Nevelson's hands, the colour black again took on this symbolic quality, becoming the quintessence of self-referentiality. Her interest focused on her own personal perception of the world, "because what my life is about is what everybody's life is about", and her aim was to reveal this world despite the fact that "life in its essence is a mystery."

The essence of the universe

In order to reveal something of this mystery, Nevelson paradoxically rendered its outlines clearer by spreading a veil of black over every object. With *Moon Garden plus One,* 1958, this approach found international recognition. The work consisted of boxes filled to bursting with old household items, dissolved into shadows by black paint, and stacked one over the other to form columns, which in turn formed walls, like Babylonian "cathedrals of heaven" – massive environments which, like African sculptures, were intended to be seen largely frontally. The boxes – initially collected, later made to measure – formed the framework within which found objects of daily use revealed their pure essential form. Louise Nevelson died in 1988, after a life of enviable artistic rigour and faith in her calling.

Frank Frangenberg

1 **Royal Tide IV,** 1960. Wood, with gold spray technique, 323 x 446 x 55 cm
2 **Shadows and Flags,** 1977/78. 7 Sculptures, Cor-Ten-Steel, Louise Nevelson Plaza at the Legion Memorial Square; crossing Williams Street, Liberty Lane and Maiden Lane, New York (NY), USA

Georgia O'Keeffe

* 1887 in Sun Prairie (WI), USA; † 1986, in Santa Fe (NM), USA

"Most people in the city rush around so, they have no time to look at a flower. I want them to see it whether they want to or not."

A rose is a rose is a rose

Her hands, everywhere these hands. Spread over a dark bunch of grapes, toying with a bright chrome car wheel, caressing a steer skull, or simply gesturing in the void, as if underscoring an important point in an unheard speech. For a long time, the famous portrait and nude photographs made of her by her partner, Alfred Stieglitz – over 300 from 1917 to 1937 – were far better known than Georgia O'Keeffe's own paintings. In Stieglitz' photographs, she even seems to reach out with her hands for her paintings as if for exquisite objects – when the paintings were being made, i.e. during the work in her studio, Stieglitz never took portraits of her.

Stieglitz, with whom O'Keeffe had a both symbiotic and difficult relationship from 1918 to 1946, the year of his death (they married in 1924), admired her work enormously. "At last – a woman on paper", he exclaimed when he first saw her charcoal drawings and watercolours in 1916 at his own Gallery 291 in New York. In his photographs, Stieglitz established a dual relationship between the artist's body and her work: first, by picturing her hands in front of the paintings, suggesting a woman of discernment, surrounded by beautiful things, receptive to aesthetic pleasure; and second, by naturalising her body, her torso, often by equating it with the open flowers in her paintings, as if art were foremost the fruit of woman's physical being, rather than the autonomous conscious result of artistic subjectivity.

O'Keeffe's recognition would hardly have been thinkable without the support of Stieglitz, who exhibited her work several times from 1916 onwards at his Gallery 291, where early on he had shown works by Picasso, Matisse and Cézanne. Nevertheless, the reception of her work long stood in the shadow of a conventional view of female art. In some idealised art-historical descriptions of this almost prototypical 20th-century artist-couple, her role was reduced to little more than that of a muse, who made variations in paint of the maestro's motifs. Her oils, inspired by the Texas and New Mexico deserts, were celebrated as depictions of the great American myth and were thus lent the status of national monuments.

In fact, O'Keeffe's true achievement was to have explored new territory for American painting on the margins of and beyond objectivity. It began with a reading of Wassily Kandinsky's essay *On the Spiritual in Art,* which

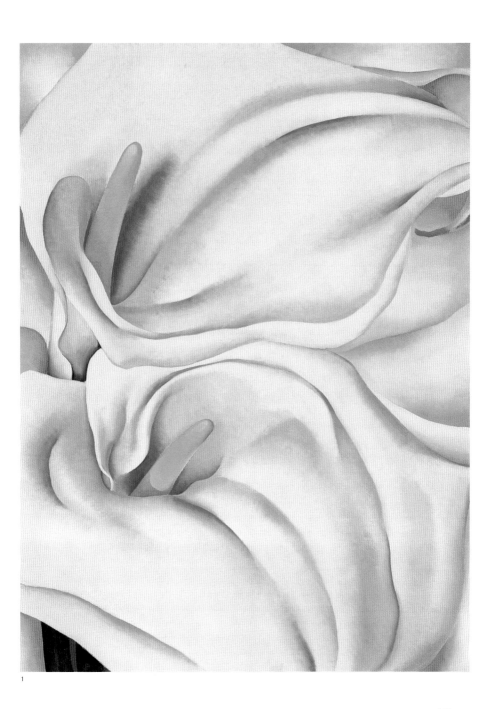

1

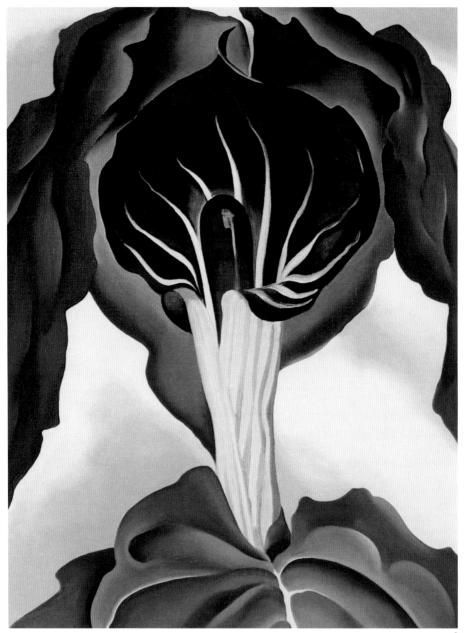

2

inspired her to do abstract charcoal drawings at the start of her career (*Special No. 5,* 1915), and continued with correspondences to Stieglitz' photographs and their emphasis on the abstract patterns in landscapes, natural scenery, and cloud formations. The results included such paintings as *Dark Abstraction,* 1924, in which landscape motifs are only vaguely detectable, if at all.

Active as an art teacher, O'Keeffe had studied in 1915 at Columbia University with Arthur Wesley Dow, an advocate of a synaesthetic theory of art. At this period she loved ragtime music and Picasso's painting, and once referred to her art works as "music", adding that "Since I cannot sing, I paint" (although she did play the violin). O'Keeffe experimented with charcoal, tracing great sweeping lines, waves, diagonals and rhythmical vortexes across the paper. Stieglitz mounted a show of her drawings without asking her beforehand, and later "remunerated" her with photographs of the works on display. The act marked the beginning of the artistic and existential liaison between photographer and painter. In 1916, O'Keeffe returned to paint and to watercolour, the medium which, according to Kandinsky, was the point of departure for spiritual reflection in art. In her *Blue Lines X,* 1916, the lines that project like steles into the empty pictorial space recall this source.

From Manhattan …

O'Keeffe's first solo show took place at Gallery 291 in 1917. In June of 1918, she moved in with Stieglitz in New York. Subsequently, the two regularly spent their summers together working at the Stieglitz family place on Lake George in the Adirondack Mountains. During the long winter months in New York, O'Keeffe painted her first large-format floral motifs in 1924, and in 1925, inspired by the view from their apartment on the 30th floor of the Shelton Hotel, she did her first skyscraper picture, *New York with Moon.* Exhibitions of her work were held annually until 1929 at the Intimate Gallery.

O'Keeffe established a painting style that very seldom overstepped the boundary into abstraction, in which every brushstroke or physical trace was expunged from the surface. Flatness and precision of handling dominated especially in her flower pieces, such as *Calla Lilies,* 1923, *Petunia and Coleus* or *Red Canna,* both 1924, but also in architectural motifs such as *The Shelton with Sunspots,* 1926. Occasionally, photographic effects such as reflection points in blinding backlight were employed. Notwithstanding the great charm of her motifs, O'Keeffe's style appeared quite unemotional, reflecting a detached coolness that corresponded to the cognitive step coming between an experience of nature and the shaping of aesthetic form. The rose as an artefact rather than as a projection screen for feminine feeling.

… into the desert

In May 1929, O'Keeffe undertook a journey with a friend to Taos, in the New Mexico desert. The spacious countryside, with its thin air and harsh light, became the artist's most important source of inspiration over the following decades. The sheer infinity of space in northern New Mexico encouraged her to call this vanishing point of her artistic quest "The Faraway". She collected animal bones scattered across the desert, and the wooden crosses set up by the Penitentes, a Catholic sect, also appeared in her compositions. In the following years, until Stieglitz' death in 1946, O'Keeffe alternated between Manhattan and the desert. Then she settled permanently in the Southwest, on a hacienda in Abiquiu near Ghost Ranch, where she worked for the following three decades. It was not until 1972, when her eyesight grew poorer, that she gave up painting.

Holger Liebs

1 **Two Calla Lilies on Pink,** 1928. Oil on canvas, 102 x 76 cm
2 **Arazee III (Jack-in-the-Pulpit III),** 1930. Oil on canvas, 102 x 76 cm

Meret Oppenheim

* 1913 in Berlin, Germany; † 1985 in Basle, Switzerland

"One is used to artists leading a life that suits them and to citizens turning a blind eye to this. But when a woman does the same, they all open their eyes."

"Freedom is not something you are given, but something you have to take"

Meret Oppenheim's oeuvre comprises more than a thousand works, yet her name remains forever linked with a single early work: the *Fur Covered Cup*, 1936, a coffee cup, saucer and spoon covered in Chinese gazelle fur. The idea for this object, one of the most famous of all Surrealist works, came by pure chance, as she once related in an anecdote. At a meeting with Dora Maar and Pablo Picasso in the Café de Flore in Paris, Oppenheim was wearing a bracelet she had designed herself, lined with ocelot fur. Picasso remarked that one could cover anything in fur, and Oppenheim agreed. Apparently, when the tea in her cup had gone cold, she called the waiter for "a little more fur". She would later transform this spontaneous association into a work of art that would be shown the same year at a Paris gallery and included in the New York Museum of Modern Art's "Fantastic Art, Dada, Surrealism" exhibition, where it was purchased by the director, Alfred Barr, for the museum's own collection. It was not until two years later, in 1938, that the *Fur Covered Cup* was given its "official" title – *Le déjeuner en fourrure* – by André Breton, one of the leading spokesmen of the Surrealist movement. Breton was referring, of course, not only to Edouard Manet's famous painting *Le déjeuner sur l'herbe*, 1863, which shows two naked women and two fully dressed men picnicking in a clearing, but also to Leopold von Sacher-Masoch's erotic novel *Venus im Pelz*, 1869, whose protagonist Severin maintains that a woman can only be a man's mistress or his slave, but never his equal partner. In giving the work this title, Breton projected onto it this hierarchical notion of the relationship between the sexes – a view that Oppenheim certainly did not share.

Meret Oppenheim grew up in southern Germany and Switzerland, and in 1932 – at the age of 18 – went to Paris to become an artist. She enrolled at the Académie de la Grande Chaumière, but preferred to work as a self-taught artist. In 1933, Alberto Giacometti and Hans (Jean) Arp visited her studio and introduced her to the Surrealist circle with whom she would exhibit regularly in the years that followed. During this time, she created drawing and paintings, poems and reports of dreams, as well as eccentric designs for appliances, with a remarkable blend of anthropomorphic and animal elements, including a pair of fur gloves with red-varnished fingernails peeping out (1936) or her *Table with Bird's Feet*, 1939, which stands on two legs with claw feet.

1

2

The public image of Meret Oppenheim was not shaped by her works alone, such as her *Seated Figure with Crossed Fingers*, 1933, generally regarded as a self-portrait with no individual facial traits or clear gender, allowing attributes to be projected on it from outside. In 1933, Man Ray asked the young artist to be his model for a series of erotic photographs. Probably the most famous of these images was created in the studio of the painter Louis Marcoussis. It shows Oppenheim seemingly lost in thought, leaning with an air of amusement on a printing press that looks for all the world like some medieval instrument of torture, her left forearm and palm covered in printer's ink. In May 1934, this photograph was published with Oppenheim's permission in the magazine *Minotaure*, and fuelled the myth of the fascinating child-woman that inspired an older generation of Surrealists.

Early fame and creative crisis

The fame that came so soon and – as it seemed – so effortlessly was to prove a heavy burden on Oppenheim's identity as an artist. She did not wish to be reduced to a recognisable style. In 1937, she returned to Switzerland because of the political situation and the threat of war. Her return marked the beginning of a period of creative crisis that continued until about 1954, dominated by a sense of having her "hands tied". Her last collaboration and final break with the Surrealists came in 1959, on the occasion of the Paris "Exposition inteRnatiOnale du Surréalisme (EROS)". Breton had invited Oppenheim to repeat the *Spring Banquet* she had organised in Berne for a circle of close friends: a feast served up on the body of a naked woman to be eaten by the guests without cutlery. Yet the Paris version of the banquet was transformed, in Oppenheim's view, into the very opposite of what she had originally intended as a feast for both men and women. Now the body became the passive object of a voyeuristic spectacle for a male audience.

It was not until the late 1960s that Oppenheim's complex and multifaceted oeuvre began to be rediscovered by a young generation of women artists in search of emancipation. When Oppenheim was awarded the Kunstpreis der Stadt Basel in 1975, she called on women, in her frequently-cited speech, "to prove through their way of life that they no longer accept the taboos that have held women in subjugation for thousands of years. Freedom is not something you are given, it is something you have to take." She herself had, in the meantime, taken the liberty of parodying her own myth. In 1970, she created a multiple entitled *Souvenir du déjeuner en fourrure*. It is a deliberately kitsch miniature version of the *Fur Covered Cup*, domesticated to a two-dimensional set with fake fur under an oval glass dome recalling a mass-produced museum-shop article. The fact that Oppenheim withdrew the seductive surface of the *Fur Covered Cup* from the reach of touch also indicates a tongue-in-cheek reminder that consuming is not the same as pleasure.

Barbara Hess

1 **Ma gouvernante – my nurse – Mein Kindermädchen,** 1936.
 Metal, leather, paper, 14 x 21 x 33 cm
2 **Object (Le Déjeuner en fourrure),** 1936. Fur Covered cup, saucer, spoon; cup:
 diameter 11 cm; saucer: diameter 24 cm;
 spoon: (l) 20 cm; overall (h) 7 cm
3 **Der grüne Zuschauer (Einer der zusieht, wie ein anderer stirbt),** 1933/1973.
 Green marble, gilded copper plate, 332 x 100 x 36 cm (without pedestal)

Elizabeth Peyton

* 1965 in Danbury (CT), USA; lives and works in New York (NY), USA

"In a way, you can be much more intimate with people you do not know."

Star-cult(ure)

In a sense, Elizabeth Peyton, who lives in New York City, was destined to be an artist from the very start, given that her parents were a hobby painter and a hobby writer. The influence of these two fields are evident in the work of this painter, draughtswoman and photographer. Her early drawings in particular include both portraits of pop and rock musicians such as John Lennon or Johnny Rotten – indeed Peyton is primarily known today for these quasi "post-modern icon paintings" – and scenes after Marcel Proust and William Shakespeare, as well as portraits of historical figures such as Napoleon's lover Mademoiselle George or Ludwig II. These portraits are based on her reading of biographies and novels, or on her interpretation of visual models such as drawings or photographs. Peyton almost never paints live models, not even nude ones; her models are almost always existing artefacts. Today, reading is still an important point of departure for her artistic work. That reading, however, is never just passive consumption, but is active in character, expressing itself, above all, in her sensitive revaluation, her emotional recording of the aesthetic models.

Peyton does not distinguish between "high" and "low" in her artistic work. She treats her protagonists from the supposedly "low culture" of pop and rock music in exactly the same way as she does the representatives of the "high culture" of literature or so-called "serious music". The artist herself once put it as follows: "I read *Melody Maker* much as I read Marcel Proust." What her "models" have in common is that they have all created a world for themselves, only to come to grief in that wonderful aesthetic act of creation. Yet in their time, they were an important source of inspiration for others. This applies to the Beatles' *Octopus' Garden* or to Marcel Proust's *Things Past* just as much as it does to Elvis Presley's Graceland or to the visions of Ludwig II of Bavaria. Peyton painted the latter king several times, like all her "stars". In *Ludwig*, 1994, painted in oil on wood – a clear allusion to traditional icon painting – he is standing against a vaguely suggested background, wearing a sky-blue suit, with his hair blowing in the wind, and with his eyes shining with pride and melancholy. As is the case here, Peyton's portraits are imbued with a mood of happiness and early sorrow. The "corporate identity" of the gallery of ancestors which she has selected is

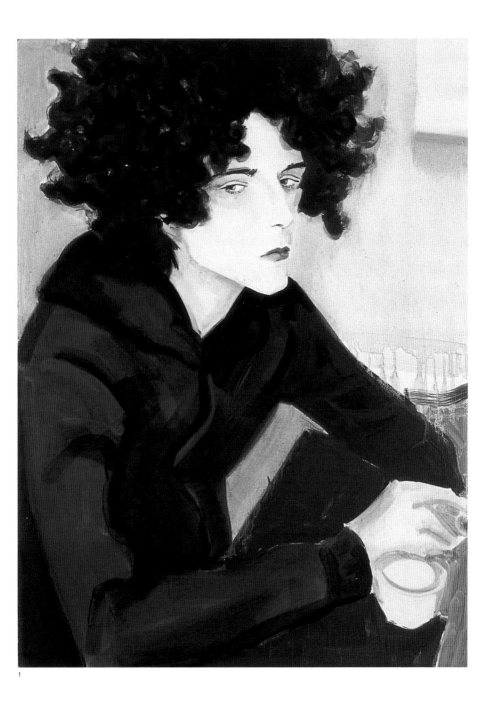

1

2

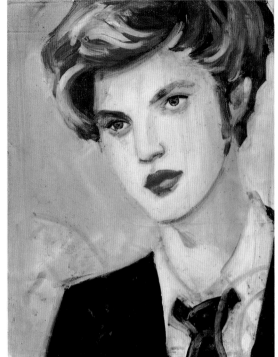

3

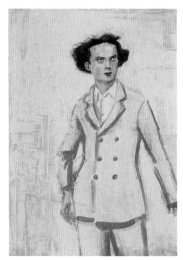

4

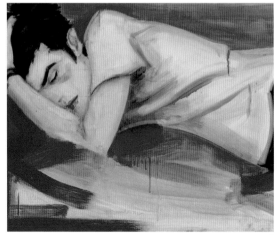

5

characterised by a tension between the utopian promise of pleasure and tragic self-destruction: the gallery includes, for example, the Sex Pistols punker Sid Vicious and grunge rock musician Kurt Cobain, both of whom, like Ludwig II long before them, committed suicide. And then there is Princess Di, who died young, and Oscar Wilde, whose demise resulted from his imprisonment for homosexuality.

Beyond place and time

Elizabeth Peyton's "stars" have another trait in common: their androgynous character, evident, for example, in the painting *Piotr*, 1996, which depicts her artist colleague Piotr Uklanski, who lives in New York, with a mug of coffee in his hand and wearing a red shirt in the tasteless style of the 1970s. The slim young man, seated slightly bent at the hip, is gazing melancholically out of the painting as if into the depths of a paradise he is dreaming of, his narrow eyes bright blue and full of longing. The work looks as if was painted with lipstick, and the background, too, is glaring red. Piotr's short dyed honey-blond hair and shapely lips are what give him an androgynous, almost feminine look. This not only bears witness to the artist's identification with her model; the androgynous aura is also a rejection of any attempt to construe genders as strictly separate. As a result, the person portrayed seems almost disembodied, suddenly becoming "essential", as Marcel Proust might have put it, in the sense that he has found his ideal essence beyond the customary understanding of roles and beyond the constraints of place and time. To achieve this very effect, Peyton portrays her sitters very much younger than they are. Like Oscar Wilde's Dorian Gray, they seem immune to the ageing process and thus to death.

Beyond intimacy and publicity

In her more recent works and exhibitions, the artist has often combined different media. Painting and photography, drawing and video enter into a dialogue with equal rights. This is seen, for example, in her artist's book *Craig*, 1998, where a photograph of the 16-year-old Ludwig II stands alongside a photo of Peyton's friend Craig, who in turn crops up in various drawings and paintings in the book. And then there are newspaper articles on the death of Elvis Presley and on the funeral of the "Queen of Hearts" Princess Di, as well as a watercolour of the coronation of Elizabeth II. The punk rocker Johnny Rotten pops up again, as do numerous drawings and paintings of Princess Di, whose early death provides the thematic counterpoint to Peyton's passion for her friend Craig. Here Peyton deals with the eternal drama of "Death and Glory", pacing out the intricate scenes both historically and in the charged area between intimacy and publicity. As she largely abandons authorship to the anonymous producers of the found (newspaper) photographs included in *Craig* and repeatedly alludes to popular figures, she succeeds in uncovering the collective character of longing and wishful thinking. She thus comes full circle, back to her early works.

Raimar Stange

1 **Berlin (Tony),** 2000. Oil on canvas, 102 x 76 cm
2 **Liam,** 1996. Oil on wood, 26 x 21 cm
3 **Piotr Passport Painting,** 1996. Oil on wood, 23 x 18 cm
4 **Ludwig,** 1984. Oil on wood, 36 x 28 cm
5 **Gavin sleeping,** 1998. Oil on canvas, 77 x 102 cm

Adrian Piper

*** 1948 in Harlem, New York (NY), USA; lives and works in Cape Cod (MA), USA**

"Interpersonal interactions are really the key to political transformation."

More than a performance

"I'm black." These words open Adrian Piper's video in her installation *Cornered*, 1988. The pale skin colour of the woman on the screen seems to contradict the claim made in the statement. In an impersonal, neutral tone of voice, Piper speaks of the questionableness of racial categories, an observation that is underlined by the birth certificates of her father, likewise light-skinned: attached to the wall behind the monitor, one of them identifies him as white, the other as black. As Piper continues, she confronts us with our own (possibly stereotyped) attitudes to racial identity: "The problem is not just my personal one, about racial identity," she declares. "It's also your problem, if you have a tendency to behave in a derogatory or insensitive manner towards blacks when you see none present."

Cornered brings together the central features of Piper's artistic endeavour: the dialogue principle, her scepticism concerning the visible, and the definition of the personal as political. Piper may include her own experience as a light-skinned black American in her work, but the fact is that racism, xenophobia and discrimination are not primarily her personal problem but are the results of social, political and economic factors. Insofar as this is the case, Piper's work should not be interpreted purely autobiographically, as critics of her work tend to do. It is far more the case that it adopts various standpoints on the question of how prejudices and stereotypes (of a racist and sexist nature in particular) are created and what role pictures play in the process.

Born in 1948 in New York City, Piper has evolved an approach coloured strongly by Minimalism and Concept Art, and thus by a certain distance with regard to the visual. Early works such as *Concrete Infinity 6" Square* or *Here and Now* (both 1968) or the *Hypothesis* series, 1969, were very much products of Concept Art's high valuation of the idea behind a work. Political developments in the late 1960s and early 1970s, however, prompted Piper to re-think her artistic strategy. She now combined the formal idiom of Minimalist Concept Art, which was perceived as too hermetic, with a direct use of her own person and body, declaring herself to be a "work of art".

Characteristic of this period were performances such as *Untitled Performance at Max's Kansas City, NYC*, 1970, or the *Catalysis* series, 1970/71. In the former, Piper, isolated from the world around her by leather gloves, a mask over her eyes, headphones and a nasal clip, moved about a popular artists' café in Manhattan, asserting her independence of the narcissism of the art avant-garde, as it were. In the *Catalysis* series she looked at the ways passers-by react to unusual forms of public behaviour, and wore a T-shirt reading "Wet Paint" around the streets of New York.

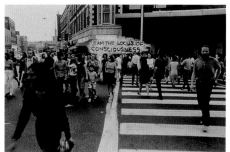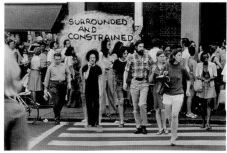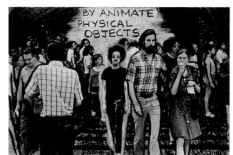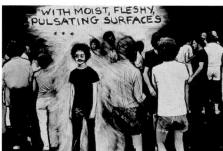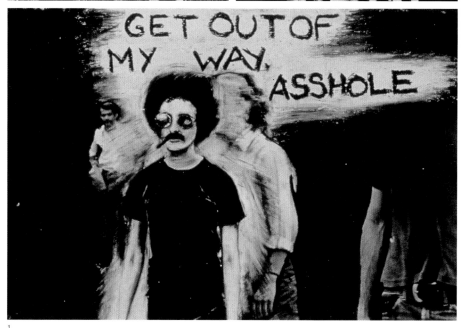

1

In these actions, Piper was testing tolerance levels towards what is perceived as "the other", towards whatever deviates from a behavioural norm. But in the *Mythic Being* series, 1974/75, she explicitly examined the construction of racial difference. Adopting the persona of an androgynous young man, wearing a black T-shirt, jeans, dark glasses, an Afro wig and a moustache, Piper presented the image that most defines social fears and stereotypes, according to which black men are frequently perceived as a potential threat: "I Embody Everything You Most Hate and Fear," Piper (in the role of this "mythic creature") ironically observed in a 1975 work combining image and text.

Piper's later multimedia installations and actions are consistent in pursuing these themes. Often they address the beholder directly. In *Art for the Art World Surface Pattern*, 1976, Piper papered the inner faces of a seemingly Minimalist white cube with newspaper clippings and photographs relating to a number of political events, from executions in Thailand to a revolt in South Africa. A voice on audio tape discussed the extent to which art can have a political impact, while the words "NOT A PERFORMANCE", printed over the clippings, emphasised that the events had lost none of their real political content through the act of artistic transformation. Similarly, *Four Intruders Plus Alarm System*, 1980, sets out to establish a communicative exchange with the beholder. Four photographs of black men, dramatically presented in lit display cases, were accompanied by tapes of various reactions to Piper's work, often rejecting it vehemently, in an eloquent reminder that dealing with the problem of racism can still breach a taboo, even with the supposedly liberal field of art.

Flexible categories

Piper creates situations in which those confronted with her work are obliged to review their own responses for example, in *Funk Lesson*, 1983, she introduces her predominantly white audience to the distinctive features of black funk music, while in *My Calling (Cards) #1 & #2*, 1986–90, she handed out visiting cards to those she had felt either sexually harassed by or discriminated against by racist remarks. In the installation *What It's Like, What It Is #3*, 1991, she reversed the usual structures of perception by featuring a black man on a video screen rejecting all the negative characteristics that are often ascribed to blacks.

Various though the media she uses have been, Piper's work since the 1970s has invariably aimed to provoke a immediate, emotional reaction in the beholder. Strikingly, she deploys particular recurring forms and images, by way of guaranteeing the attention of the audience. Above all, however, she uses serial variation as a means of ensuring that the uniqueness of a person cannot be perceived from a single point of view or by a simple act of categorisation. Piper, who has studied the philosophy of Immanuel Kant closely, is not concerned with any general rejection of categories, but she does insist that they must be flexible, and capable of change. It is this that guides her artistic work throughout: its many voices and perspectives and its irony are forever disrupting the structures of clichéd categorisations that are the foundation of discrimination.

Astrid Wege

1 The Mythic Being: I Am The Locus #1 – #5, 1975. Oil painting and chalk drawing on photograph, 20 x 25 cm
2 Funk Lessons, 1983. Performance, University of California, Berkeley (CA), USA
3 Funk Lessons, 1983. Performance, Anna Leonowens Gallery, Halifax, Nova Scotia, Canada

Bridget Riley

* 1931 in London, England; lives and works in London and Cornwall,
England, and in France

**"To treat images of the past as historical documents
or as evidence of outmoded concepts is wrong: they
are specific solutions to ongoing artistic problems –
and this is what makes them of interest today."**

The eye

Due to their serial structuring, various Op Art works – such as those of Victor Vasarely – have been redis-
covered in the context of electronic lounge projects and experimental music, and, as synaesthetic analogies between
acoustic and visual phenomena, have become part of the "planetary folklore" with which Vasarely always associated
them. Since our perceptions are now being reconditioned by the new media, it makes sense to recall the optical
experiments of the 1960s, which at the time were something like the signature of the period, later becoming its
everyday myth and design icon. Riley's work can also be considered within this context of retroactive reception,
although that does not do complete justice to her art.

From the start, Riley has been concerned with what she terms the "formal structures of seeing", just as were
the Impressionists and Pointillists in the 19th century. When the French painters of classical Modernism began work-
ing *en plein air*, they trusted, like the empirical scientists of the day, to the evidence provided by their eyes rather than
to the conventional schemes of imitating nature, understanding what they saw as primarily a spectacle of light and
colour. Now, it may seem a large leap from 19th-century colourism to Op Art, and indeed, the first exhibition of mod-
ern painting Riley ever saw, in 1947, was a show of van Gogh's work at the Tate Gallery in London. Her achievement,
as Robert Kudielka has pointed out, has consisted in using the means of abstract painting to take the step from
imagery oriented primarily to the colour spectrum to a spatial plastic approach to colour on the plane.

Riley grew up in Cornwall, spending the war years in the Padstow area. She received private instruction,
which allowed her largely to follow her own bent, and studied at Cheltenham College, where she concentrated on art
education. From 1949 to 1952, Riley attended Goldsmith's College of Art in London, later recalling that drawing from
the nude was about all she learned at art school. Until 1955, she continued her studies at the Royal College of Art,
where her fellow students included Frank Auerbach and Peter Blake. The urge to stake out a unique position in the
art world led to a period of deep self-doubt and eventually to a nervous breakdown. Riley turned to commercial art.

In 1958, she saw a Jackson Pollock show at the Whitechapel Art Gallery, and the following year, at a sum-
mer academy, her interest in Futurism and Neo-Impressionism was awakened. Riley met Maurice de Sausmarez, who
became her friend and mentor. She copied Georges Seurat's *Le Pont de Courbevoie*. Yet her last figurative picture,

1

Pink Landscape, 1960, was not so much in the vein of divisionistic colour separation rather it aimed at a complete synthesis of landscape depiction and chromatic event.

Following another creative crisis as well as her separation from de Sausmarez, Riley entered her "black and white period" 1961, the most famous phase of her career, in which she took light-dark contrasts to the extreme. The visual effects of her geometric formal repertoire were all too rapidly appropriated by trivial culture. She found a new partner in the painter Peter Sedgley. A key work at this time was *Kiss,* 1961, in which two monochrome black areas impinge such that the white dividing line can be read as a horizon. If this work was still indebted to hard-edge painting, the visual effects of permutations of black and white triangles (as in *Shiver,* 1964) or of black waves on a white ground (*Crest,* 1964), induced optical illusions of the kind seen in scientific experiments.

Op Art

Riley became a star. Her 1965 exhibition with Richard Feigenbaum in London was sold out before it opened. New York fashion boutiques decorated their display windows and clothing fabrics with Riley motifs. Other artists tried to turn this sudden popularity to their own ends, for example Josef Albers, who called Riley his "daughter", or Ad Reinhardt, who sought to protect her from "wolves". Riley undertook legal steps to prevent the unauthorised reproduction of her works, but in vain. Nevertheless, the disputes over the countless Op imitations did result in changes in American intellectual property law. Still, Riley was afraid her imagery had been worn out, as it were, for a long time to come. And, in fact, the reception of her works in the 1960s prevented a clear view of her later production.

Waves, stripes and lozenges

After using tinted grey values from 1965 to 1967, Riley again turned to straight colours (*Chant* and *Late Morning I,* both 1967). In 1968, she became the first woman painter ever to win the Grand Prize at the Venice Biennale, although the award ceremony was prevented by student demonstrations. Her first retrospective (1970/71) was seen by 40,000 visitors, more than any other solo exhibition of contemporary art at that period. Stripe combinations were used to cancel out individual colour identities in favour of a single colour "flow". Later paintings brought an even more intensive concern with colour. Like the earlier works, they were concerned with rhythm, dynamics and an exploitation of the tensions between individual colours and the colour continuum. At this point, Riley switched from acrylic to oil paint. After the artist had become acquainted with ancient Egyptian grave paintings during a trip to Egypt, she can be seen to be making an attempt in her pictures, which are now mainly organised on the basis of vertical stripes, to break up the unified colour effect in favour of individual colour values.

In the 1980s, Neo-Conceptual artists such as Philip Taaffe or Ross Bleckner took up Riley's insights, making obvious references to them in their work. Riley, who was meanwhile active as a guest professor and curator and advisor to museums, began to concentrate in 1986 on combinations of trapezoids. Her most recent work has combined wave and trapezoidal elements (*Rêve,* 1999).

Holger Liebs

1 Shade, 1981. Oil on canvas, 170 x 144 cm
2 Blaze 1, 1962. Emulsion on board, 109 x 109 cm

Pipilotti Rist

* 1962 in Rheintal, Switzerland; lives and works in Zurich, Switzerland, and Rotterdam, The Netherlands

"With no respect for technology, I ride towards the sun in the computer and with my brain tongue, mix the pictures just in front or just behind my eyelids."

A magic chamber full of moving pictures or video means: I see

Pipilotti Rist's emotional videos and pop-style installations, and her interdisciplinary work with music and moving images, as well as her witty cultivated personality and her constantly changing outfit, make her a pop star of the art scene. In 1997, she was even appointed director of the Swiss Expo, a position she gave up a year later.

Rist's colourful videos and video installations are exactly in keeping with the mood of the time. Her computer-manipulated films do not look cool, objective or intellectual, but very sensuous. A harmonious combination of soft music and dreamy pictures penetrates our subconscious, enabling the viewer to submerge him- or herself in the world of visions and everyday myths generated by the artist, whose associative sequence of images displays no linear narrative structure (with an explicit beginning and end). Underwater shots with splendid plant worlds, a kissing mouth filling a whole screen, bare feet in a yellow flowerbed or a naked female body decorated with strass crystals à la Ophelia in a meadow, a harmonious combination of body and nature, and trance-like music: Rist's richly imaginative and poetic images, sometimes deliberately kept blurred or distorted, allow us to forget everyday life.

As a child of the 1960s, Rist grew up with the medium of television but also with pop culture, and the popularity of her works is attributable to her effortless handling of the phenomena of mass culture. While studying at the College of Applied Art in Vienna, she made trick and super-8 films. In 1986, she changed to the video department of the Basle College of Design, at the same time changing her first name from Charlotte to Pipilotti. This latter was because her friends called her Pipi – after Pipi Longstocking – while her family called her Lotti. She appeared as a musician with the Les Reines Prochaines rock group, incorporating their music into her videos.

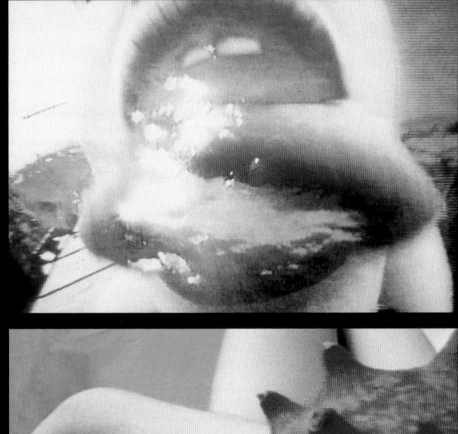

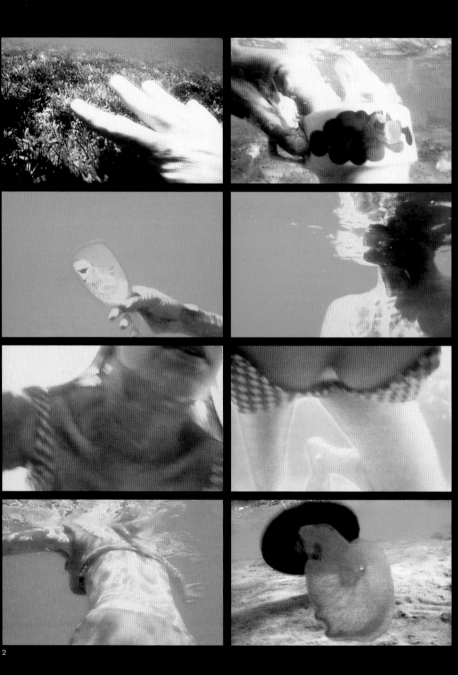

2

Between kitsch and dream

Her first video, *I'm not a girl who misses much*, was created in 1986, and shows her skipping up and down calling out the sentence of the title. In the clip *Entlastungen (Pipilotti's Fehler)* [Absolution (Pipilotti's Mistakes)], 1988, she worked with abstract-painterly TV screen interference, distorting and thus fictionalising the image of reality. In 1989, she produced the video installation *Die Tempodrosslerin saust* (The Speed Throttler Roars) jointly with Muda Mathis: on the wall hung 175 different handbags, while in front of them 14 monitors were set up alluding to the road to Calvary. Rist later compared the video "with a compact handbag with room for everything: painting, technology, speech, music, movement, crummy running images, poetry, hustle and bustle, intimations of mortality, sex and friendliness." The video clip *Pickelporno* (Pimple Porno), 1992, was what finally made her famous. Numerous natural features – icebergs, waves, flowers, clouds and fire – provide an obbligato accompaniment to a couple physically coming together. Her subsequent videos likewise take up the topics of eroticism, sensuality, sexuality and the female body. In *Selbstlos im Lavabad* (Selfless in the Bath of Lava), 1994, she looks at the viewer from a small monitor recessed into a wooden floor, her upper body naked, surrounded by sea of flame, screaming for help. The installation *Das Zimmer* (The Room) dates from the same year. An outsize red couch with two armchairs and a huge remote control and small TV are a humorous but critical reference to the importance of the mass medium in a consumer world. Adults become children, re-recalling the magic that the goggle box exercised on the first TV generation. Her extensive, symmetrically constructed video projection *Sip My Ocean*, 1996, is installed in the corner of a room, the corner forming a central axis. The floor of the dark room is laid with soft blue carpet. The video pictures, accompanied by melodious music and soft female song, are underwater shots of a swimming woman and colourful plants as well as everyday objects – such as kitchen appliances and a mini TV – that are falling into the sea. They all drift about and then meet on the central axis, before vanishing out of the room together.

Cocky, shrill and colourful

Pipilotti Rist stirs up the mind using art and pop, everyday life and TV, addressing all the senses and arousing positive emotions. She also undermines taboos and clichés with kitsch and humour. In her video installation *Ever is Over All*, 1997, a woman with an outsize phallic flower stalk cheerfully smashes the windows of parked cars, benevolently watched by a policewoman. The "flowers instead of weapons" motto of the Flower Power generation is translated into a light-hearted picture story as realistic satire. *Nothing*, a machine that produces and fires thick, milky-white and smoke-filled soap bubbles like cannonballs at set intervals, was exhibited at the Venice Biennale in 1999. In the same year, Rist was awarded the Wolfgang Hahn Prize in Cologne, where she installed two amply laid-out, tapering, flesh-coloured wall sculptures in the Ludwig Museum. If the visitor stuck his head in the circular openings, he saw various videotapes inside. Rist's work *Eine Spitze in den Westen, ein Blick in den Osten* (A Point to the West, a Glance to the East) is formally reminiscent of the visual line of a videotape and the projection head of a video beamer: it isolates the viewer, separates head and body and concentrates the gaze on the videos – a move that brings seeing and experiencing into harmony.

Ulrike Lehmann

1 **Pickelporno,** 1992. Video stills
2 **Magnanimity Mate With Me /Sip my Ocean,** 1994-1996. Video stills

Niki de Saint Phalle

* 1930 in Neuilly-sur-Seine, France; † 2002 in San Diego, California, USA

"If a woman really wants to take the path to the pinnacle of world art, then she can. I am proof of this!"

Power to the Nanas

During her lifetime, Niki de Saint Phalle has already become the immortal heroine of a whole generation of women, the myth of a woman who has succeeded in breaking out of the traditional role ascribed to her and achieving self-fulfilment in her art. Christened Catherine Marie-Agnès Fal de Saint Phalle, she was born in 1930 near Paris to a wealthy French-American banking family, subsequently growing up in New York. At first, Saint Phalle's career promised to be everything that might be expected of the daughter of such a privileged family. However, having been abused by her father at the age of eleven, she suffered from a behavioural disorder and had to change schools several times. At the age of 18, she ran away from home, married Harry Mathews and worked as a photo model. She gave birth to a daughter when she was 20, then attended acting school. Four years later her son was born. After a serious nervous breakdown which required treatment in hospital, she decided to become an artist, because painting had helped her to deal with the crisis.

In 1960, Saint Phalle met the sculptor Jean Tinguely in Paris and left her husband and children to live with him. She started making assemblages of plaster and found objects, into which she integrated plastic bags full of paint. In staged happenings, she took pot shots at these reliefs, with the result that the paint was splattered on the white plaster. She called the resulting works *Tirs* (Shots). "I was shooting at men, society and its injustice, and myself… I was totally addicted to this macabre but delightful ritual." The art critic Pierre Réstany nominated Saint Phalle for the artists' group Nouveaux Réalistes, to which Arman, César, Christo, Yves Klein, Daniel Spoerri and other male artists belonged. After two years of provocative shooting happenings, she retreated into an inner, more feminine world and began to paint brides, pregnant women and whores, "different roles which women can assume in society".

In 1965, Niki de Saint Phalle created her first Nanas – those voluminous, brightly coloured sculptures of women that have made her world famous. Inspired by her pregnant friend Clarice Rivers, she initially formed them out of wool, wire and papier mâché, later out of polyester. The following years were highly productive. In Stockholm, she had a 28-metre-long reclining Nana *Hon* (She) erected (1966); together with Jean Tinguely she produced a 15-

part group of figures for the roof of the French pavilion at the World Exposition in Montréal (1967); her play *All About Me* was staged in Kassel (1968); in the South of France she had three Nana houses built and undertook her first architectural project (1969–1972); and her film *Daddy* was premièred in New York (1973).

A place to dream

In 1971, the year in which her granddaughter was born, Saint Phalle married Jean Tinguely. As a result of inhaling poisonous polyester fumes while producing her Nanas, her lungs were irreparably damaged, with the result that in the mid-1970s she spent time in several Swiss health resorts to alleviate the problem. On lonely walks in the mountains, the artist hit on the idea for a sculpture park, "a place to dream, a garden of joy and fantasy". Italian friends of hers placed a piece of land at her disposal in Garavicchio in Tuscany, and at her own expense she set about laying the *Giardino dei Tarocchi*: monumental metal figures based on the 22 tarot card motifs, covered in cement and inlaid with mosaics of mirror, glass and ceramic. The largest of these is a sphinx representing the card of the empress. During the more than ten years required to lay out this tarot garden, Saint Phalle set up house inside that Sphinx-like figure, living and working in her belly and sleeping in her left breast. "Twenty years ago I left my children for my art. Here, I myself lived inside a mother figure, and in those years I grew closer to them again." In 1993, the garden was declared part of the French cultural heritage on Italian territory and opened to the general public.

In late summer 1991, Jean Tinguely died suddenly. Although the two had lived with different partners, they had never really fully separated and remained good friends, telephoning daily and collaborating on several works: the *Fontaine de Stravinsky*, 1983, beside the Centre Georges Pompidou in Paris, and the *Château-Chinon* fountain, 1988, in Château-Chinon, the home town of the former French president François Mitterrand. They had been planning a 15-metre-high stele for the patio of the Bundeskunsthalle in Bonn.

A new Noah's Ark

As Tinguely's widow, Niki de Saint Phalle had to administer the artist's estate and decided to donate his works to the city of Basel, where a new Tinguely Museum was to be built. Before it opened in 1996, she left Europe to move to southern California. Her lung problem had become a cause of serious concern, and she hoped it would improve in a warm climate. Moreover, she was half American and the Americans loved her art. Saint Phalle worked over the death of her former partner in her moving reliefs, the *Tableaux éclatés*, 1992/93, the motifs of which – controlled by motors – fall apart and back together again. She calls these reliefs "Méta-Tinguely" and they remind her of Jean Tinguely's kinetic sculptures and the beginning of their work together.

The home the artist had chosen for herself soon began to exert an influence on her new works: the glowing colours of the houses in La Jolla, and in particular the indigenous animals. She models gulls, dolphins, seals and killer whales, painting them in bright colours. A project she had repeatedly postponed assumed a new relevance: a Noah's Ark with 39 animals for Jerusalem. Unlike the biblical Ark, the work is to depict the animals not entering but leaving the ark – for safe ground. Niki de Saint Phalle, too, seems to have finally reached her destination.

Uta Grosenick

Niki de Saint Phalle has always been believed that artists are part of a movement whose members are not assessed and distinguished according to race, religion or gender. For this reason, she has refused to be part of numerous exhibitions and publications devoted exclusively to women artists, and also did not make any pictures available for this book.

Cindy Sherman

* 1954 in Glen Ridge (NJ), USA; lives and works in New York (NY), USA

"A degree of hyper-ugliness has always fascinated me. Things that were considered unattractive and undesirable interested me particularly. And I do find things like that really beautiful."

Peeping Cindy

In the 1970s, Performance Art and Body Art increasingly addressed the pictorial media, especially the blueprints of femininity disseminated by them. In the artistic fallout, the body was consequently often presented as an interchangeable symbol within the system of the mass media or deployed as malleable artistic material. For other artists, the embodiment of self was what mattered, the body serving to ensure an authentic female essence. Cindy Sherman's early works could easily be explained by this artistic context, but also by her own way of life or by the pleasure she took – as she has said in interviews – in dressing up and in making use of disguise. Yet a biographical interpretation would fail to appreciate that she has only ever seen herself as an actress participating in her photographic sets and that it has never been a matter of Cindy Sherman the person. This applies to the *Untitled Film Stills*, started in 1977, a series of black-and-white photos that first brought her to international attention. In these stills, she presents imaginary scenes from films never made, films in the style of B or horror movies as well as the *nouvelle vague*. She stages herself, mostly rather clumsily, in cliché-ridden female poses hinting at a melodramatic or kitschy story. As both photographer and actress, Sherman is always simultaneously the subject and object of her work. She thus plays out culturally defined women's roles that are reproduced in the various mass-media genres.

One of her working methods is to expose structurally the voyeuristic aspect of looking, as in *Untitled Film Still No. 2*, 1977. Through an open door, we see a woman looking at herself in a bathroom mirror. Such similar constellations of gazes, which at one and the same time create themes and subvert the seductive character of bodies but also the gloss of a photographic image, are also typical of *Centerfolds,* realised in 1981. This series of photos shows women reclining or huddled up after being photographed for the centrefold of a porn magazine. Admittedly, a subtle sense of absence seems to withdraw them from the visual probe of the camera, since they do not look at the camera in the normal way of porn photography. Rather, their gaze seems to be directed towards an indeterminate distance outside the pictorial field. Their bodies, too, stray beyond the pictorial borders or vanish in shadow, so that they are not visually comprehensible as complete figures.

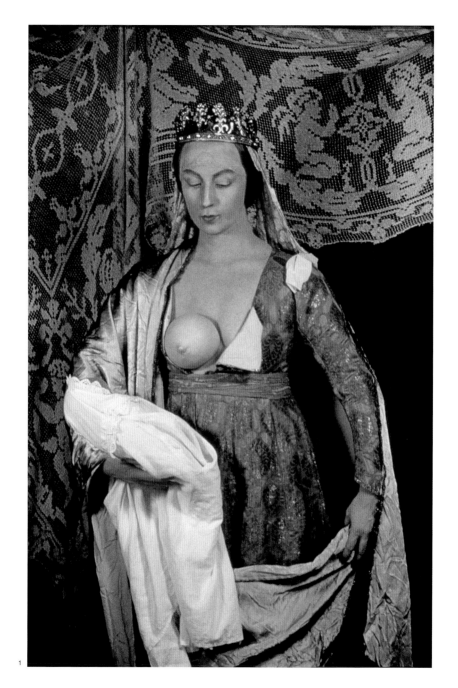

1

2

3

4

Since the 1980s, Sherman has also accepted commissions from fashion designers, creating for example adverts that run grotesquely counter to the usual clichés of female beauty by means of absurd theatricalities such as false teeth, scars, grimaces, deformed body parts and unflattering poses. Thus, typically enough, a work commissioned by Dorothee Bis was rejected by the company, while in the late 1990s Comme des Garçons commissioned a whole series from her. In *Fairy Tales*, shot between 1985 and 1989, Sherman explored the tales and fairy tales of the Grimm brothers. The viewer is exposed to scenarios that evoke eerie sensations, but which – unlike children's fairy stories – do not leave behind a promise of happiness. What remains are open changeable bodies without definite tangible form.

History portraits

Whereas 1960s and 1970s performance artists still used their bodies as strategic alternatives to the public representation of women by bringing their corporeal features into play, Sherman has increasingly withdrawn from her pictures as an actress, leaving the field to dolls and artificial limbs. In her *History Portraits*, 1988–90, she contrives old-master-style portraits, playing with pictorial symbols and arrangements familiar from the originals which she deploys in a disturbingly altered manner. She swaps sexes around and presents the illusionist techniques of an apparently authentic but in fact idealising portrait painting. In *Sex Pictures*, 1992, Sherman works more explicitly than before at taking the lid off erotic fetishism and the cultural attributes of the female body. The latter is seen not as a locus for finding definite identify, but as an unstable changeable construct, always in danger of becoming a scene of horror and fragmentation. The female body becomes a traumatic agent constantly subverting the orderliness of the visible: body fluids that are no longer clearly classifiable, sexes that are not defined unambiguously, hybrids formed from man and beast. Phenomena of dissolution on the frontiers between the subject and otherness are formally run through, while undertones of parody constantly colour the atmosphere. For Sherman's creatures claim no naturalness for themselves. Theirs is an artificiality theatrically presented with the aid of cheap tricks such as exaggerated coloration or visible seams joining artificial body parts.

Sherman adopts a similar approach in her first cinema film *Office Killer*, 1997, which is about a shy female office worker who turns the dilemma of her social marginalisation into criminal energy, making a career as a serial killer. The corpses of her colleagues pile up in her cellar like the utensils and artificial limbs in Sherman's studio. In her latest series, *1999*, which alludes to the surrealist photographic sets of Man Ray or Claude Cahun, Sherman returns to black-and-white photography, creating set pieces of battered, dismembered and reassembled plastic figures which with their gaze appear to address the viewer often directly, sometimes scornfully, and in a traumatised or almost aggressive manner. Cindy Sherman's ability to disturb lies in both this ambiguity and these fractures, but also in her changing strategies and orientations, as well as in her turns of parody, all of which characterise her work.

Ilka Becker

1 **Untitled,** 1989. Colour photograph, 170 x 142 cm
2 **Untitled,** 1987. Colour photograph, 121 x 182 cm
3 **Untitled,** 2000. Colour photograph, 76 x 51 cm
4 **Untitled,** 1994. Colour photograph, 169 x 109 cm

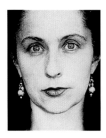

Kiki Smith

* 1954 in Nuremberg, Germany; lives and works in New York (NY), USA

"The body is our common denominator and the stage for our pleasures and our sorrows. I want to express through it who we are, how we live and die."

Art as journey into the cosmos

As the daughter of opera singer Jane Smith and Minimalist artist Tony Smith, Kiki Smith grew up in an artistic family. She and her sisters helped their father by building paper models for his sculptures. As a teenager, Kiki joined the hippie movement and enthused about back-to-nature ideas. She took an interest in popular art and in crafts, and admired the work of Frida Kahlo. She spent a year in San Francisco living with the Tubes rock group. At the age of 24, she studied at the Hartford School of Art in Connecticut for three terms, drawing still lifes, mainly round pill boxes and cigarette packets. Later, she saw her encounter with these noxious substances as the beginning of her artistic fascination with the body.

In 1976, Smith moved to New York, worked in the Tin Pan Alley Bar, and became a member of the Collaborative Projects Inc. group of artists (Colab for short), whose particular thing was creatively transforming everyday objects, selling the products in A More Shop. The breakdown of the barriers between artwork and utilitarian object, between applied, decorative and fine art, was also characteristic of Smith's later work. In 1979, a year before he died, her father gave her a copy of *Gray's Anatomy*, and she drew the cell structures and innards of the human body from it. In 1980, she exhibited her large-scale anatomical drawings for the first time, in a group exhibition. The death of her father "heralded my real birth as an artist". Her first reaction to his death was to put a latex hand she had found in the street into her aquarium (later into a preserving jar) and let algae accumulate on it. *Hand in Jar*, 1983, was a key experience for her that was to influence her subsequent artistic work. She investigated the interdependence of nature and world as collaboration and teamwork, and took an interest in parasitic infestation, symbiotic relationships and the interfaces of life and death. The algae growing in the *Hand in Jar* as dead matter became for their part a living body again. Resurrection, reanimation and regeneration became henceforth leitmotifs in her work. She delved into the relevant literature to read about the way the human body was treated and how its significance evolved from Antiquity to the Middle Ages and the Renaissance. The embroidered drawings *Nervous Giants*, 1987, were a further investigation of the body as a system, of its symbolic values and significance.

Numerous drawings and sculptures date from this time, made of sundry materials such as glass, porcelain, paper, clay or bronze. They depict innards and parts of the body, such as *Ribcage*, 1987 (a ribcage), *Shield*, 1988 (a

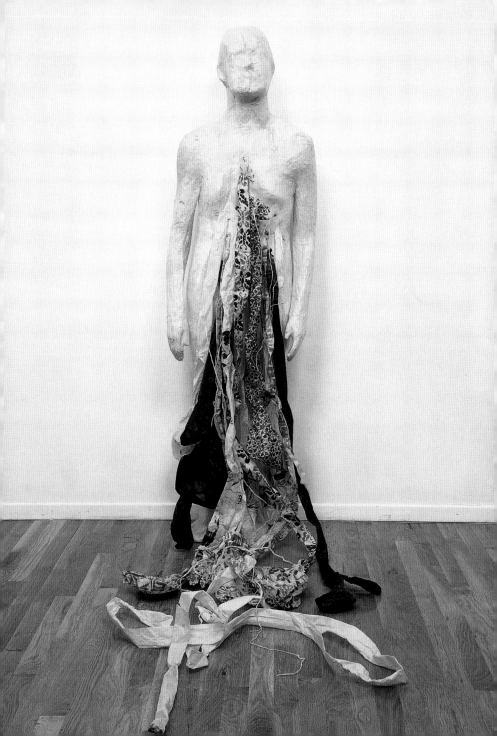

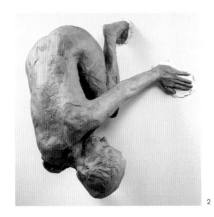

2

3

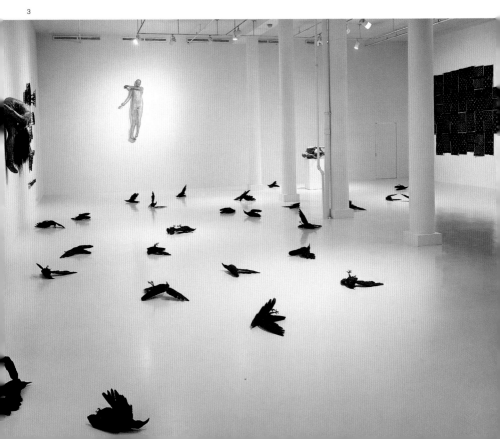

pregnant belly as a shield), *Womb*, 1986 (a womb in the form of two empty nutshell halves) or *Second Choice*, 1987 (various organs sitting like fruit in a ceramic fruit bowl, as a reaction to the trade in organs). At the same time, Smith did drawings of embryos as symbols of birth, e.g. *All Souls*, 1988. She is not interested in scientific presentation (unlike Leonardo da Vinci for example), but in expressing emotional and sensuous connotations related to her own experiences. The body parts shocked the public, and, appropriating Mary Shelley's homunculus hero, whom she had admired in her youth, Smith called herself Kiki Frankenstein.

"Kiki Frankenstein"

Her first whole-body figure was *Untitled*, 1987, which was contrasted with X-ray photos. When Kiki's sister Beatrice died of AIDS the following year, her sculptures became more potent symbols of inner injury and vulnerability, such as the erect flayed *Virgin Mary*, *Tale*, 1992, a female figure crawling on all fours dragging a long trail of excrement behind her, or *Blood Pool*, 1992, a reclining female body in embryonic position, her spine open at the back.

Kiki Smith draws inspiration from art historical works such as Grünewald's Isenheim altar, from biblical and mythical figures such as Lilith, Lot's wife or Mary Magdalene, but also from fairy stories and her own dreams. When, in 1992, she dreamt that she was to liberate a bird, it became at one and the same time a blow for freedom and a turning point in her own artistic endeavours. In *Getting the Bird Out*, 1992 – a bird hanging on a thread rising from the mouth of a human head – she related man to animal, increasingly foregrounded the ambivalent humanity-nature-the cosmos relationship between romanticism and exploitation, and began to see the world as a whole in the reality of its dichotomies. Alongside pictures of the moon (*Moon* or *Thirteen Moons*, both 1997), of the stars and of the continents, she developed enchanted poetic ensembles that seem – like a fairy story – as if transported from the world or to come from another age, while remaining eloquent of it. For the *Paradise Cage* exhibition in the Museum of Contemporary Art in Los Angeles in 1996, she and the Coop Himmelb(l)au group of architects produced an impressive cosmic scenario of stars and 28 glass animals, which were placed on a large, circular, blue ground surrounded by tall steel rods, recalling Noah's Ark or other legends. In soft hatching, Smith depicted animals like the wolf that are partly threatened with extinction and yet live on in fairy stories and fables as ambiguous symbols, combining them with representations of hands, crystals and stars (*Peabody [Animal Drawings]*, 1996). In her video *Night Time Wolf*, 1999, a digital animation of drawings, a white wolf is shown against a black background, loping untiringly towards an unknown destination – the future – yet looking the viewer meantime directly in the eye.

Kiki Smith's works unite past and future with a view to making the excesses of the present and the individual's role in the world more comprehensible. She creates a new feeling for nature and the human body, re-animates its significance in a technologically and scientifically oriented world, and provokes reflection with shocking but also poetic images.

Ulrike Lehmann

1 **Untitled,** 1993. Nepal paper and methyl cellulose, 160 x 47 x 390 cm
2 **Lilith,** 1994. Papier mâché and glass, 43 x 80 x 81 cm
3 **Jersey Crows,** 1995. 27 parts, each 16 x 45 x 28 cm to 41 x 50 x 60 cm.
Installation view, PaceWildenstein, New York (NY), USA

Rosemarie Trockel

* 1952 in Schwerte, Germany; lives and works in Cologne, Germany

"Art about women's art is just as boring as art by men about men's art."

Between feminism and science

Rosemarie Trockel is an artist who works with every conceivable medium and form. Her previous, continually changing and ambivalent oeuvre, shot through with arcane references to art history, might at first appear not to be from a single hand, and yet numerous self-references are detectable.

Trockel, who originally planned to become a biologist, and who attended a school of applied art, the Cologne's Werkkunstschule, from 1974 to 1980, especially likes to take as her subject matter anthropological and scientific phenomena. Animals (dogs, but above all, monkeys as alter egos and "mimickers" of human beings) have appeared in every medium and phase of her career as subjects and symbols. She investigates patterns of thought and behaviour, and her videos suggest the empirical approach of scientific observation and study. A case in point is the video *Julia, 10-20 Years,* 1998, a long-term study of a girl's development. Yet despite her apparently rational methods, Trockel's pieces abound with irony (sometimes directed against herself), humour and poetry. And not rarely they are based on feminist convictions. In reply to Beuys' statement that "Every man is an artist", Trockel's motto since 1993 has been: "Every animal is a female artist."

Trockel's reputation was established by knitted images, first shown in 1985 at the Rheinisches Landesmuseum, Bonn, which were, and still are, a provocation to the art world. Abstract patterns or familiar symbols – such as the Playboy rabbit, hammer and sickle, or woolmark – were introduced into the knitted image as integral parts of the picture support. By choosing the material of yarn and the activity of knitting, considered typically female, Trockel set out to test the validity of this underrated medium in the context of fine art. At the same time, she subverted the issue by having each one-off image made industrially by computer, rather than creating it by hand. This ran counter not only to the classical idea of painting, but also to accepted methods of mass production.

In addition, many of Trockel's knitted pictures represented ironic commentaries on works by other artists. Thus *Joy,* 1998, with its repeating pattern of blue sailboats in tile-like squares, was a reply to Sigmar Polke's *Carl Andre in Delft,* while *Cogito ergo sum,* 1988, referred to Kasimir Malevich's *Black Square.* The theme of yarn and knitting continued to inform subsequent works. The object *I See Red Wool,* 1985/92, a ball of red yarn with an eye gazing from its centre, was a self-ironic commentary on Trockel's own early knitted pictures. Her video film *Untitled*

(Woolfilm), 1992, showed a woman in a black sweater which was unravelled from the bottom up until the woman in the small image was naked, a large empty white surface appearing at the end, as if to invoke a *horror vacui.* Trockel's one-minute black-and-white short film *A la motte,* 1993, was a well-nigh analytic study of the destruction of knitwear by moths. At the end, the film was repeated in reverse, suddenly making the process appear productive and creative. At a 1995 show in Vienna's Galerie Metropol, the artist presented psychologically penetrating portraits of her family, in the media of plaster and drawing. Her self-portrait, by contrast, was done by means of stitches, in reference to her knitted imagery.

With the *Electric Range Pictures* (from 1991), Trockel took up another femininely connoted medium, simultaneously commenting on the emergent Neo Geo style. The video *Interview,* 1994, was linked with this group of paintings and sculptures. It represented a burner plate, multiplied with the aid of a computer and juxtaposed to form diverse configurations, creating the impression of a heated question-and-answer debate.

Human beings as observers

The video medium, adopted in 1978, took on increasing weight in Trockel's oeuvre. In *Animal Films,* 1978–90, she combined sequences from animal films and photographs taken from television. Further films on the subject followed, such as *Parade,* 1993, abstract configurations formed by caterpillars in a natural setting, or *Napoli,* 1994, a flock of birds that created the impression of moving abstract imagery, accompanied by music. In 1994, Trockel's videos had their first showing, under the title *Anima,* at the Museum für Angewandte Kunst, Vienna. In 1999, she represented Germany at the Venice Biennale, presenting three related films at the German Pavilion. On view in the main room was a greatly enlarged, black-and-white eye that looked from left to right – a symbol of the perception of art, but also evoking the Orwellian vision of "Big Brother Is Watching You" as well as the ancient symbol of the Eye of God. In the room on the left, Trockel showed a small-format projection of a film about a playground and children in a soapbox race, in which the role of the spectator and the factors of time, speed, behaviour and memory were addressed. By means of double exposures, slow motion and blurring, Trockel reawakened memories of her own childhood. In the room to the right, the film *Sleeping Pill* was on view. It showed a room full of people who, as if in a behavioural experiment, were resting or sleeping in cocoons suspended from the ceiling or on mattresses spread around the floor. Yet continual disturbances from the people's coming and going, getting up and lying down again, dominated the surreal scene. Here, too, the artist toyed with viewers' expectations regarding the normality of certain behaviour.

In 1996, Trockel began collaborating on joint projects with Carsten Höller, an artist and biologist. For documenta X in Kassel, they built a *House for Pigs and People,* a sort of experimental lab and observation post for behavioural research which drew crowds of viewers. At Expo 2000, the Hanover World Fair, the two artists displayed an eye-shaped pavilion as a *House for Pigeon, Person and Rat (1:1 Scale Model).* At irregular intervals, 20 animal models made of aluminium moved mechanically through the air, emerged from the wall, or crept along the floor. In their midst, on a ramp, stood a person, in the role of observer.

Rosemarie Trockel's works address the themes of perception and recognition, memory and experience, and an involvement with her art elicits reactions of this very nature. Yet her work never allows for any hard and fast interpretation. The diversity of media and themes within her oeuvre as a whole is matched by the complexity and ambiguity of each individual work.

Ulrike Lehmann

1 **Untitled,** 1989. Wool, 185 x 150 cm
2 **Fury I,** 1993. Mixed media, 100 x 100 cm
3 **Fury II,** 1993. Mixed media, 100 x 100 cm
4 **Kevin at Noon,** 2000. Coloured pencil on paper, 71 x 100 cm

Rachel Whiteread

* 1963 in London, England; lives and works in London

"I look like the you I turned into, being your imprint. You are exactly what is lost since only you would fit the mould which I have become."

Spectacular sculptures

"The inner world of the outer world of the inner world" – Peter Handke's phrase would be an apt motto for the sculptural oeuvre of Rachel Whiteread. The London artist, who also works in the media of drawing, photography and video, has focused since 1988 on the theme of the inner life of mundane utilitarian objects and spaces such as bathtubs, closets, washbasins, entire rooms and houses. She has developed a casting process by means of which a negative form can be produced, what she calls a "perfect copy of the interior" of such things.

A good example of Whiteread's technique is the sculpture *Ghost,* 1990. At 468 Archway Road, North London, she found a room in a typical English house of the early 19th century. The room evinced all the elements we associate with such architecture: door, windows, fireplace, wallpaper remnants, plank floor, light switches, skirting boards, window ledges. The artist proceeded to cast this interior in plaster, section by section. She decided to do without moulds and tried to avoid every intermediate step, instead relying on a simple direct casting process. Traces of use on the room's walls were faithfully recorded on the surface of the cast. Finally Whiteread assembled the separate blocks, confronting the viewer with the volume of the room transformed into a solid. We see a walled-in room, a space whose negative impression prevents not only access, but also the existence of any life there.

Set up in an exhibition space, the lapidary yet alien piece *Ghost* conveys an eerie sense of fear that approaches the traumatic. One recalls Freud's theory that the eerie represents a return of suppressed emotions to the surface. And then there is the story of the Arctic explorer who was caught in his igloo during an extreme cold wave. With every breath he took, the exhaled air froze on the inner wall of the igloo, so that the man, who had to breathe to stay alive, virtually walled himself in by breathing – a fatal trap between the poles of shelter and confinement.

Among the most compelling aspects of *Ghost* is the negative shape of a light switch. Here we are confronted with a sign of the interaction between the room and the people who once occupied it. Even though they are not present, as is almost always the case in Whiteread's work, these people's existence makes itself felt in the traces they have left behind. The scale of her pieces, neither reduced nor enlarged but life-sized, also makes reference to human existence.

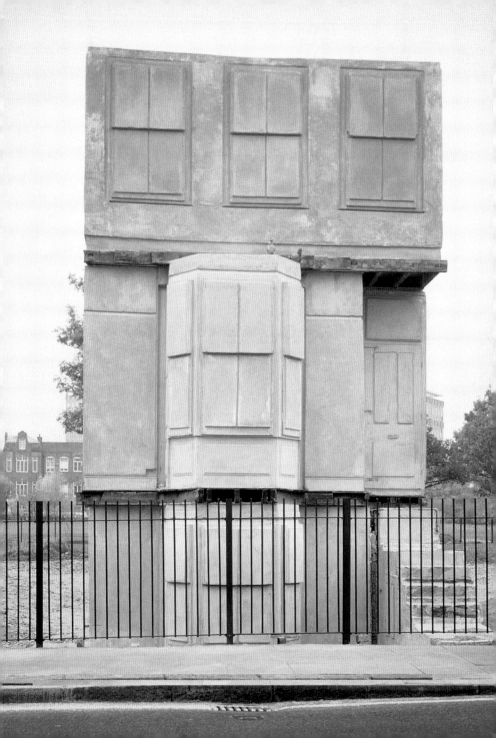

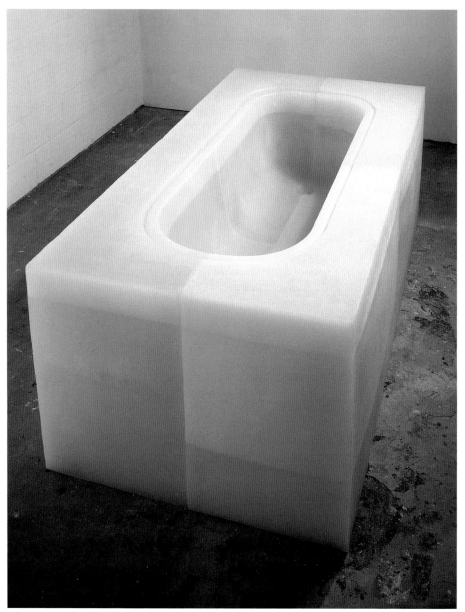

2

The anthropomorphic character of her closets (*Closet*, 1988), beds (*Untitled [Air Bed]*, 1992), or bathtubs (*Esther*, 1990), is further underscored by the body-related mundaneness, the all-too-human nature of the various functions possessed by the objects she casts – dressing, sleeping, washing or dwelling. Indicative of this, Whiteread developed her casting process on the basis of casts taken from her own body during her student years.

A life-sized past

In her sculpture *House*, 1993, the artist's work took on a monumental quality, despite the fact that in this case, too, the original size of the house on Grove Road was retained. After casting it in concrete, she removed the exterior walls and the roof, leaving a block-like solid impression of the rooms standing. Still, compared to artworks intended for showing in a gallery or museum, the dimensions of this three-storey building in London's East End were unusually large, resulting in a sense of monumentality. The private interiors of the former residential building took on an archetypal character. At the same time, the notion of the "security of one's own four walls" was subverted, and the comforting idea of "my home is my castle" was undermined by exhibiting private interiors for all to see. This factor triggered harsh criticism and protest in the immediate neighbourhood, and, in January 1994, *House* was demolished by decision of the irate populace. All that remained were black-and-white photos and a video documentation, which can now be shown at art exhibitions – that is, in other interior spaces.

Memento mori

A design for a Holocaust monument in Vienna is one of Whiteread's more recent projects. This is a "nameless library" cast in light-grey concrete, installed in an area of ten by seven metres on Judenplatz, in the immediate vicinity of the Or Sarua Synagogue. The walls of the library, including bookshelves and a blind door, are turned outwards to public view, as a memorial to the extermination of over 65,000 Austrian Jews by the Nazis. In addition, the piece recalls the fact that the survival of Judaism during its millennia-long diaspora rested not least on books and writings. Rachel Whiteread's "books of horror" are cast in natural rubber and fibreglass, such that each separate page remains visible. Even more clearly than in other works, memory and a record of transitoriness play a key role here.

Raimar Stange

1 **Untitled (House),** 1993. Installation view, corner of Grove Road and Roman Road, London, England
2 **Untitled (Yellow Bath),** 1996. Cast resin, polystyrene, 80 x 207 x 110 cm

Andrea Zittel

* 1965 in Escondido (CA), USA; lives and works in New York (NY) and Altadena (CA), USA

"I start out from the standpoint of a consumer, not from that of an expert."

Less is more

An inundation of stimuli and pressure to consume are two of the operative terms continually used with regard to the influence of mass culture on the individual. The former supposedly leads to distraction and nervous overloading, the latter to an awakening of futile needs, prestige thinking, and meaningless superficiality. Andrea Zittel's blithe "applied art", at first glance ascetic but in fact quite sensuous, can be interpreted against the background of this discussion. She stands, as it were, on the other shore, and her mundane "art world" lacks every form of moralising attack, overhasty critique, or complaining cultural pessimism. Rather, the lifestyle she offers is rife with both pragmatic and utopian aspects, and upholds the dignity of the individual within mass culture without losing sight of the factor of desire.

Her works, which amount to something in the nature of a well-considered product range to cover all basic human needs, are located between design and sculpture. The user-friendly clothing, tableware, furniture or living modules designed by Zittel are equally suited for daily use as to auratic exhibition in an art space. She has even launched a label, an enterprise called "Administration Service Zittel, A–Z", with which she is present not only on the art scene. "A–Z" on the one hand refers to the artist's name, and on the other represents an alphabetical completeness of goods and services that has a long history in advertising and its claims. It is precisely between these poles of individual emancipation and mere mass, of desirable art and dubious commerce, that the attitude to life advanced by Zittel moves.

At the start of her career, the artist designed articles of clothing – mostly for herself – and then wore them every day for a six-month period. Her idea was to design the perfect outfit for every season. In addition, she wanted to confront the social convention of having to change one's clothing every day with a self-imposed constancy. This is why she referred to her dresses as "uniforms". The *Dress for Spring Summer 1991,* for instance, was a simple sleeveless linen sheath, while her *Dress for Fall Winter* 1992–1993 was almost bizarre by comparison, being a combination of heavy leather suspenders and a tailor-made man's shirt, worn with a black taffeta skirt and a petticoat of wool jersey and blue tulle, whose hem of green satin adorned with little green silk flowers brought a touch of colour back into a cold grey winter. Later, Zittel supplanted the principle of a six-month change by what she termed

the "rectangle rule", which permitted the wearing of any piece of clothing as long as it consisted of a mere rectangle.

Optimal functionality, a sure sense of style, and a touch of cool poetry are also found in the furniture that Zittel designs, which includes beds. In a catalogue which doubled as an advertising and sales brochure, she announced: "The Carpet Bed. Elegance, economy, and just the right energy. Complete. Roll it up, then lay it down. Move as independently and impulsively as you have ever dreamed." Her simple geometric beds, which often recall Constructivist floor coverings, are prime examples of the idealism that underlies Zittel's furnishings and utilitarian objects.

Prototypes

Compelling results thanks to highly reduced yet intelligent design – this is how the corporate identity reflected in the chairs and tables, rugs and clocks, even entire interiors of "A–Z" might be described. Their ascetic configurations are intended to encourage the unfolding of individuality and pleasure – an intention to which only ideal form can do justice. And yet these purist art pieces are also conceivable as mass products. The term "prototype" applied by Zittel to many of her objects indicates the intermediate stage in which her pieces often exist. Since March 1995, buyers of the artist's works can decide whether they want an "original prototype" or a "registered copy". If they decide on the latter, they receive a construction drawing and the address of a manufacturer, which permits them either to have the piece replicated as it is or altered to suit their taste – a type of series production that leaves room for individual needs.

Escape vehicles

Zittel became widely known in 1997 thanks to the *A–Z Escape Vehicles*, 1996, presented at documenta X in Kassel, Germany. These were configurations resembling small-scale mobile homes which, like much of her furniture, had wheels, making them truly mobile. Yet they were intended not so much for actual travel as for journeys into the self, into a dream paradise that is literally utopian. Though the exterior of all the vehicles was identical, the interiors were designed to meet the individual needs and desires of their respective owners. Each could enter his or her own personal fantasy world when "escaping" from harsh reality into the self-designed interior. The artist's own *Escape Vehicle* recalled a grotto once created by King Ludwig of Bavaria. This escapist aspect was also present in Andrea Zittel's *A–Z Deserted Islands*, 1997, a work that consisted of small white fibreglass and plastic islands floating on water and inviting viewers to board them for a romantic voyage beyond the mundane.

Raimar Stange

1 **A–Z Deserted Islands I-X,** 1997. Fibreglass, wood, plastic, flotation materials, vinyl seat, vinyl logo, each 1.07 x 2.24 x 2.16 m. Installation view, Public Art Fund Project, Central Park, New York (NY), USA, 1999
2 **A–Z Escape Vehicle: Pre-Customised Shell,** 1996. Steel, insulating material, wood, glass, 1.52 x 1.02 x 2.13 m
3 **Installation view "Andrea Zittel Living Units",** Museum für Gegenwartskunst Basel, Basle, Switzerland, 1996/97

Photo Credits

Abramović, Marina: 1, 3, 4: Courtesy Sean Kelly Gallery, New York (NY); 1: © Photo: Elio Montanari; 2: Courtesy of the artists; portrait: © Photo: Tomas Adel

Ahtila, Eija–Liisa: © Crystal Eye Ltd., Helsinki. 1, 2 , portrait: Courtesy Gasser & Grunert, Inc., New York (NY)

Anderson, Laurie: 1–4: Courtesy of the artist and Sean Kelly Gallery, New York (NY); 1: © Photo: Adriane Friere; portrait: Courtesy Warner Bros. Records, Inc., © Photo: Annie Leibovitz

Beecroft, Vanessa: 1, 2, portrait: Courtesy Deitch Projects, New York (NY)

Bourgeois, Louise: 1, 2: Courtesy Cheim & Read, New York (NY); 3, portrait: Courtesy Galerie Karsten Greve, Cologne, Paris, Milan, St. Moritz; portrait: © Photo: Peter Bellamy

Clark, Lygia: 1–4, portrait: Courtesy Lygia Clark Collection/Museu de Arte Moderna do Rio de Janeiro, Rio de Janeiro

Darboven, Hanne: 1, portrait: Courtesy Sperone Westwater, New York (NY); 2: Courtesy Galerie Konrad Fischer, Düsseldorf; © Photo: Daniela Steinfeld

Delaunay, Sonia: 1– 4: © L & M Services B. V., Amsterdam; © Photos: Musée national d'art moderne, Paris, Paris; 1: © Photo: Philippe Migeat, portrait: © Photo: Florence Henri

Dijkstra, Rineke: 1–4, portrait: Courtesy of the artist

Dumas, Marlene: 1: Courtesy Galerie Paul Andriesse, Amsterdam; © Photo: Peter Cox; 2-4, portrait: Courtesy of the artist; portrait: © Photo: Dieter Schwerdtle

Emin, Tracey: 1–4: Courtesy White Cube/Jay Jopling, London; 1: © Photo: Stephen White; portrait: © Photo: Johnnie Shand–Kydd

Export, Valie: 1–3, portrait: Courtesy of the artist; 1: © Photo: Peter Hassmann; 2: © Photo: Archiv Valie Export/Gertraude Wolfschwenger; 3: © Archiv Valie Export; portrait: © Photo: Peter Rigaud

Fleury, Sylvie: 1, 3: Courtesy Mehdi Chouakri, Berlin; 2, portrait: Courtesy Galerie Hauser & Wirth & Presenhuber, Zurich

Genzken, Isa: 1, 2, portrait: Courtesy Galerie Daniel Buchholz, Cologne; portrait: © Photo: Wolfgang Tillmans

Goldin, Nan: 1–3, portrait: Courtesy of the artist; portrait: © Photo: David Armstrong

Goncharova, Natalia: 1: Museum Ludwig, Cologne; © Photo: Rheinisches Bildarchiv, Cologne; 2: © Photo: AKG, Berlin; 3: Courtesy Galerie Gmurzynska, Cologne

Guerrilla Girls: 1, 2: © Guerrilla Girls

Hatoum, Mona: 1–3, portrait: Courtesy White Cube/Jay Jopling, London; 1, 2: © Photo: Edward Woodman; portrait: © Photo: Johnnie Shand-Kydd

Hepworth, Barbara: © Alan Bowness, Hepworth Estate; 1: Courtesy PaceWildenstein, New York (NY); Photo: © Ellen Page Wilson; 2: Courtesy Tate Gallery, London; Photo: © Tate Gallery Picture Library 3: Courtesy Tate Gallery, London; Photo: © Tate Gallery Picture Library; portrait: Courtesy the Hepworth Estate; Photo: © Alan Bowness, Hepworth Estate

Hesse, Eva: 1: Museum Ludwig, Cologne; © Photo: Rheinisches Bildarchiv, Cologne; 2, 3, portrait: © The Estate of Eva Hesse, Courtesy Galerie Hauser & Wirth, Zurich; portrait: © Photo: John A. Ferrari

Höch, Hannah: 1: © Staatliche Museen zu Berlin – Preußischer Kulturbesitz, Nationalgalerie; © Photo: Jörg P. Anders; 2: © Kupferstichkabinett. Staatliche Museen zu Berlin – Preußischer Kulturbesitz; © Photo: Jörg P. Anders; 2: © Berlinische Galerie, Hannah-Höch-Archiv, Berlin; © Photo: Hermann Kiessling; portrait: © Photo: AKG, Berlin

Women Artists
Ed. Uta Grosenick / Flexi-cover,
576 pp. / € 29.99 / $ 39.99 /
£ 19.99 / ¥ 5.900

Art Now
Ed. Uta Grosenick, Burkhard
Riemschneider / Flexi-cover,
640 pp. / € 29.99 / $ 39.99 /
£ 19.99 / ¥ 5.900

"An essential reference book, *Art Now* is a must-have." —*Kultureflash*, London

"Buy them all and add some pleasure to your life."

★
ICONS